About the Author

Barbara Obermeier is principal of Obermeier Design, a graphic design studio in Ventura, CA. She is the author of *Photoshop CS3 All-in-One Desk Reference For Dummies*, coauthor of *Photoshop Elements 6.0 For Dummies*, and has contributed as author, or coauthor, on numerous books. Barb is also a faculty member in the School of Graphic Design at Brooks Institute in Santa Barbara, CA.

Dedication

I would like to dedicate this book to Gary, Kylie, and Lucky.

Author's Acknowledgments

I would like to thank my project editor, Becky Huehls, who did an exceptional job managing this book; Steven Hayes, a most excellent Executive Editor; Michael Sullivan, a great technical editor; Becky Whitney, who made my writing sound even better; and all those in the trenches—the dedicated production staff at Wiley Publishing.

Publisher's Acknowledgments

We're proud of this book; please send us your comments through our online registration form located at `www.dummies.com/register/`. Some of the people who helped bring this book to market include the following:

Acquisitions and Editorial

Project Editor: Rebecca Huehls

Executive Editor: Steven Hayes

Copy Editor: Rebecca Whitney

Technical Editor: Michael Sullivan

Editorial Manager: Leah P. Cameron

Editorial Assistant: Amanda Foxworth

Sr. Editorial Assistant: Cherie Case

Cartoons: Rich Tennant (`www.the5thwave.com`)

Composition Services

Sr. Project Coordinator: Kristie Rees

Layout and Graphics: Stephanie D. Jumper, Jennifer Mayberry, Melanee Prendergast, Tobin Wilkerson

Proofreaders: Laura Albert, Joni Heredia

Indexer: Christine Spina Karpeles

Publishing and Editorial for Technology Dummies

 Richard Swadley, Vice President and Executive Group Publisher

 Andy Cummings, Vice President and Publisher

 Mary Bednarek, Executive Acquisitions Director

 Mary C. Corder, Editorial Director

Publishing for Consumer Dummies

 Diane Graves Steele, Vice President and Publisher

 Joyce Pepple, Acquisitions Director

Composition Services

 Gerry Fahey, Vice President of Production Services

 Debbie Stailey, Director of Composition Services

Contents at a Glance

Table of Contents

Welcome to the exciting world of digital photography! Whether digital photography is a new interest of yours or it's your passion, *Digital Photography Just the Steps For Dummies* has something just for you.

About This Book

This book is for those of you who don't want fluff — just the information to get your answers and go back to shooting or editing your photos. The book wasn't written in a linear format, but completing one chapter before you begin another can be helpful. Don't worry: I let you know when that's the case. When you need an explanation or want to get something done, follow these simple steps:

1. **Pick the task.** Check out the table of contents or the index to find what you're looking for.

2. **Find it fast.** This step is easy because tasks are grouped logically into parts and chapters.

3. **Get it done.** Follow the steps, look at the figures, and move on to the next task. No fear, no fuss.

Why You Need This Book

Digital Photography Just the Steps For Dummies gives you just what you want — and nothing more. Why wade through dry user manuals (unless it's absolutely necessary) and 800-plus-page books when all you want is a quick answer to your question or a snappy solution to your problem? Direct steps and figures are all you need, leaving you precious time to go out and *use* that digital camera.

Introduction

Conventions used in this book

⟶ Menu commands use the ⇨ symbol. It tells you to click your mouse on the menu command in front of the symbol and then, when the menu choice behind the symbol appears, click it: for example, File⇨Save.

⟶ Web site addresses appear in a monospace font to make them easy to identify. Type them exactly as you see them: for example, `www.dummies.com`.

⟶ Because the range of cameras and software is so diverse, I give you only general instructions. When your instructions may be different, consult your user manual.

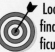 Look for this icon throughout the text to find helpful insights, explanations of difficult concepts, and ways to save time and trouble.

This book takes you through the world of digital photography from preparation to post production. You start out by examining equipment, proceed to discovering a little about photography, and move on to composition and capture. From there, you find out how to edit and improve those captured images and then to organize, manage, and share your photos.

How This Book Is Organized

Digital Photography Just the Steps For Dummies is divided into three parts.

Part 1: Acquiring Digital Photos

This part starts out with brief information on equipment and accessories and photography basics. From there, you find valuable information on composition and capturing specific types of subjects. I round out this part by assisting you in getting your photos from their original source, whether it's your camera or scanner or other means, onto your computer for editing and storage.

Part II: Editing and Enhancing Digital Photos

Trying to capture the perfect image is an ideal worth striving for, but in case you fall short, plenty of tools can help you edit and enhance your photos in postproduction. A popular choice is the inexpensive yet powerful Adobe Photoshop Elements, which is the program I use for the steps in these chapters. If you don't have Elements, don't worry: Many general concepts covered in this part are universally applicable.

Part III: Managing and Sharing Your Photos

Don't get caught with the digital version of the proverbial shoebox overflowing with photos. Organizing and managing your photos isn't hard, or even that time consuming, if you can embrace it from the get-go and implement it as part of your digital photo workflow.

After you clean up and organize your images, what good are they sitting on your hard drive? Get them out into the world! Share your photos with friends and family in a variety of ways — online sharing sites, CDs, photo books, PDF slide shows, and prints, for example.

Get Ready To . . .

Look over the table of contents or index to find an answer to a burning question about digital photography. If you don't have one yet, get out and shoot! I'll be here waiting for you if you need me when you return.

Part I
Acquiring Digital Photos

Purchasing a Camera and Accessories

Chapter 1

Keeping up with technology is a never-ending story. Just when you think you have a decent handle on it, a new and improved product hits the streets. No worries: Really, the best way to determine which kind of camera you should buy is to first determine your needs. Ask yourself the vital questions listed in the first section of this chapter. What's your budget? How often will you use the camera? What kind of photos will you mostly be taking? And so on. After you determine your needs, take your time researching and then shopping for the right choice. Talk to people, read reviews, and even take a couple models for a test drive. You want to make sure that the investment you make yields the camera that best suits your needs.

Obviously, if you're already a proud and satisfied camera owner, you can skip this chapter and dive right into the topic of your interest.

Get ready to . . .

Check Out Camera Features

Feature	Description
Size	Your options range from a small (compact) model with limited features and low cost to a large DSLR with professional photography features and a four-figure cost.
Image processor	This type of camera electronics helps color fidelity and overall image quality.
DSLR	The high-quality digital single-lens reflex camera migrated from SLR film cameras. It has detachable lenses and full manual features, as shown in Figure 1-1.
LCD	The liquid crystal display uses, on consumer cameras and some DSLR cameras, a 2 ½- to 3-inch display to frame the subject. Most DSLR cameras use the optical viewfinder to shoot an image.
Sensor cleaning	This higher-end feature vibrates the sensor to remove dust.

Figure 1-1: A digital SLR camera

Feature	Description
Output formats	**JPEG:** This lossy, compressed format is the most common format.
	RAW: This higher-end feature saves data directly (unprocessed) from the sensor. It has a significantly larger file size than other formats and is used by professional photographers and graphic designers for maximum image quality and editing flexibility.
	RAW+JPEG: This DSLR feature simultaneously saves an image in both file formats. See Figure 1-2.
	AVI: Most consumer cameras can shoot low-resolution half- or full-VGA, short-duration movies. Not applicable in DSLR cameras.
Power options	**Lithium ion battery pack:** Proprietary, rechargeable, high-performance, costly batteries. **AA alkaline batteries:** Common, easily obtainable battery. **AA NiMh batteries:** Rechargeable, higher-performance AA batteries. **AC adapter**: Optional AC power adapter.
Camera technology	**Exif 2.1:** Stores camera-specific information in addition to JPEG image info. **Exif 2.2:** Adds header with printer info to Exif 2.1 data. **PictBridge:** Uses USB cable to connect camera directly to a supported printer. **PIM:** Uses Proprietary Epson technology equivalent to Exif 2.2.

Figure 1-2: Output formats on the image quality menu.

 Another feature to investigate is the camera-to-computer image transfer, which performs transfers using a supplied cable. Older cameras may use slow-speed USB 1. High-speed USB is the transfer method on on newer models. A few models also support WiFi.

Examine Image-Capture Features

Feature	Description
Resolution	Ranges from 6 to 14 megapixels (and climbing) and is based on CCD/CMOS sensor capabilities. The bigger-is-better concept lets you create larger prints without observable pixilution. A 14.2MP camera is shown in Figure 1-3.
Image stabilization	Compensates for camera shake. Very useful when not using a tripod.
Frames per second	The speed at which a camera can shoot an image. DSLR cameras are significantly faster than consumer cameras. Important when capturing a moving subject.
Modes	A popular feature for fixed, automatic camera operations. Modes include Macro, Burst, Portrait, Landscape, Sports, Stitch Assist, and Special Scenes. Select Manual mode to focus manually and set the shutter speed, aperture, ISO, and white balance.
Face detection	A type of camera electronics that automatically detects faces and corrects for face focus.
Red-eye reduction	Corrects red-eye by employing a preflash.

Figure 1-3: Product specs for a digital SLR camera

Determine Your Needs

Before you start looking at cameras, ask yourself these important questions to determine your needs:

1. How much money is in my budget?

2. How often will I use my camera? Will I take occasional family photos or become a proficient amateur photographer?

3. What kind of photography am I interested in? Will I shoot landscapes, portraits, my child's soccer games, and other fast-moving subjects?

4. What kind of lighting will I typically work with — outdoors, indoors, or both? What about weather conditions?

5. Which is the most critical criteria — portability (when you need it small, like the camera shown in Figure 1-4) or feature rich?

6. Will I print photos, and will I want to print large photos?

7. Can I use my existing equipment, which makes compatibility important?

8. Am I willing to learn a little about photography so that I can use a more manual mode?

If possible, test a camera before plunking down your hard-earned dollars. Some camera stores rent cameras for a daily fee. If you happen to have a friend or family member with a digital camera you're interested in, that's all the better. Also, make sure to talk to people who have digital cameras and read reviews in magazines and on Web sites like www.dpreview.com.

Figure 1-4: Portability is an important consideration

Understand Resolution

Number of Megapixels	Image Size in Pixel Dimensions*	Approximate Print Size at 300 dpi
2	1600 x 1200	4 x 6
3	2048 x 1536	5 x 7
4	2464 x 1632	5 x 8
6	3008 x 2000	7 x 10
8	3264 x 2448	8 x 11
10	3872 x 2592	9 x 13
12	4290 x 2800	9 x 14
16	4920 x 3264	10 x 16

* Pixel dimensions may vary depending on the camera model.

 A megapixel is one million pixels and is the unit measurement for the number of pixels a digital camera can capture. Pixel is short for picture element, the smallest element in a digital image. The more pixels in an image, the bigger you can print the image, as shown in Figure 1-5.

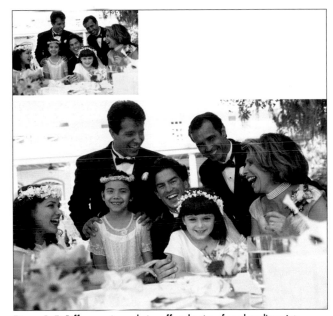

Figure 1-5: Differences in resolution affect the size of good-quality prints
Purestocke

Choose the Right Camera

Style	Cost	Description
Compact	$125 to $300	Easily slips into shirt pocket or small purse. Uses fixed lens and internal flash. Strict auto-functionality. Some models have image stabilization. Good ultracompact cameras are now entering the market.
Point and shoot	$200 to $400	Provides better performance than compact style, but larger. Uses fixed lens and internal flash. Most models have powerful image processors and image stabilization.
Prosumer	$300 to $600	Has the power of a DSLR with the convenience of a point-and-shoot model. Usually has a fixed, high-range zoom lens with some lens attachment or external flash interchangeability options. Select manual or multiple auto modes. Can shoot images as RAW files.
DSLR	$600 to $5000	Aimed for serious hobbyists and professional photographers looking for a mid-level camera, as shown in Figure 1-6. Purchase as a camera system. Extensive interchangeable lens and external flash options. Shoots both RAW and JPEG file formats simultaneously.

Some newer DSLR models allow the image to be framed in the LCD display. If this is a desirable feature for you, look for it in the camera specifications.

Figure 1-6: Choose a camera according to your needs and your budget

Evaluate Lenses

Feature	Focal Length	Comments
Focal length	N/A	The distance between the optical center of the lens and the CCD/CMOS chip. Determines the area of image coverage. Expressed in millimeters. Various lenses are shown in Figure 1-7.
Wide angle	14 to 35mm	A prosumer/DSLR lens that shoots a wide area in a tight space. May produce distortion.
Normal	28 to 50mm	A DSLR lens; for full-frame sensor cameras, 50mm is considered normal. For a small-sensor cameras, like Canon EOS or Nikon D series, 28 to 35mm is normal.
Telephoto	100 to 400mm	A prosumer/DSLR lens that shoot subjects at a distance.
Macro	N/A	A prosumer/DSLR lens that shoots subjects up close. On consumer cameras, select a mode for close-up shots.
Zoom	N/A	Variable optical focal length, from wide angle to normal to telephoto. Non-DSLR cameras also zoom digitally; avoid digital zoom to preserve image quality.

Figure 1-7: Lenses are valuable accessories
istockphoto.com

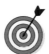 Filters screw to the end of prosumer/DSLR lenses to protect the lens, filter out UV light (UV), reduce water or glass reflections (polarizing), or obtain a wider dynamic range (graduated neutral density). For details on using filters, see Chapter 3.

 In any discussion about using lenses with DSLR cameras you must consider the complex concept of the crop factor. *Crop factor* is a ratio used to compensate for the fact that digital image sensors are smaller than the 35mm film frame. Therefore, if you take a photo with the same lens on a digital camera and a film camera, the digital camera shows a smaller area of the image. And, when you use a lens on a camera with a smaller sensor, the lens has a larger equivalent size. For example, a 50mm lens on a camera with a crop factor of 1.6 creates an equivalent lens of 80mm.

Look at Zooms

Type	Factor	Comments
Optical	3x to 18x	Uses the lens mechanism to change the focal length of the lens, allowing you to zoom closer to or farther away from the subject. Non-DSLR camera specs express zoom as a value of X. A 10X zoom is roughly equivalent to a zoom factor of 28 to 200mm.
		Compact and point-and-shoot camera lenses typically cannot be replaced. Prosumer cameras have limited lens interchangeability options, but usually have a built-in lens that can't be replaced. DSLR cameras have a wide variety of zoom lens options. A DSLR with a zoom lens is shown in Figure 1-8.
Digital	3x to 6x	Not applicable to DSLR cameras. Uses camera electronics to zoom closer to or farther away from the subject, after reaching your camera's optical zoom limits. Selects a portion of your digital image and magnifies it while reducing image resolution and adding noise. Easily observable in your LCD display while zooming. Avoid using digital zoom to preserve image quality. Move closer to your subject, if possible. Consider purchasing a telephoto zoom lens.

Figure 1-8: A DSLR with zoom lens
www.sxc.hu

Choose Flash Features

Feature	Description
Internal	Flash type built into camera body and found on non-DSLR cameras.
Pop-up flash	On DSLR cameras, automatically pops up under low light conditions with greater flash than internal flash.
Hot shoe connector	Requires connection on top of camera to connect an external flash.
External flash	A prosumer/DSLR option that offers greater flash range and control (see Figure 1-9). Attaches to a hot shoe.
Range	Reflects the maximum effective range of the flash.
Auto mode	Turns on flash when low light levels exist
Fill or Force mode	Flash always fires. Useful for portraits, especially in harsh sunlight.
Red-eye reduction	Flash fires initially to close subject's iris before main flash fires and image is captured.

Figure 1-9: A DSLR with an external flash
istockphoto.com

Look at Storage Media

Media	Gigabytes	Description
Compact Flash (CF) card	1, 2, 4, 8, 16	Largest and oldest card type still in widespread use, and shown in Figure 1-10.
Secure Digital (SD) card	1, 2, 4, 8	Smaller than CF; most common mini and micro sizes used in other, smaller devices.
Secure Digital High Capacity	4, 8, 16	Newer version of SD (SDHC) Card.
XD picture	1, 2	Newest and smallest card type.
Memory Stick Pro card	1, 2, 4, 8	Used with Sony cameras and Sony devices. Duo version also in use.

Figure 1-10: Compact flash is a common type of storage card
www.sxc.hu

The media in this section is available in various speeds. Slower-speed media cards are substantially less expensive than newer, faster cards, but can affect camera performance. The slower the card, the longer it takes the camera to read and write to the card. Slower cards can potentially affect the frames per second (FPS) performance of your digital camera.

Pick and Choose Accessories

Accessory	Comments
Extra battery	A critical accessory, shown in Figure 1-11.
Battery charger	Provided with camera.
Extra media cards	Always good to carry.
Tripod mount	Common on higher-end cameras.
Camera bag	Needed to carry and protect camera and accessories.
Image editing software	Typically bundled by manufacturers. Other popular programs available include Adobe Photoshop, Adobe Photoshop Elements, Lightroom, and Aperture.
External multiformat card reader	USB device that connects to your computer and reads multiple card-reader types. Remove card from camera and insert into reader, and then access the files on the card media.
Photo printer	Inkjet printer specifically designed for printing camera images.

Figure 1-11: Important accessories: extra batteries, extra storage card, and tripod

For more information on lenses, see the section "Evaluate Lenses," earlier in this chapter. For details on using filters, tripods, and reflectors, see Chapter 3.

Understanding Camera Basics

Chapter

2

You have the camera, and you have the motivation. You may even have a few shots under your belt. Now you're ready to understand a few basic concepts about photography and how your camera works.

This chapter gives you a brief rundown on exposure, aperture, shutter speed, ISO, and a few key photographic terms. Because of differences between camera makes and models, some setting names and locations may be different from what you find here. Be sure to have your camera's user manual handy, and remember that nothing beats getting out there and putting your camera through the ringer. Try every setting, get a shot, and see what happens: That's really the only way to truly feel comfortable with your camera. After you do all that, if you still want to go back to the comfort zone of Auto mode, go for it.

Get ready to . . .

Understand Exposure

1. *Exposure* refers to the amount of light allowed to fall on the image sensor in the camera during image capture.

2. Note the interrelationship between ISO, aperture, and shutter speed in regard to exposure: *Exposure* is the result of the combination of the "speed" of your image sensor (ISO), the length of time that the image sensor receives light (shutter speed), and the size of the lens opening (aperture). See details on each setting later in this chapter.

3. Changing one of these three settings causes one or more of the other settings to change in an attempt to properly expose the image. For example, if you change the ISO, the aperture and shutter speed change to capture the shot at the same exposure. If you increase the speed of the shutter, the aperture or ISO also changes. The same concept applies to changing the aperture. Manually, for example, you can produce the same exposure if you increase the size of the aperture, decrease the shutter speed, and keep the ISO constant.

4. The terms *overexposed* and *underexposed* refer to images captured with too much light and not enough light respectively, as shown in Figure 2-1 and Figure 2-2.

Figure 2-1: An overexposed image

Figure 2-2: An underexposed image

Set the Shutter Speed

1. To set the shutter speed, you must be in either Manual mode (M on the Mode menu or dial) or Shutter Priority mode (S, or Tv, as in *time value*) on the Mode menu or dial. Setting your camera to Shutter Priority mode enables you to manually set the shutter speed while the camera determines all other settings. See Chapter 3 for more information on this mode.

 Shutter speed is the length of time the shutter remains open and the image sensor captures the photo. In automatic modes, your camera determines the shutter speed.

2. Set the shutter speed by turning the dial (located on the front or top) and looking at the LCD display. If you can't locate the dial, check your camera's user manual.

3. Shutter speeds are measured in fractions of seconds to seconds and usually range from 30 seconds to $^1\!/_{4000}$, or sometimes $^1\!/_{8000}$, of a second. Some cameras also have B (Bulb) mode, which enables you to keep the shutter open as long as you hold down the button (in Manual mode).

4. A shutter speed of $^1\!/_{125}$ is a good overall setting to use. For speeds slower than $^1\!/_{60}$ of a second, you should use a tripod or monopod to avoid camera shake and to ensure a sharp image. If you don't have a tripod and your camera has an image-stabilization feature, be sure to turn it on.

5. To intentionally blur an image with a moving subject (motion blur), as shown in Figure 2-3, set the shutter speed to a slower speed. To freeze the action in a shot, as shown in Figure 2-4, use a faster speed.

6. When using longer lenses, you may need to increase the shutter speed to keep photos sharp. As a guideline, use a speed that's larger than the lens focal length. For a 55mm lens, anything over $^1\!/_{60}$ is acceptable, and so on.

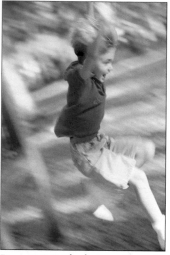

Figure 2-3: Set the shutter speed to a slower setting to blur an image
PhotoDisc

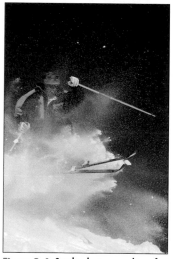

Figure 2-4: Set the shutter speed to a faster setting to freeze movement
PhotoDisc

Know about Aperture

1. To set the aperture, your camera must be in either Manual mode (M on the Mode menu or dial) or Aperture Priority mode (A or Av, which stands for *aperture value*) on the Mode menu or dial. Setting your camera to Aperture Priority mode enables you to manually set the aperture while the camera determines all other settings. See Chapter 3 for more on this mode.

2. Set the aperture by turning the dial (located on the front or top) and looking at the LCD display. If you can't locate the dial, check your camera's user manual.

3. Changing your camera's aperture can control the depth of field (how much of the image is in focus). Basically, set the aperture to a smaller opening (a higher number) to gain greater depth of field, as shown in Figure 2-5. Set the aperture to a larger opening (a smaller number) to create a shallower depth of field, as shown in Figure 2-6. For more on depth of field, see Chapter 3.

Figure 2-5: Small aperture; large depth of field.
PhotoDisc

Aperture, also known as an *f-stop,* refers to the size of the opening in the lens of the camera when the image is captured. The size of this opening determines how much light is allowed into the camera. The larger the f-stop, the smaller the opening. Therefore, f/22 is a much smaller opening than f/2.8.

See "Understand Exposure," earlier in this chapter, to find out about the interrelationship between shutter speed, aperture, and ISO.

Figure 2-6: Large aperture, shallow depth of field.
PhotoDisc

Understand ISO Settings

1. Press the ISO button on your camera.

2. Look at the ISO menu on your camera's LCD. Set the ISO speed. ISO speeds usually run at 50, 100, 200, 400, 800, 1600, or 3200.

3. The lower the number, the less sensitive your image sensor is to light. This results in a photo with very fine grain, as shown in Figure 2-7. An ISO setting of 100 is considered average, but a low ISO speed may not work in low-light scenarios. Normally, you want the lowest ISO setting possible for best quality, unless you want a grainy shot for creative reasons.

4. A high ISO number makes your image sensor more sensitive to light and creates a grainy, noisy image, as shown in Figure 2-8. High ISO settings may be necessary in low-light situations, especially when using a faster shutter speed or a smaller aperture, or both — for example, when shooting a moving subject inside.

5. ISO, aperture, and shutter speed are interrelated in regard to exposure. When you change the ISO, the aperture and shutter speed change as well to capture the shot at the same exposure. For example, changing the ISO from 100 to 800 causes the aperture to decrease and the shutter speed to increase.

6. In automatic modes, your camera "chooses" an ISO setting, according to the lighting in the shot, unless you override it.

 In film photography, *ISO* is an indication of how sensitive the film is to light. It's also referred to as *film speed*. In digital photography it's an indication of how sensitive the image sensor is.

 Keep in mind that a tripod can help you capture a sharp image in low-light conditions, thereby enabling you to avoid a higher ISO speed.

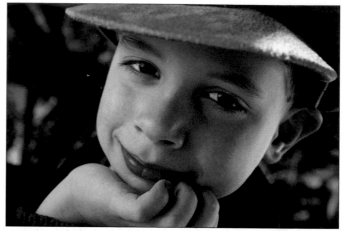

Figure 2-7: A finely grained image
Corbis Digital Stock

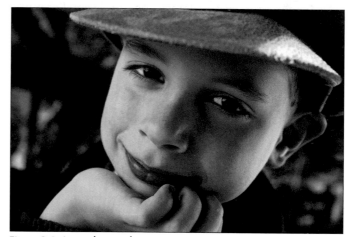

Figure 2-8: A coarsely grained image
Corbis Digital Stock

Use Exposure Compensation

1. Ensure that your camera is set to any mode except Manual (M) mode.

2. Press the shutter button halfway. Check the exposure indicator on your camera's LCD. It shows the shutter speed and aperture setting.

3. Specify your exposure compensation (EV compensation). Press the Av $^+/-$ button and turn the dial on your camera. Positive amounts increase exposure (lighten), and negative amounts decrease exposure (darken), as shown in Figure 2-9.

4. To set the EV compensation back to neutral, turn the dial until the setting goes back to the center, or 0, of the scale.

 Exposure compensation is an adjustment you can make to slightly alter the exposure setting established by the camera. This adjustment, which enables you to slightly over- or underexpose your photo, can come in handy when shooting a dark object against a bright background or in backlit situations.

Figure 2-9: An image with positive, zero, and negative EV compensation
Ryan McVay/PhotoDisc

Set Image Quality

1. Your camera may enable you to set image quality. On the menu, locate the Quality setting on the LCD. Press Set.

2. Use the arrow buttons to toggle through the Quality menu and choose a setting, as shown in Figure 2-10. Press Set.

3. Here's a brief description of some typical image-quality settings, based on an 8-megapixel DSLR (digital single-lens reflex) camera:

 - **JPEG (Joint Photographic Experts Group):** A file format and method of compression for digital images. JPEGs create small file sizes because of extensive compression. On the downside, the compression is lossy and can degrade images after repeated saves.

 - **TIFF (Tagged Image File Format):** A file format often intended for printed output. File sizes are large.

 - **RAW:** A file format that captures data from the camera's sensor. It's considered the closest thing to a digital "negative." All processing is done after the image capture in an image-editing program. File sizes are large.

 - **Small:** Adequate for 5 x 7 prints.

 - **Medium:** Adequate for 8 x 10 prints.

 - **Large:** Adequate for 11 x 17 prints. (Note that RAW images accommodate this size.)

 - **Fine:** Produces the best quality but less compression — and, therefore very large file sizes.

 - **Normal:** Produces better compression but lesser quality — and, therefore, smaller file sizes.

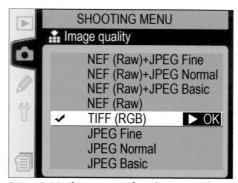

Figure 2-10: Choose a setting from the image quality menu

 On some cameras, you can shoot both RAW and JPEG simultaneously, thereby giving you more options in postprocessing. Just be sure to have plenty of large capacity memory cards on hand.

Set White Balance

1. Press the WB (White Balance) button on your camera. If you cannot locate the button, check your camera's user manual. Note that your camera must be in Manual (M) mode.

 The *white balance* setting attempts to compensate for differences in the color temperature of the lighting conditions, thereby minimizing unwanted color casts. For example, twilight or snowy environments have a cool, blue light. Sunset or candlelit environments have a warm, yellow light. Fluorescent lighting has a green, cool quality.

2. Look at the White Balance menu on your camera's LCD and specify a setting using the arrow buttons. Press Set.

3. Here's a brief description of typical white balance settings:

 - **Daylight or Sunny:** For capturing images in bright outdoor light.

 - **Shade:** For photographing in shady areas.

 - **Cloudy:** For shooting on overcast days.

 - **Fluorescent:** For shooting under fluorescent lights (tubular bulbs) often found in offices, schools, and other commercial buildings. Figure 2-11 shows an image shot on the Auto setting and then on Fluorescent.

 - **Tungsten:** For photographing under incandescent (regular household bulb) lighting.

 - **Flash:** For shooting with a flash.

 - **Custom:** For shooting white objects (such as a white card purchased at the camera store), which serves as the reference for the white-balance setting.

Figure 2-11: An image shot on the Auto setting and then Fluorescent.

 In automatic modes, the white balance is set automatically. However, if your images are showing a color cast, you may need to adjust the white balance manually. You can also use filters to mimic certain lighting conditions. If you cannot do it "in camera," you can do it in postproduction in Photoshop Elements or another digital imaging program. See "Remove Color Casts," in Chapter 8.

 When shooting RAW images, you custom-adjust the white balance in your digital imaging program.

Nail Your Focus

1. Set your camera to autofocus (using the AF mode switch or button), which enables the camera to make all focusing decisions. If your camera also has various autofocus options, choose them from your LCD menu: for example, One Shot (still subjects), AI Servo or Continuous (moving subjects), or AI Focus (automatically switches from One Shot to Servo). Compose your shot and press the shutter button.

2. Set your camera to Manual focus to put the focusing control in your hands. Using the MF mode switch or button. Also change the M/AF setting on the lens barrel. Adjust the focusing ring on the lens of your camera. Compose your shot and press the shutter button.

3. When you want to shoot a subject off-center, as shown in Figure 2-12, it may help to lock the focus. To do this, set the autofocus option to One Shot AF mode. If your camera has an option to select a single focus point or AF, select it. (Check your camera's user manual to find out how.) Focus on your subject. Press the shutter button halfway down. Recompose your shot with the shutter button still pressed. Finally, press the shutter button the rest of the way.

 Locking the focus can also help when shooting two people in the center of the frame. If you don't lock the focus, sometimes the couple is out of focus while whatever is between them looks as sharp as a tack. New, higher-end cameras are being outfitted with face-recognition capability to avoid this snafu.

Figure 2-12: Lock the focus to shoot an off-center subject
Todd Pearson/PhotoDisc

Use the Zoom Feature

1. Focus on your subject and press the Zoom button until you achieve the framing you want.

2. Compose your shot and press the shutter button.

3. If your camera has an image-stabilization feature, be sure that it's activated, to help eliminate camera shake and the resulting image blur.

4. Keep in mind that zooming in with an optical zoom shortens the depth of field and causes the background to become blurrier, as shown in Figure 2-13. Make sure that this effect is what you want.

Lenses with optical zooms are "real" zoom lenses. The lens brings the subject closer. Digital zooms aren't really zooms: They simply enlarge the center of the scene in the camera and crop out the rest, and they can degrade image resolution and quality. If quality is paramount, you may want to avoid employing a digital zoom. You may have to disable the digital zoom by using a menu option or avoid pressing the zoom past the optical maximum setting.

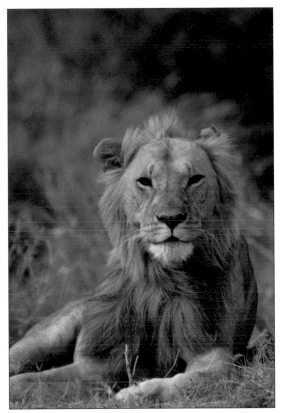

Figure 2-13: Zoom in to your image
Purestock

Match Your Meter to Your Environment

1. Put your camera in Manual (M) mode and press the Metering button (an eye icon or check your camera's user manual).

2. Select a metering mode from the LCD menu:

 - **Matrix, multi-segment, multi-zone, or evaluative metering:** Bases exposure on the entire frame, or on all zones, as shown in Figure 2-14. This overall setting looks at the subject's position and brightness, foreground, middle ground, and background lighting; averages them; and then determines the appropriate exposure.

 - **Spot, or partial, metering:** Bases exposure on the light in the center of the frame (approximately 9 to 10 percent of the frame). This metering mode works well for backlit scenes, where the background is much brighter than the subject.

 - **Center-weighted metering:** Weights, or favors, the center and then averages the entire scene. This mode is also good for complex lighting situations.

 All DSLRs and many point-and-shoot cameras have various metering modes. These modes define the way the image sensor in the camera measures the light in the shot and then calculates the appropriate exposure for the image.

Figure 2-14: Evaluative, partial, and center-weighted metering modes
Corbis Digital Stock

Use EXIF Data

1. If your camera is capable of displaying EXIF data, press the Info button while in Preview mode to view the data in the camera's LCD.

2. You can view EXIF data on your computer by right-clicking an image and choosing Properties (in Windows) or Get Info (on a Mac) from the context menu.

3. You can also view EXIF data in most image-editing programs, such as Adobe Photoshop Elements (shown in Figure 2-15), Aperture, iPhoto, Lightroom, and others.

4. EXIF data includes the camera's make and model , the date and time, image dimensions and resolution, shutter speed, and the aperture, ISO, and lens settings.

 EXIF, which stands for Exchangeable Image File and refers to the information that's embedded into your image data when you take a digital photo. This information can be valuable in determining what went right and wrong in your shots, especially in bracketing situations. (See Chapter 3 for more information.)

Figure 2-15: EXIF data in Photoshop Elements

Taking Digital Pictures

Chapter

3

After you buy the equipment and understand the basic concepts of how an image is captured (see Chapter 2), it's time to start shooting some photos. Don't worry initially about ensuring perfect composition (see Chapter 4) or capturing your subject by using the recommended techniques (see Chapter 5). Your most important task at this stage is to get to know your camera. See how it works and become comfortable with the basic principles of capturing an image. You may never want to leave the warm, comfy confines of Automatic mode — that's fine. But then again, you may get a wild hair one day and wonder what lies in the world of Manual mode.

Because so many makes and models of cameras are available, I can't go into detail on every particular mode or setting. This chapter simply gives you a few pointers on using a couple of useful and inexpensive accessories, using both natural and artificial light and working with elements like aperture and depth of field. Remember that you have no film to process, so get out there and push those buttons.

Get ready to . . .

Use Filters

1. For digital cameras, these types of filters can be beneficial:

 - **Polarizing** filters help reduce unwanted reflections from water and glass. They also help to increase contrast and color saturation. This type of filter is especially helpful when shooting landscapes, where they create bluer, darker skies. Be sure to use a circular polarizing filter.

 - **Ultraviolet (UV)** filters protect expensive lenses. Although UV filters can benefit landscape shots by adding clarity to hazy images, some photographers recommend that you avoid using it with a digital camera.

 - **Neutral density** (ND) filters, shown in Figure 3-1, reduce light in all wavelengths, so you can use slower shutter speeds or wider apertures. ND filters can come in handy when shooting subjects in bright light where you want a motion blur, as in waterfalls or river rapids.

 - **Graduated neutral density (GND)** filters help you obtain a wider dynamic range, by gaining detail in highlight and shadow areas — especially useful in landscapes with a bright sky and a dark ground.

 - **Infrared** (IR) filters allow only infrared light to pass thorough the lens, creating beautiful glowing images with dark skies and bright white foliage.

 - **Special effects** filters that create starbursts and other special effects can be fun to use.

2. Make sure that the filter you purchase is of good quality (Hoya and Tiffen make good ones) and fits the size of your lens. Also, your camera must be capable of mounting a filter. Depending on your camera model, you may also need to purchase an add-on adapter. Be sure that the filter you purchase is multicoated, to prevent unwanted reflections. For more on lenses, see Chapter 1.

Figure 3-1: A UV and ND filter

 Sometimes, using a filter can cause nasty occurrences, like lens flare and *vignetting* (darkening around the edges). If this happens, remove the filter and reshoot. Avoid using a polarizing filter on a wide-angle lens. The filter causes the color of the sky to be strangely uneven.

 For digital cameras, you can skip the warming, cooling, and fluorescent conversion filters. You can alter the color of the light within your camera, or in Adobe Photoshop or Adobe Photoshop Elements later, by using the White Balance controls.

Set Up a Tripod

1. Attach your camera to the tripod, as shown in Figure 3-2. Many tripods come equipped with a quick-connect plate that detaches from the tripod. If so, slide the foot of your camera onto the plate and then attach the plate to the head of the tripod.

2. Establish the height of your tripod by adjusting the legs and neck of the tripod. Be sure to lock the legs and neck so that they don't slip.

3. Adjust the head of the tripod until you have the exact angle you want for the camera.

4. Look through the viewfinder or LED screen and check the height and angle. Make any necessary adjustments.

5. If you're using a lens with an Image Stabilization or Vibration Reduction setting, you may want to turn it off when using a tripod (unless the lens also has a setting for detecting tripods). These settings enable you to hold a camera in low-light settings and decrease the incidence of camera shake. When you use a tripod, however, the setting can cause your photos to be blurry.

Figure 3-2: Use a tripod to ensure sharp focus
iStockPhoto.com

 Tripods are especially vital for taking shots that require the shutter speed to be slower, thereby helping to eliminate camera shake. Slower shutter speeds, which enable you to use wider aperture settings, are often used in low-light situations, such as bad weather, sunsets, and nighttime. You will also want to use one when using a telephoto lens.

 If you can't stand lugging around a tripod, try a monopod — it's like a tripod but with only one leg. A monopod is more portable and is easy to set up and move around, and it takes up less space in tight locations or in crowds.

Use Reflectors

1. When shooting a photo of a person outdoors in harsh, midday light, first position the person so that the sun isn't in their eyes. (This step also helps avoid squinting).

2. Place a reflector under your subject's face, but obviously not in the photograph, as shown in Figure 3-3. This step helps to reflect light under the chin, nose, and eyes and fill in the harsh shadow areas. Look for even, flattering lighting.

3. When shooting a person, a pet, or an object, next to a window indoors, place a reflector on the side away from the window to help reflect light back to the shadow side of the subject.

4. Compose and take the photo. Review it and make any necessary adjustments.

Figure 3-3: Use a reflector to fill in shadow areas
iStockPhoto.com

 A *reflector* is a fabric screen, usually silver (whiter light) or gold (warmer light), that you use to bounce the flash off to spread the light wider and thereby soften its harshness. A reflector is also used to add light to fill in shadows or dark areas. Pros also use umbrella reflectors to direct their flash into. Reflectors come in all sizes and can cost from $50 for a smaller one to more than $100 for a larger version. A "poor man's" reflector can consist of white foam core or mat board either as is (uncovered) or covered with tinfoil.

 Try bouncing the flash into a reflector to diffuse and soften the light from the flash.

Use Diffusers

1. If your flash unit comes with a built-in diffuser, as shown in Figure 3-4, simply slide or pop it over the face of the flash.

2. If you purchased an external diffuser, follow the instructions that came with the unit to install it over the flash head.

3. Compose and take your photo. Review it and make any necessary adjustments.

 The price of a diffuser ranges from $10 for a simple diffuser to use with a pop-up flash to more than $100 for a more professional version. You can make a diffuser from semitransparent Scotch tape, white tissue paper, cellophane, thin plastic container lids, or any other item that is semi-opaque and safely covers the flash head.

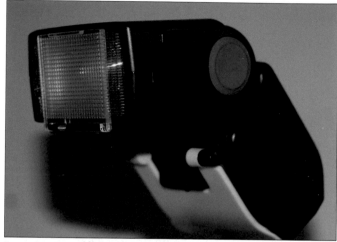

Figure 3-4: Use a diffuser to soften the flash

 A *scrim,* another kind of diffuser, is a panel of translucent material on a frame, which is placed between the light and your subject to soften harsh light. A scrim can also be made fairly easily with PVC tubing and cheap gauze or white nylon fabric.

Light Your Subject

1. When shooting outdoors, the best times of day are early morning and late afternoon, when the light is softer and the shadows are longer. For portraits, bright midday sun causes ugly shadows on faces and squinty eyes. Move your subject into shady areas instead or use a fill flash to fill in the shadow areas. Keep in mind that overcast days are especially useful for photographing people, as shown in Figure 3-5.

2. Be careful of shooting photos when the light source is directly behind your subject *(backlighting)* — unless, of course, you're aiming for a dramatic silhouette look. Your camera may adjust the light meter to the lighter background and not to your subject, thereby creating an overly dark foreground or subject. Using a fill flash can help in this situation. You may also need to turn on the flash manually.

3. When shooting indoors, try positioning your subject next to a window, that doesn't have direct sunlight streaming through.

4. In low-light situations indoors, use your camera's flash. You can also add light inexpensively by using table lamps or clip-on utility lights. Position the lights at a 45-degree angle to your subject, if possible.

5. Make certain that the brightest light source isn't directly shining into the lens. This situation can cause *lens flare*, or those nasty light circles or rainbow effects that mar images.

6. Use diffusers, scrims, and reflectors when needed (see the earlier sections of this chapter) to soften or add light.

Figure 3-5: Shoot in soft, outdoor light
Purestock

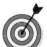 When talking about light, remember to consider the direction, intensity, and color of the light and the concept of natural-versus-artificial light.

 Remember that a flash doesn't help in landscape shots: Your subject needs to be nearby to benefit from a flash. Also remember that a flash increases the depth of field, which may or may not be a desirable effect.

Shoot in Auto Mode

1. Set the Mode dial or button to A (Auto mode) as shown in Figure 3-6. In Auto mode, your camera makes all decisions about setting the focus, aperture, shutter speed, ISO, and white balance and determines the need for flash. You may also need to switch your DSLR lens from A to Manual.

2. Compose your shot in the viewfinder or LED screen.

3. Press the shutter button halfway to give your camera a moment to establish the shot.

4. Press the shutter button the rest of way to capture the image.

 Another automatic mode is Portrait mode. Try this mode when the primary subject of your shot is human. In this mode, your camera specifies the aperture and shutter speed to optimize the result. Portrait mode should also keep the background in focus (creating a deep depth of field). In addition, if you have a red-eye reduction flash, it should also kick in.

Shoot in Manual Mode

1. Set the Mode dial or button to M (Manual mode) on your camera, as shown in Figure 3-7. In Manual mode, you must make all decisions about setting the focus, aperture, shutter speed, ISO, and white balance and determine the need for flash. See Chapter 2 for a brief explanation of these settings. If you're a novice in using Manual mode, try it first in a casual situation that isn't a once-in-a-lifetime event.

2. Compose your shot in the viewfinder or LED screen.

3. Press the shutter button halfway to give your camera a moment to establish the shot.

4. Press the shutter button the rest of way to capture the image.

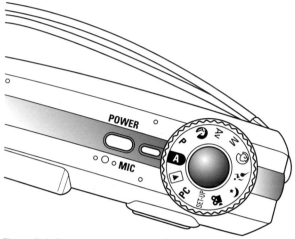

Figure 3-6: Set your camera to Auto mode

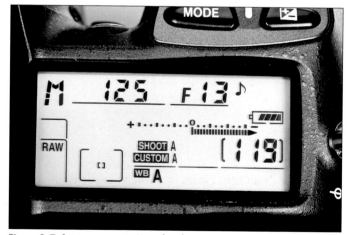

Figure 3-7: Set your camera to Manual mode

Take Close-Ups in Macro Mode

1. Set the Mode dial or button to Macro (sometimes it's a flower icon) on your camera. Macro mode enables you to shoot extremely close-up subjects, such as flowers, insects (shown in Figure 3-8), and product details for online auctions. Check your camera's documentation to find out the particular focusing distance that Macro mode is capable of.

2. Compose your shot in the viewfinder or LED screen. Focusing in Macro mode can be tricky, so be sure that the focal point you want is in focus; if it's not, make the necessary adjustments. In addition, macro photography benefits from the use of a tripod. (See "Set Up a Tripod," earlier in this chapter).

3. Press the shutter button halfway to give your camera a moment to establish the shot.

4. Press the shutter button the rest of way to capture the image.

Figure 3-8: Set your camera to Macro mode for close-up shots
Digital Vision

Shoot in Aperture Priority Mode

1. Set the Mode dial or button to Aperture Priority mode (A or Av) on your camera. This semiautomatic mode enables you to choose your own aperture setting. The camera then chooses all other settings, such as shutter speed, focus, white balance, and ISO.

2. Aperture Priority mode is especially useful when you're looking for a specific depth of field. Setting the aperture to a large number creates a smaller opening (like f/16), letting less light into the camera and resulting in a larger depth of field. Setting the aperture to a small number (like f/2.8) creates a larger opening, which lets in more light and results in a shallower depth of field, resulting in an out-of-focus background, as shown in Figure 3-9.

3. Your camera's shutter speed adjusts accordingly. With a larger aperture (opening), your camera most likely automatically chooses a slower shutter speed. Conversely, with a smaller aperture, your camera chooses a faster shutter speed.

4. Press the shutter button halfway to give your camera a moment to establish the shot.

5. Press the shutter button the rest of way to capture the image.

Figure 3-9: Use Aperture Priority mode to better control the depth of field
PhotoDisc

 You can also choose Shutter Priority mode (S or Tv). Similar in concept to Aperture Priority mode, this mode enables you to choose the shutter speed while the camera chooses the remaining settings. This mode can come in handy when shooting subjects in motion, from sports shots to moving cars to rushing water. Depending on the shutter speed you choose, you can "stop the action" or intentionally create a blurred effect.

Bracket Your Exposures

1. Set your camera to the Automatic Bracketing (AEB or BKT) setting.

 Bracketing occurs when you take several shots using different camera settings, usually having to do with exposure. It's usually done in difficult lighting situations or with overly contrasting subject matter, to ensure that one of your captures yields a satisfactory image. Bracketing can also be done with focus, white balance, and flash.

2. Depending on your camera model, it automatically takes multiple shots (often three to five) using different settings. It should base the first shot on the setting that the meter says is correct. It then takes one or two shots overexposed and one or two shots underexposed from that first setting, as shown in Figure 3-10.

3. If your camera is in Burst or Continuous or Continuous Drive mode, you need to press the shutter only once. If your camera is in Single Shot mode, you have to press the shutter three to five times. Check the details in your camera's manual to use AEB or BKT mode.

 You can also manually bracket the exposure by physically changing the settings on your camera.

Figure 3-10: Different exposure settings of the same subject

Work with Depth of Field

1. To create a shallow depth of field, as shown in Figure 3-11:

 - Shoot in Portrait mode (look for the letter *P* or a head icon), which sets the camera to a larger aperture.

 - Set your camera to Aperture Priority (A or Av) mode. (See the earlier section "Shoot in Aperture Priority Mode.") Choose a large aperture, which, ironically, is indicated by a smaller number. For example, f/2.8 is a larger aperture than f/16. Try various aperture settings to create the depth of field you want.

 - Use a telephoto lens and fill your frame with the subject. The longer the focal length of your lens, the shallower the depth of field.

 - Move close to your subject. The closer you are, the shallower the depth of field.

2. To create a deep depth of field, as shown in Figure 3-12:

 - Shoot in Landscape mode (look for the mountain icon), which sets the camera to a smaller aperture.

 - Choose A or Av mode and a small aperture, such as f/16 or f/22. Experiment with settings to create the depth of field you want.

 - Use a wide-angle lens to increase the impact of the deep depth of field.

 - Move farther away from your subject.

 Depth of field refers to how much area is in focus in front and in back of your subject. Use shallow depth of field to minimize (by blurring) a busy, distracting background and make your subject a stronger focal point. Use deep depth of field to keep a sharp focus from the foreground to the background of your image.

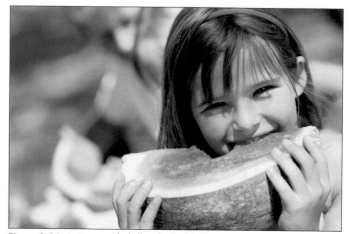

Figure 3-11: An image with shallow depth of field
Corbis Digital Stock

Figure 3-12: An image with deep depth of field
Corbis Digital Stock

Work with Camera RAW Images

1. If your camera is capable, set the mode to RAW. You may be able to capture RAW images only in Manual mode.

2. Compose and take your photo.

3. Copy the RAW images from your camera or card to your hard drive. (Chapter 6 explains how.)

4. Open the photo in your software program. In Elements, choose File⇨Open.

5. Navigate to your RAW images and select one. Click Open. Note that when you open the image, Elements creates a copy, preserving the original RAW image.

6. In the Camera Raw dialog box, crop, rotate, and straighten the image by using the tools in the upper-left corner of the dialog box, as shown in Figure 3-13.

7. Specify options for White Balance, Temperature, Exposure, Contrast, Clarity, and other settings. Keep an eye on the Preview area to see the effects of your settings. Zoom in and out as needed using the Zoom tool (in the upper-left corner) and the magnification percentage (in the lower-left corner).

8. Click the Detail tab to access the Sharpening settings. Complete all other adjustments before you sharpen. (For more about sharpening, see Chapter 7.)

9. If you muck up this process and want to start over, press Alt (or Option on a Mac) and click Reset. When you have processed the image to your liking, click Open Image to process it and open it in Elements. Click Done to make the settings you established the new default settings for your RAW image.

Figure 3-13: Process Camera RAW images

Camera RAW images are the closest thing to pure "digital negatives" as you can get, which means that the camera doesn't process the image internally (unlike with JPEG or TIFF files). You must have software (such as Adobe Photoshop, Photoshop Elements, or the camera's proprietary software) that can open and process the file after capture. In the Camera RAW dialog box, you have controls to adjust the white balance, exposure, and contrast. Although working with Camera RAW requires a little more knowledge, it gives you the best image quality and maximum flexibility in image editing.

Some cameras can capture both RAW and JPEG photos simultaneously, giving you the option of choosing either format. Just be sure to have plenty of media cards on hand for storing all these files. RAW images are very large.

Getting the Best Shot

Chapter 4

The best camera, a great location, and some technical prowess all certainly contribute to the making of a good photograph. But other elements must come into play as well. Knowledge of basic composition is a key ingredient in the quality of a photograph, and there's nothing complex or difficult to remember. In fact, just employing a couple of basic principles improves your photo-taking significantly. You'll find, as you take more photos, that these compositional concepts will start to become second nature.

The other ingredient? Serendipity, of course, or just being in the right place at the right time. Sometimes, there's no discounting just plain ol' good luck.

Get ready to . . .

Find a Focal Point

1. If a photo contains too many elements, the eye doesn't know where to look first. A *focal point* draws your viewer to a main point of interest within the image. One of the easiest compositional tasks is to find a clearly defined focal point.

2. To create a clear focal point, include only necessary elements that contribute to the compositional strength or emotional value of your image:

 - If you're shooting people or animals, try to get close to them.

 - If you're shooting scenes, find something interesting to include in the frame, as shown in Figure 4-1. Shots of mountains and beaches are fine, but how many are truly memorable? But throw in a climber scaling the mountain wall or a surfer wiping out on a wave and you elevate the visual impact to another level.

 Problems to avoid include too much background and random clutter and bystanders.

Figure 4-1: Find a focal point
Brand X Pictures

Compose with the Rule of Thirds

1. Use the rule of thirds to position your chosen focal point. If you divide an image into a grid of nine equal segments, as shown in Figure 4-2, the elements that are most pleasing to the eye and also most likely to be noticed first are those located at a grid intersection.

2. To apply the rule of thirds to various shots, consider these examples:

 • **In a scenic shot:** A low horizon creates a spacious feeling, and a high horizon gives an intimate feeling.

 • **In a portrait:** Try putting the face or eyes of the person at an intersecting point.

3. If you have an autofocus camera, lock the focus when you're moving from center because the autofocus sensor locks on to whatever is in the center of the viewfinder. Center your subject in the viewfinder, and apply slight pressure to the shutter release button to lock the focus. Then reposition your subject at an intersecting point and take the photo.

Avoid Mergers

1. Unless you're going for a lowbrow, humorous shot, be sensitive to poles, tree branches, and other objects growing out of people's or animals' bodies. Photographers refer to these undesirable bodily extensions as *mergers*.

2. Also be careful not to amputate body parts in your shot, known as *border mergers,* as shown in Figure 4-3.

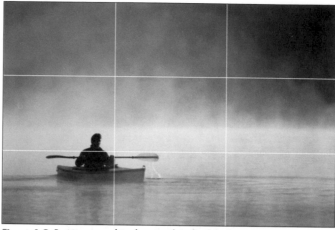

Figure 4-2: Position your subject by using the rule of thirds
Corbis Digital Stock

Figure 4-3: Avoid border mergers
Corbis Digital Stock

43

Find Leading Lines

1. *Leading lines* draw the eye into the picture, as shown in Figure 4-4. They add dimension and depth and can be actual lines or lines implied by the composition of elements.

2. To compose photos with leading lines, look for elements such as roads, fences, rivers, and bridges. Diagonal lines are dynamic. Curved lines are harmonious. Horizontal lines are peaceful. Vertical lines are active.

 The best leading lines enter from the lower-left corner and end at a point of interest — the ultimate payoff.

Use Framing

1. A *frame* welcomes you to an image, adds depth, and creates a point of reference, as shown in Figure 4-5.

2. To compose photos with frames, use foreground elements to frame your subjects. Elements such as tree branches, windows, and doorways can frame wide or long shots. Close-up shots can also be framed.

3. Decide whether to keep your framing elements sharply focused or soft. Depending on the shot, sometimes sharply focused framing elements can distract from, rather than enhance, the focal point.

Figure 4-4: Leading lines bring the eye into the image
Flat Earth

Figure 4-5: Frame your image with elements
Flat Earth

Shoot from Unexpected Angles

1. Try to take photos from *angles* other than straight on at five to six feet off the ground — the world of the average snapshot. Changing your viewpoint can exaggerate the size of the subject either larger or smaller; enhance the mood of the shot; or make a dull shot more interesting, as shown in Figure 4-6.

2. Depending on your particular subject, try a bird's-eye view (above the subject) or a worm's-eye view (below it).

Create a Mood with Distance

1. Getting close to your subject makes the image personal, warm, and inviting. Avoid including excessive background elements, and intimately fill your frame with your subject, especially when photographing people, as shown in Figure 4-7.

 Use eye contact when photographing people. Remember that children, animals, and other height-challenged subjects aren't at the same eye level as adults. Try getting down on the ground, at their level.

2. On the other hand, just as shooting close can create a feeling of intimacy, shooting a subject with a lot of space around it can evoke a sense of loneliness or isolation. It depends on your intended message.

Figure 4-6: Use an unexpected angle to exaggerate a subject
Corbis Digital Stock

Figure 4-7: Getting close to your subject
Purestock

Reduce Background Clutter

1. Most people worry only about cutting off people's heads when they shoot. In actuality, most people include way too many elements in their shots, distracting from the focal point. Background clutter that adds nothing to the value of your shot should be eliminated.

2. To reduce unnecessary elements in your photo compositions, here are a few tips:

 - **Get close.** Fill your frame with your subject.

 - **Move your camera, yourself, or your subject.** Try shooting a vertical or diagonal shot if the subject warrants it. If moving your camera isn't enough, move around your subject and try unexpected angles. Look for compositions that minimize or avoid distracting elements around your subject, such as poles, wires, fences, or bright lights.

 - **Include only complementary background elements.** If your background elements are interesting and give context to your subject, include them, as shown in Figure 4-8. These elements can include props, landmarks, and natural components.

 - Try blurring an unavoidable, undesirable background by using a wider aperture (like f/4 rather than f/11 or f/16) on your camera. This strategy makes the depth of field shallower so that your subject is sharp but the background isn't. Keep in mind that some consumer digital cameras use image sensors that are about one-third the size of a 35mm frame, making the lens close to the sensor, which increases the depth of field. This type of sensor can make it hard to blur the background. You can always blur the background by applying a blur filter. See Chapter 11 for details on applying filters.

Figure 4-8: Include only complementary background elements
Purestock

Look for Balance

1. Create balance in an image through the arrangement or placement of the elements in your image.

2. Think of balance in regard to color, shapes, and contrast.

3. Balance can be symmetrical (harmonious or formal) or asymmetrical (dynamic or informal), as shown in Figure 4-9.

Keep the Horizon Straight

1. When shooting horizons, keep them straight, as shown in Figure 4-10. You don't want it to appear that everything in your image will run off one side.

2. If your camera has a viewfinder screen with a built-in grid for that purpose, be sure to use it.

3. You can purchase a bubble-level accessory to let you know whether your camera is tilted.

4. Using a tripod can also help keep your horizons straight. (Some also come with built-in bubble levels.)

Figure 4-9: Asymmetrical balance is dynamic
PhotoDisc

Figure 4-10: Keep horizons straight
Corbis Digital Stock

Use Contrast

1. Mixing light with dark provides contrast, which in turn creates impact, as shown in Figure 4-11.

2. To highlight contrast in a photo composition, just be sure that the high-contrast area of your image is also the focal point, because that is where the eye looks first.

3. In color images, contrast can also be achieved by using complementary colors, such as red and green, yellow and blue, and cyan and orange. Look for contrast in both nature and your own setups.

Find the Light

1. In addition to considering *exposure* (the amount of light that enters the lens), you can think about light in several ways, such as the direction, intensity, color, and quality of light.

2. To incorporate these characteristics of light into your compositions, here are a few tips:

 - **Time:** The best light for photographs is usually around dawn or dusk. The light is warmer and softer, and the shadows are longer and less harsh. Avoid midday light, when the sun causes ugly shadows and squinting. Shoot neon when the intensity of the neon lights is the same as the outside light, not when it's pitch black.

 - **Weather:** Cloudy or overcast days can be excellent for photographing, especially portraits. The light is soft and diffused, as shown in Figure 4-12.

 If you must take pictures at midday, diffuse light with a scrim or reflector.

Figure 4-11: Contrast creates impact
PhotoDisc

Figure 4-12: Overcast days provide soft light for portraits
Digital Vision

- **Direction:** Photographing a subject with *backlighting* (lighting that comes from behind) can produce a dramatic image, as shown in Figure 4-13. Light shining diagonally, such as early morning or late afternoon, creates softer and longer shadows. Avoid lens flare by not having your brightest light source shine directly into your lens.

- **Color:** The light at midday is white, the light at sunrise and sunset is orange and feels warm, and the light in shaded areas and at twilight is blue and appears cool.

- **Creative:** When possible, use lighting creatively to lead the eye, create a mood, or evoke an emotion. Look for compositions created with light illuminating or shadowing an object.

Figure 4-13: Creatively use light in an image
Digital Vision

Watch Movement In and Out of Frames

1. If your subject can move, whether it's a car, a person, an animal, or another object, leave more space in front of it than behind it. You want to give your subject room to move into the frame, as shown in Figure 4-14. Otherwise, the viewer may get an uncomfortable feeling of departure.

2. Also, if a person or animal is looking out onto a scene, make sure that you include some of that scene so that the person or animal is given a point of view.

Figure 4-14: Giving the subject room to move within the frame
Brand X Pictures

Choose a Depth of Field

1. When you can, try to include an element in the foreground, middle ground, and background to create depth and a sense of scale. Of course it's better if those elements add meaning to the image, as shown in Figure 4-15.

2. Use foreground elements to frame your subject and also add perspective.

3. Make sure to use a greater *depth of field* (areas of sharpness in relation to your focal point) when shooting elements in all three distances.

Use Texture and Shapes

1. Look for interesting textures to add definition and for lines and shapes to create interest, as shown in Figure 4-16.

2. Remember that textures and shapes are enhanced with the use of light and shadow. They also come into play even more when shooting black-and-white images.

Figure 4-15: Including an element in the foreground, middle ground, and background
Corbis Digital Stock

Figure 4-16: Using texture for added definition
Digital Vision

Capturing Your Subject

Maybe you bought your camera for a specific mission. You're traveling on an exciting vacation to an exotic locale or you have a new child or puppy or hobby or event coming into your life. Regardless of the initial impetus that drove you to buy the camera, you most likely want to capture much more than that subject later. Certain subjects and circumstances call for slightly different techniques. In this chapter, I brush the surface and give you a few tips to help you photograph certain subjects. If you skipped Chapter 4, you may want to give it a gander before diving into this chapter. Most of the composition tips presented there apply to whatever you're trying to capture here and will make your photograph that much stronger.

The beauty of digital photography is that you don't have to worry about the cost and time spent in film processing, so you can let your experimental and creative juices flow and snap away without worry or guilt. Just stock up on a few memory cards and delete the rejects when you have a little time.

Get ready to . . .

Take a Portrait

1. If possible, shoot the person in a location where they feel comfortable. Chat with the person and make them feel more relaxed.

2. Incorporating general rules about composition (see Chapter 4), like getting in close and using the rule of thirds, can help to make a great portrait. Try placing the eyes along an intersecting grid line and reducing background clutter, unless it contributes to the shot in some way (see Step 11). Note that many cameras have a Portrait mode that keeps your subject in focus while blurring the backround.

3. Use direct eye contact for the highest level of intimacy and engagement. If your subject is looking away from the camera (which can add mystery), decide whether you want to include space to show the person's point of view.

4. Try to capture an aspect of the person's personality, as shown in Figure 5-1, or tell a story.

5. If the person is posing, try to grab some candid shots when they're not paying attention. If you're posing the person, have them turn slightly to the side, angle their shoulders, and lean in slightly toward the camera.

6. Shoot a variety of shots: close-ups, medium shots, and even full body. Create a lot to choose from.

7. Shoot outside in natural light at 45 degrees to the sun. Overcast days create a soft, flattering light. Shooting right before sunset creates a soft, warm light. Avoid harsh mid-day sun at all costs. People squint and the sun causes nasty shadows across the face. If you must shoot then, use a fill flash, or reflector, to fill in those shadows.If you're shooting in Manual mode, check the camera's white balance setting for both outdoor and indoor shots.

Figure 5-1: Capture people's personalities
Purestock

8. Place people near a window, at 45 degrees, when shooting inside. To light the shadowed side of the face, use a reflector (see Chapter 3) or even a house lamp placed at 45 degrees. Remember that soft lighting is the key with portraits. Make sure to set the white balance to indoors. If you must use a flash, be sure to set red-eye reduction mode.

9. Keep a low ISO (100 to 200) to minimize noise. ISO settings refer to how sensitive the image sensor is to light. If you're using a slow shutter, use a tripod to ensure a sharp capture. If you're shooting in Manual mode and not using a tripod, set the shutter to around $f\,{}^1/_{125}$.

10. Selecting your camera's Portrait setting keeps the person in focus and the background out of focus. Some cameras also have a Portrait/Landscape setting, which keeps both in focus.

11. When shooting kids, get down to their level, be patient, and grab some candid shots.

12. If you're shooting two people centered in the frame, you may have trouble getting them, and not the background, in focus when using auto focus. Try focusing on one person and locking it (press the shutter halfway). Then reposition the camera on the couple and press the shutter all the way.

13. Try photographing an environmental portrait, where you shoot a person in surroundings that speak to who they are in regard to their profession, hobby, or personal life, as shown in Figure 5-2. Include tools of the trade or props when appropriate.

14. If you're shooting someone you don't know — for example, while on vacation — be sure to ask for the person's permission.

Figure 5-2: Try to capture an environmental portrait
PhotoDisc

Get That Group Shot

1. Sometimes, taking a great group shot is a matter of serendipity. But usually it requires direction and setup from the photographer. Don't be afraid to play director and tell people where and how to stand, sit, or position themselves. Just be considerate of people's time and don't make them wait too long.

2. Find the best location and, if possible, use props such as trees or other natural elements to arrange people.

3. After you scout and set up the location, position people in a variety of poses. Depending on the number of people, having some sit and others stand can work well, as shown in Figure 5-3. Stagger people in front and behind.

4. Having people get close, tilting their heads toward each other, and even touching one another often makes the shot more intimate and engaging.

5. If you have an especially large group of people or active kids or pets, try to elicit a volunteer assistant to help with the directing. Also, when shooting really large groups, moving higher and shooting down on them enables more people to squeeze into the frame.

6. If you're shooting a group of people engaged in a certain activity, bring elements of the location or activity into the shot, as shown in Figure 5-4, to give the photos context.

7. Finally, after you set up the shot, try to get people to relax. Use humor to get people to smile naturally. It's the next best thing to spontaneity.

Figure 5-3: Put people in a variety of poses in interesting locations
Purestock

Figure 5-4: Include elements of an activity
Purestock

Capture Animals

1. As with shooting children, move down to an animal's level. For an intimate photo, capture the animal close and at eye level. If you physically can't get close, consider a zoom lens. Get your pet's attention by holding a treat or toy next to the camera.

2. Try to photograph the animal in a location it likes so that the animal is relaxed and comfortable. A location that provides context adds to the ambience of the photo.

3. Capture the animal's personality and charm. Is your dog a live wire? Is your cat the ultimate couch potato, as shown in Figure 5-5? Whatever its personality, try to capture the special trait that defines the pet. And, like portraits of people, often the candid, rather than posed, shot is the best.

4. Be careful of using a flash when shooting an animal. The flash may make the animal uncomfortable and even scare it. Try to capture the animal in natural light, if possible.

5. If the animal you're photographing has very dark or very light fur, you may need to slightly underexpose or overexpose, respectively, to retain detail in the fur.

6. As when capturing athletes, you may need to shoot on a fast shutter speed (check your camera's Manual mode capability) or in Sports mode, which selects a fast shutter for you. Also consider Continuous, or Burst, mode if your animal is quick. That way, you're almost sure to capture a photo you like.

 Zoos offer their own set of challenges. Because the animals may not be close to you, you may need a zoom or telephoto lens. A tripod comes in handy as well. If you're shooting through glass, find a clean spot and get as close to the glass as you can. To eliminate reflections, a lens hood can help. And, if it's available, include some natural surroundings with the animal to give the photo context, as shown in Figure 5-6.

Figure 5-5: Capture the animal's personality
Corbis Digital Stock

Figure 5-6: Include natural elements around the animal
Image State

Capture Action or Sports

1. Have a plan. Know in advance what kinds of shots you want to get. Of course, being familiar with the sport helps you determine which shots would be interesting to capture.

2. If possible, position yourself in the best locations to capture the action. These locations may vary as the game, activity, or time of day goes on. In general, keep the sun at your back.

3. If you can't get close to the action, a telephoto zoom lens is helpful. To capture a wide area of activity, add a wide-angle zoom to your equipment.

 A monopod (like a tripod, but with one leg) is extremely useful when using long, heavy lenses. Why a monopod? Because it's lightweight and almost as steady a tripod, but it can be moved easily to chase action subjects.

4. Be in the right place at the right time, as shown in Figure 5-7. Sometimes, timing is so critical that capturing that excellent shot means pushing the shutter just before the perfect moment. Take into account any shutter lag your camera has.

5. Be aware of the background and elements around your focal point. Unless they add context, keep them simple and nondistracting, as shown in Figure 5-7.

6. For most sports, shoot at a fast shutter speed (at least $f\,{}^{1}\!/_{500}$). Set your camera to Shutter Priority mode so that if the light changes, the shutter speed stays the same and the aperture adjusts accordingly. Your camera may also have a Sports or Action mode setting.

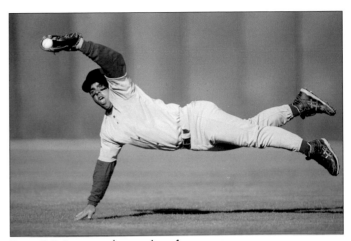

Figure 5-7: Be aware and capture the perfect moment
Corbis Digital Stock

7. When shooting in low light without a fast lens (f/2.8 or so), try a higher ISO setting. Just be aware that it may add noise to your images. Remember that some sports also don't allow you to use a flash.

8. If players are on the move, give these settings and techniques a try:

 • Set your camera to continuous focus mode, which better enables you to track a moving player.

 • Try Manual Focus mode. Auto focus may be fine for the subject you're capturing, but becoming comfortable with manual focus can help you get a shot when auto focus falls short.

 • Keep the camera on the player and adjust the focus continuously (called *follow focus*).

 • Focus on the area you expect the action to move into (the *zone focus*), as shown in Figure 5-8.

 • Follow the action and press the shutter (at a slower speed) while still moving the camera *(panning)*. This technique creates the illusion of movement in a photo.

9. If you're trying to capture a sequence, set your camera to Continuous Shooting mode, or rapid frame advance.

10. Don't forget shooting the preparation, the sidelines, the crowd, the aftermath. Sometimes the most interesting and poignant shots aren't even of the action.

Figure 5-8: Use zone focus and shoot where the action will be
Corbis Digital Stock

Shoot Landscapes

1. Composition is the element that separates a memorable landscape shot from a mundane one. Check out the composition tips in Chapter 4, which explain how to use a focal point, the rule of thirds, framing, and leading lines. You also find out basics about including a foreground, middle ground, and background and shooting from different angles.

2. To capture expansive vistas, a wide angle lens serves you well. If you don't have one, try capturing the scene in several shots and stitch them together using the Adobe Elements Panorama feature. Some cameras also come with software to assist you in creating panoramas. See Chapter 12 for tips and techniques.

3. Go for the maximum depth of field (see Chapter 3). Use a small aperture setting and a slower shutter speed. Note that many cameras have a Landscape mode which will set up your shot for maximum depth of field.

4. Use a tripod and shutter release for the sharpest image.

5. Keep a low ISO for noise-free images.

6. Add people or animals to gain a sense of scale or contrast or even a point of interest, as shown in Figure 5-9.

7. Take advantage of reflections if you're shooting water.

8. Shooting at dawn (and immediately afterward) and dusk (and just before) give you soft, warm lighting, as shown in Figure 5-10. Stormy skies make dramatic backdrops. If you have a boring sky, try a polarizing filter for added color and contrast or keep the horizon line high to minimize the amount of sky in the shot.

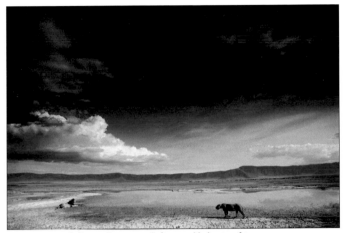

Figure 5-9: Include people or animals for an added point of interest
Corbis Digital Stock

Figure 5-10: Dusk provides warm, soft, yet dramatic lighting
Corbis Digital Stock

Take a Night Shot

1. Shooting at night usually means shooting in low light, so the camera aperture needs to stay open longer, which requires a slow shutter speed and a longer exposure ($f\,^1\!/_{30}$ or longer), as shown in Figure 5-11. Use lenses capable of at least f/2.8. If you want to use a faster shutter speed, increase the ISO setting. Just keep in mind that the higher the ISO, the more noise your image may contain.

 Remember that a flash helps only if your subject is directly in front of you.

2. Many cameras have a Night mode setting. Try this setting to see whether it yields good results. Also try Manual mode. Sometimes, automatic settings don't give you the best images.

3. Because you need a longer exposure, use a tripod to keep your camera as still as possible. Use a cable release, or self-timer, so that pressing the shutter button doesn't cause shakiness in your image.

4. Experiment with auto focus and manual focus. Sometimes auto focus doesn't work optimally in low-light environments.

5. If you're not sure which settings work best with your camera, bracket your shots (see Chapter 3). Note which settings you're using for each shot so that, next time, you're familiar with what worked.

6. Start shooting before dark. Try taking shots at dusk, or soon after. Capturing neon is especially nice before it gets really dark and a little natural light is left, as shown in Figure 5-12.

Figure 5-11: Night shots usually require a slower shutter speed
Corbis Digital Stock

Figure 5-12: Shoot neon before it gets pitch black
Corbis Digital Stock

Shoot in Bad Weather

1. Take advantage of bad weather's creative benefits. Clouds diffuse the light and eliminate harsh shadows, making for nice landscapes and even portraits. Stormy skies create dramatic backdrops for landscape shots (as shown in Figure 5-13) or singular objects, such as trees or barns. Rain enhances colors and adds texture and reflections on surfaces. If the scene is gray, include a spot of color. Dark objects and colors against white create exaggerated contrast, as shown in Figure 5-14.

2. In bad weather, there's usually less light. Make sure that your camera is capable of having a wide aperture or longer shutter speed, or both. A tripod helps keep images sharp, especially for longer exposures. A cable release or self-timer can also be handy. In extremely cold weather, keep a spare battery or two warm in your pocket. Cold weather zaps battery life.

3. Snow and fog may confuse your camera's light meter, so play it safe and bracket your shots (see Chapter 3). At least, open your aperture one to two stops. For snowy shots, watch the white balance. If your camera has Snow mode, use it. Play with shutter speeds to capture falling rain or snow.

4. Protect your equipment. Keep your camera as dry as possible. Keep a soft, scratch-free cloth to wipe off any water. Going from extreme cold into a very warm environment can cause condensation to form in your equipment, so allow your equipment to warm up gradually under your coat; then put it in a camera bag before going into a warm room. Finally, make sure all your equipment is totally dry before you put it away.

Figure 5-13: Stormy skies make for dramatic backdrops
Corbis Digital Stock

Figure 5-14: Ordinary objects look extraordinary in snow
Corbis Digital Stock

Shoot Food

1. Take time to set up a pleasing arrangement. Think of the food in terms of color, shape, texture, line, and so on. If you have time and the food still looks good, set up alternative arrangements also.

2. Use simple props where appropriate to help "set the stage" and give context to the food, as shown in Figure 15-15. Think of your setup as a kind of still life.

3. Shoot it quickly. Capturing food is all about getting the shot before the food starts to deteriorate. You may want to have two sets of whatever food you're shooting. Use one set as the "stand-in" for lighting and arrangement. Then use the other set to act as the "real" model.

4. Get close to the food and shoot at plate level or higher. One technique that's often used is to shoot with a macro lens, focusing on one part of the dish and letting the surrounding elements blur, as shown in Figure 5-16. This technique provides a strong focal point while still maintaining the context mentioned in Step 2. If you don't have a macro lens, check your camera to see if you at least have a Macro mode, which optimizes your settings for close ups.

 Food stylists all have their secret tips in making food look great. You hear stories about using shaving cream instead of whipped cream, airbrushing food with paint and so on. A couple more appetizing tips are to brush vegetable oil on food to make it glisten and of course spraying water on bottles to make them look wet and cold.

Figure 5-15: Use simple props to give food context
Digital Vision

Figure 5-16: Use a macro lens to create a strong focal point
Digital Vision

Photograph a Wedding

1. Be prepared with charged batteries, free memory cards, and other equipment, like lenses and a tripod ready to rumble.

2. Make a shot list. Know when special moments are happening — arrivals, ring exchange, cake cutting, the kiss. And, remember that sometimes the best shots are the candid ones — the bride getting ready, the ring bearer anxiously tossing around the pillow, or the bride and groom goofing off, as shown in Figure 5-17.

3. Scout out the best locations and vantage points for your shot. But remember to stay out of the way of working professionals and the views of the guests. Consider being extra courteous and asking the professional for permission to shoot while he is working.

4. Shoot a few throwaway shots to test the lighting. Use a flash only if it's allowed. If it is, consider using a flash diffuser to soften the light. If not, open the aperture to a wide setting.

5. Remember the relevant tips in Chapter 4, such as getting in close, eliminating background clutter (as in Figure 5-18), composing with the rule of thirds, shooting at angles, and finding the light.

6. If you're shooting a group of people, see the section "Get That Group Shot," earlier in this chapter.

 Note that this section heading isn't "How to Be an Amateur Wedding Photographer." You can find lots of helpful books on that single topic. This section just gives you a few tips on how to take some nice photos at a family or friend's wedding.

 A recent trend in wedding photography is the "trash the dress" shot, where after the ceremony, the bride does something in her wedding dress that would normally be thought of as unheard of. See www.trashthedress.com.

Figure 5-17: Capture candid moments
Purestock

Figure 5-18: Include elements of an activity
Purestock

Shoot for Online Auctions

1. Shoot your object against an uncluttered background to draw attention to what you're selling. If you can't afford a light box or shooting table, make one for around $10 (see http://strobist.blogspot.com/2006/07/how-to-diy-10-macro-photo-studio.html). Or, at least use a solid-colored sheet, attractively draped as a backdrop, as shown in Figure 5-19.

2. Get close to your object to show pertinent details. When doing so, put your camera in Macro mode, if possible.

3. Take several shots from different angles. The more you show, the more that interested bidders feel the object is bid-worthy. If showing scale is important, put a penny or ruler in one of the shots.

4. If you're inside and don't have a light box or an inexpensive lighting kit, shoot next to a bright window. If you still need more light, clamp a utility light in position; shine it at a 45 degree angle to the object. Chapter 3 explains lighting in detail.

5. Use a tripod to ensure that your images are sharp.

6. Shoot large items, such as furniture, where they give a sense of context. If you sell clothing, invest in a cheap mannequin or dress form. When shooting jewelry, using a light box is definitely the way to go (see Figure 5-20).

7. If necessary, crop, clean up, and adjust the color and contrast in your image-editing program (see Chapters 7 and 8). Also, size the image for display on-screen. Check the file specs on your auction site so that images load properly and quickly. A few minutes spent prepping your image pays off in the end.

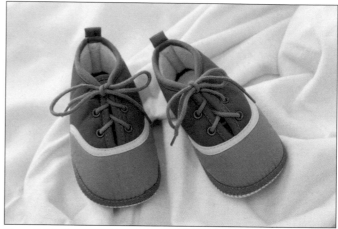

Figure 5-19: Shoot your object against a solid-colored cloth
Purestock

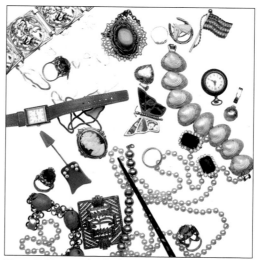

Figure 5-20: Minimize glare in jewelry shots
Photodisc

Transferring Your Images

*B*efore you can share and enjoy your photos, you have to first put them on your computer. You may have digital photos in your camera or media cards. You may have some photos burned to CD or DVD, and you may have printed some that now need to be scanned and stored. You may even have a few tucked away in a cell phone. If you don't own an image-editing program, like Adobe Elements, you probably want to look around for a simple digital-asset-management program to help you keep all those images organized and easy to find.

At first, managing your photos may not seem like a big deal. But after you get the hang of using your camera (or you go on a killer vacation), you'll that find your photos start quickly multiplying into the digital equivalent of an overflowing shoebox. And although, initially, transferring all your archived images into a management program is time consuming, after you're done, you'll have that relaxed feeling that comes with being uber-organized.

Chapter

6

Get ready to...

Transfer Images from a Camera or Card Reader to Your Computer

1. Connect your camera or card reader to your computer by using a USB cable. If your computer has a media card slot, insert your card. If your camera has a docking station, plug it into your computer and place your camera in the dock.

2. Choose from one of these options:

 - If you installed software that came with your camera, follow the steps accordingly.

 - In Windows Vista, the computer detects the connection and, in the Autoplay dialog box, shown in Figure 6-1, asks you what you want to do with your images. The Import Pictures command imports your images into the Windows Photo Gallery application. The Open Device to View Files command launches Window Explorer and displays your device (camera or memory card). Select the camera folder containing your images, select the ones you want, choose Edit⊏>Copy to Folder, and choose a folder in which to place them on your hard drive. Note that if you have Elements installed, the Adobe Photo Downloader may pop up. Just click Cancel if you don't want to use it.

 If Vista doesn't recognize your camera, find it by choosing Start⊏> Computer. Double-click the camera icon, shown in Figure 6-2, to see your images. Select some images, choose Edit⊏>Copy to Folder, and choose a destination folder.

 - On a Mac, the computer sees your camera or reader as another drive on your computer. Double-click the icon and then the folder, and Option+drag the images you want to keep to another folder on your desktop.

 For extra insurance, keep your files on your storage media and burn a backup CD or DVD from the photos on your hard drive. After the CD or DVD is burned, delete the files from the storage media.

Figure 6-1: The Autoplay dialog box

Figure 6-2: Your computer should recognize your camera as another drive

Transfer Images from a Camera or Card Reader in Elements

1. Connect your camera or card reader to your computer via a USB cable. If your computer has a media card slot, insert your card. If your camera has a docking station, plug it into your computer and place your camera in the dock.

2. If you're using Elements on a Windows computer, make sure that you're in the Organizer. If the Windows operating system interrupts to ask what you want to do with your images, click Cancel.

3. If the Adobe Photoshop Elements Downloader 6.0 appears, select the name of your camera or card reader from the Get Photos From menu, shown in Figure 6-3. If the downloader doesn't appear, double-click the Adobe Photo Downloader icon (the camera with the downward-pointing arrow) on the taskbar. Or choose File➪Get Photos and Video➪From Camera or Card Reader.

4. In the Import Settings section, specify a location for your images by clicking Browse (or Choose on a Mac). Choose a folder or create a new one. You can specify a subfolder.

5. If you want, change the names and numbers of your images in the Rename Files and Rename Files Counter Fields section. Select the Preserve Current Filename in XMP option to retain the current filename as the name stored in the metadata of the image.

6. In Windows, select the Open Organizer When Finished check box to display the images when the importing is complete. In the Delete Options section, specify whether to delete files after copying.

7. Click Get Photos to start the copying process.

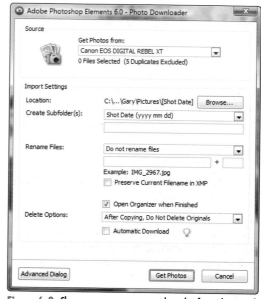

Figure 6-3: Choose your camera or card reader from the Get Photos From submenu

 On the Mac, Adobe Bridge automatically launches when the Downloader is selected in Step 3. You can then specify to have Bridge launch whenever it detects a camera or card. Or, in Bridge, you can choose File➪Get Photos from Camera.

Import Images from Your Hard Drive into Elements

1. In Elements, in Windows, open the Organizer.

2. Choose File➪Get Photos and Video➪From Files and Folders.

3. Navigate to your hard drive and select the folder containing the files you want.

4. In the dialog box, select a file type or choose All Files to import all types of files, as shown in Figure 6-4.

5. Check Get Photos from Subfolders to grab those photos, and, if necessary, select the Automatically Fix Red Eyes check box.

6. Click Get Photos. Your files are added to the Organizer, as shown in Figure 6-5.

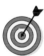 On a Mac, use Adobe Bridge to import and manage all your files.

Figure 6-4: Choose All Files to import all types of files

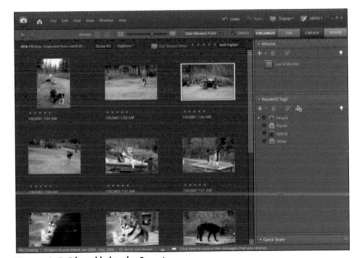

Figure 6-5: Files added to the Organizer

Import Images from a CD or DVD into Elements

1. Insert your CD or DVD in the drive on your computer system.

2. In Elements, in Windows, open the Organizer.

3. Choose File⇨Get Photos and Videos⇨From Files and Folders.

4. Navigate to your CD or DVD drive and select the photos you want to import.

5. Select Copy Files on Import to import a high-resolution copy of the image, as shown in Figure 6-6. Select Generate Previews to import a low-resolution copy of the image. See Chapter 7 for more on resolution.

6. If you want to keep the original master photo offline, type the name of the volume for the CD or DVD that contains the photo, for easier locating later.

7. Select Automatically Fix Red Eyes if you want to eliminate any red-eye effect in your photos while importing.

8. Click Get Photos, and your images are imported into the Organizer, as shown in Figure 6-7.

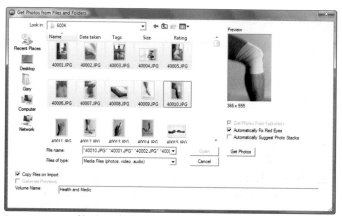

Figure 6-6: Copy files from a CD.
Eyewire, PhotoDisc

Figure 6-7: Files added to the Organizer.

Scan an Image

1. In Elements, in Windows, launch the Organizer (you can also be in Full Edit mode) and select File⇨ Get Photos and Videos⇨From Scanner. On a Mac, in Full Edit mode, choose File⇨Import and select your scanner.

2. In Windows, select your particular scanner from the Scanner drop-down menu in the Get Photos from Scanner dialog box, shown in Figure 6-8.

3. Click Browse (or Choose on a Mac) to select a destination for the scans.

4. Select a file format from the Save As drop-down menu. If you choose JPEG, select a Quality slider. The higher the quality, the larger the file size. If you plan to edit the scan, choose TIFF as the file format. JPEGs use lossy compression and degrade after they're repeatedly saved in JPEG format.

5. Click OK to open your scanner utility program (for scanners with TWAIN drivers), as shown in Figure 6-9.

 If you don't have Adobe Elements, you can still scan an image (by using your scanner's utility program) and then save it to your hard drive.

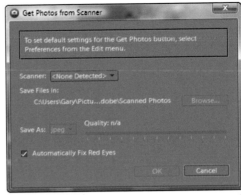

Figure 6-8: Select your scanner.

6. Follow the instructions that came with your program. For the most part, you probably specify the area you want to scan and then select the output dimensions. Be sure that the width and height are set properly for the output size you want.

7. You also most likely select a resolution for your specific form of output. Use either of the following two resolutions, as a general rule of thumb:

- **72 pixels per inch (ppi)** for files you want to show on the Web and on-screen.

- **300 ppi** for files you want to print to your desktop inkjet or laser printer or when sending files to offset commercial printers.

8. Your program may also offer controls for color correction.

9. Preview the scan. Most scanner utility programs support previewing a scan before you scan the image.

10. If you're satisfied, click Scan, Acquire, OK, or a similar command, depending on your particular scanner and utility program.

11. The scan opens in the Get Photos window in the Organizer. Click the Back to All Photos button to view your scan along with the other files in the Organizer window.

Figure 6-9: Use your scanner utility program
Corbis Digital Stock

In Elements, you can save time by scanning multiple images at one time. Simply arrange them on your scanner and follow the preceding set of steps. Then choose Image⇨Divide Scans. Elements divides the images into separate image windows. As an added bonus, they're also straightened.

Scan Negatives and Slides

1. Make sure that your scanner can scan negatives and slides. You can't scan a negative or slide on a scanner that's capable of scanning only reflective art (prints and papers, for example).

2. Ensure that your negatives and slides are very clean. You can purchase compressed air to eliminate run-of-the-mill dust. For other types of grime, check with your photo-processing store for the appropriate cleaning fluid. Because negatives and slides are so small, every dust speck is amplified when scanned.

3. Scan at the highest optical resolution. Because slides are so small, 1 $f\frac{1}{2}$ x 1 inch or so, you need to scan them at a high enough resolution to compensate for enlarging the dimensions. For more on resolution, see Chapter 7. Remember: If you plan to print the scanned images, you want a final resolution of around 300 ppi at your final output dimension (4 x 6 or 8 x 10, for example).

4. If your scanning software offers controls for color and contrast correcting, use them to optimize your scan. You can also correct and enhance scans in Elements (see Chapters 7 and 8).

5. Consider scanning color and grayscale images in the Millions of Colors image mode. That way, you ensure that the maximum tonal range is captured. You can always convert images to grayscale using software such as Elements (see Chapter 12).

6. Save scanned images as TIFF files for optimum quality. But remember that their file sizes can be large. If you want to save them initially as JPEG files, be sure to save them in TIFF or PSD format if you're going to edit them. Repeatedly opening, editing, and resaving JPEGs can eventually degrade image quality because of the lossy compression that's used.

 Whether or not you have a whiz-bang slide or negative scanner, scanning is just plain time consuming. If time is precious, check out a scanning service, like www.scancafe.com, as shown in Figure 6-10. Prices can be as low as 19 cents per negative or as little as $24 per slide. Plus, you pay only for what you want to keep. The services can also scan prints.

Figure 6-10: If time is limited, try using a scanning service, like www.scancafe.com

Capture a Still Image from a Video

1. Ensure that the latest version of QuickTime (Mac) or Windows Media Player (Windows) is installed on your computer.

2. In Elements, in the Editor in Full Edit mode, choose File⇨Import⇨Frame from Video.

3. In the dialog box, click Browse and navigate to a video. Click Open.

4. Click Play to start the video.

5. Click Grab Frame to capture a frame of the video as a still image, as shown in Figure 6-11. You can also press the spacebar.

6. If your video format supports it, click the Fast Forward and Rewind buttons to move forward and backward through the video.

7. Click Done when finished.

8. Choose File⇨Save, as shown in Figure 6-12, to save each captured still image to your hard drive.

 Elements supports ASF, MPEG, M1V, MOV, MPG, VI, and WMV file formats.

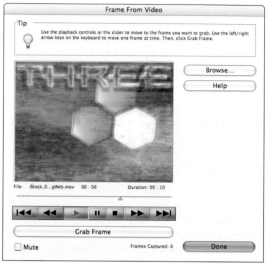

Figure 6-11: Capture still images from a video
istockphoto.com

Figure 6-12: Save your captured still images
istockphoto.com

Transfer Mobile-Phone Photos to Elements

1. Follow the instructions in your mobile phone's documentation about copying photos from the phone to your computer's hard drive.

2. In Elements, launch the Organizer and choose File↔ Get Photos and Videos↔From Mobile Phone. The Specify Mobile Phone Folder dialog box opens, as shown in Figure 6-13.

3. Select the Automatically Fix Red Eyes check box, if needed. Then click Browse to navigate to the folder where your mobile-phone images were copied in Step 1.

4. Click OK to import the mobile-phone photos in the Organizer.

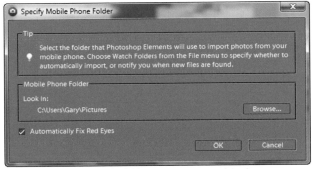

Figure 6-13: Navigate to the folder containing your mobile-phone images

 When you're using a Nokia phone, the Adobe Photo Downloader automatically launches when you connect the phone to the computer. On a Mac, the Adobe Photo Downloader also appears automatically when you connect a phone to the computer.

Part II
Editing and Enhancing Digital Photos

Quick-Editing Your Images

*Y*ou may be a great photographer with the ability to capture that perfect shot every time. Or, you may be a mere mortal, like the majority of us, and need a little help getting those images ready to display and share. Elements offers a wide range of help, from simple one-click fixes to more manual, multi-step methods of refinement and repair. Color shifts, crooked photos, too much background clutter, overly dark shadows — none of these problems is more than a couple minutes away from being fixed.

This chapter, along with Chapter 8, gives you a full set of editing tools for almost any correction you need to tackle. But before you run off and do just that, this chapter starts off by offering some important and fundamental information about editing your digital images. Getting your work environment ready for editing, having a good grasp on the interrelationship between resolution and dimension, and understanding different image modes and file formats are vital in preparing your images for their ultimate debut.

Get ready to . . .

Prepare to Edit

1. Keep your desktop color a neutral gray. For color correcting, you don't want colors and patterns behind or around your images to influence the way you "see" those images.

2. Keep the walls around your monitor as clutter free as possible. Don't display any wildly colored posters that influence the way you see your images.

3. Keep the lighting in your work area as consistent as possible.

4. Calibrate your monitor. Try to obtain a screen color as neutral (gray) as possible. You want to standardize your display so that your image-viewing experience is consistent. Windows users can check out Adobe's Gamma utility, though it isn't compatible with Vista. Mac users can use Display Calibrator Assistant. If you're serious about image editing, consider a hardware-and-software calibration package, starting at $75. Check out www.color vision.com and www.gretagmacbeth.com.

5. Check your preference settings (choose Edit⇔Preferences on the PC or Elements⇔Preferences on the Mac), as shown in Figure 7-1. Preference settings help you to customize certain behaviors of the program. The Elements Help file gives good information on each setting.

6. Establish your color settings (choose Edit⇔Color Settings), as shown in Figure 7-2. Using the appropriate color settings helps you better manage color among all your devices. See Chapter 15 for more on color settings.

7. Test your production workflow. View your images in different Web browsers. Print images using different print settings. Find out what works best and how to compensate for any deficiencies in your equipment and methods.

Figure 7-1: Establishing your setting preferences

Figure 7-2: Specifying color settings

Choose Image Modes

1. Image modes determine the number of colors in an image. Before converting an image from RGB color to another mode, perform all necessary editing. Only RGB images can access all Elements tools and commands.

2. Choose Image⇨Mode. Select from one of the following available image modes:

- **Bitmap:** Different from image pixels in the Bitmap file format, in Bitmap mode they're either black or white. You must first convert a color image to Grayscale before you can convert it to Bitmap mode. After you choose Bitmap mode, select an output resolution of 72 ppi (Web) or 300 dpi (print). Choose a method from the Use drop-down list. Figure 7-3 shows the effect of three options: 50% Threshold, Pattern Dither, and Diffusion Dither.

- **Grayscale:** Click OK when prompted to discard your color information. This mode converts a color image to a grayscale one, as shown in Figure 7-4. Grayscale images contain 256 brightness levels or levels of gray. For better ways to convert color to grayscale, see Chapter 12.

- **Indexed Color:** Indexed Color mode supports 256 colors or fewer (refer to Figure 7-4) but not layers. The GIF file format uses this mode to prepare graphics for the Web. First, select the Preview option. Choose options for the palette, number of colors (if you want), transparency, and dithering. It isn't vital to know the definition of each setting. This mode is for on-screen images, so simply view the Preview image and experiment.

- **RGB Color:** This mode is the default color mode for Elements and digital photos. RGB Color images (refer to Figure 7-4) can display up to 16.7 million colors.

3. Click OK.

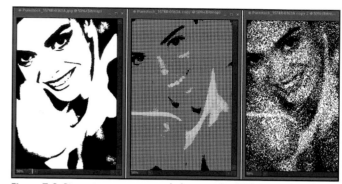

Figure 7-3: Bitmap images contain pixels that are either black or white
Purestock

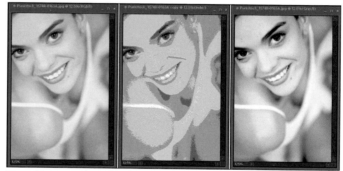

Figure 7-4: RGB color, indexed color, and grayscale images
Purestock

Choose among File Formats

1. Choose File⇨Save As. Select from one of the following available file formats:

 - **Photoshop (.psd, .pdd):** The Elements native file format makes all editing tools and features available. It supports layers, all image modes, and bit depths. Photoshop files are suitable for high-resolution printing. Compare this format with the TIFF format.

 - **BMP (.bmp, .rle, .dib):** The Bitmap file format supports all image modes and all bit depths. This format is used for system resource files, such as desktop wallpaper.

 - **CompuServe GIF (.gif):** A popular Web file format, used mostly for graphics, such as logos, Web buttons, small illustrations, and text. GIFs are small in size, but support only Indexed Color mode (256 colors or fewer). If color integrity is important for your Web images, use the JPEG format instead.

 - **JPEG (.jpg):** JPEG, which stands for Joint Photographic Experts Group, is one of the most popular file formats. JPEGs, which support RGB Color mode, are compressed to reduce file size. The compression scheme they use, however, is lossy and can degrade image quality if you repeatedly open and resave images. When you select the JPEG format and click Save, a dialog box appears, as shown in Figure 7-5. Choose a Quality value. The value 0 is the lowest quality but has the highest compression (and smallest file size). The value 12 is the highest quality but has the lowest compression (and larger file size). JPEGs do not support layers. Reserve JPEGs for images to be viewed on the Web and for attaching to e-mail messages. For image prints, use the Photoshop or TIFF file formats. If you must save an image as a JPEG, edit it first and save the original as a Photoshop file. Then save a copy as a JPEG.

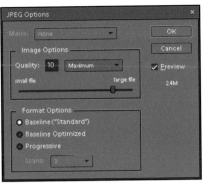

Figure 7-5: JPEGs offer a range of quality and compression settings

- **Photoshop PDF (.pdf):** PDF stands for Portable Document Format, and Adobe developed it for exchanging files: Anyone with Acrobat Reader, a free download from Adobe, can view PDF files. PDFs support layers and all image modes. They're suitable for printing and as downloadable documents hosted on Web sites. In the Save Adobe PDF dialog box, specify the Compression and Image Quality settings, as shown in Figure 7-6. Choose High quality for print images, and Low or Medium Low quality for Web images.

- **Photo Creation Format (.pse):** This format is used to save multipage Elements projects to a single file format.

- **TIFF (.tif):** TIFF, which stands for Tagged Image File Format, supports layers and all image modes. When you select this format and click Save, a dialog box appears, where you specify various options. You can compress these files in a variety of schemes, including LZW and ZIP, which are lossless and therefore do not degrade image quality. Select a byte order (PC or Mac), and leave other options at their defaults. TIFF is an excellent file format for use in illustration and page-layout programs as well as in Microsoft Word. TIFF images are suitable for high-resolution printing.

2. Click Save. If presented with an Options dialog box, specify your settings. If you aren't sure what to choose, you probably can leave them at their default settings. Click OK.

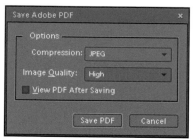

Figure 7-6: PDFs are helpful for exchanging files

 The preceding list of file formats represents just the most popular and widely used formats. Elements supports more, such as CT, JPEG 2000, PCX, Photoshop EPS, Photoshop RAW, PICT File, PNG, Scitex, and Targa. Elements can also open Camera Raw files.

 Most digital cameras can capture images in one or all of these file formats: Camera RAW, JPEG, and TIFF.

Establish Color Settings

1. Choose Edit⇨Color Settings.

2. Choose one of the following management options in the Color Settings dialog box that appears, as shown in Figure 7-7:

 - **No Color Management:** Leaves your image untagged.

 - **Always Optimize Colors for Computer Screens:** Uses sRGB as the working space and tags images accordingly. Some color printers, as well as online photo services like Kodak, prefer this workspace. This setting is also preferred for screen images.

 - **Always Optimize for Printing:** Uses Adobe RGB as the working space. The color in this workspace has more colors than can be seen on your monitor. Be certain that if you choose this workspace, your printer can handle the colors. This setting is often used for print images.

 - **Allow Me to Choose:** Lets you choose between sRGB and Adobe RGB—good if you prepare images for both screen and print.

3. Click OK.

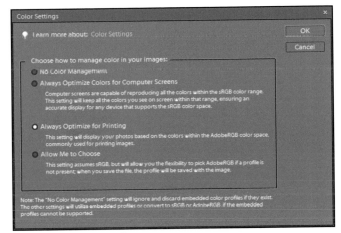

Figure 7-7: Choose your color settings

Photoshop Elements, along with Adobe's other programs, uses color profiles to help manage the color between your monitor and your output (prints, Web sites), between programs, between devices, and between platforms. Your images are tagged with color profiles to help identify their original working spaces.

Work with Resolution and Dimension

1. In Full Edit mode, open an image.

2. Choose Image⇨Resize⇨Image Size.

3. Examine the dimensions and resolution of your image. Elements allows you to change the pixel dimensions, physical dimensions, and resolution of an image in two ways:

 - **Select the Resample Image option.** You can change the pixel dimensions or file size, physical dimensions, and resolution. If you increase any of these three options, Elements *resamples* the image, which adds pixels and typically degrades image quality, as shown in Figure 7-8, depending on the severity of the requested resampling. Consequently, when you delete pixels, you downsample. Downsampling is okay when you do it to prepare high-resolution images for viewing on the Web.

 - **Deselect the Resample Image option.** You can't change the pixel dimensions or file size — only the physical dimensions and resolution, which have an inverse relationship. Increase the physical dimensions, and the resolution decreases. Raise the resolution, and the physical dimensions decrease.

4. Click OK to confirm your changes, or click Cancel to close the dialog box.

 A *pixel* (short for *picture element*) is the smallest component of a digital image. Each pixel resides in a specific grid and has only one color value. The number of pixels determines an image's resolution. If you have 72 pixels across a linear inch (a 1-inch horizontal line), you have 72 *pixels per inch* (ppi), a low resolution suitable for on-screen viewing. If you have approximately 266 to 400 pixels per inch, your image is considered high resolution and is suitable for printing.

Figure 7-8: Resampling can degrade image quality
Digital Vision

 If you want to preserve the quality of an image when you resize it, be sure to deselect the Resample Image box. This action prevents the image from being resampled. When you increase the image resolution, its dimensions decrease accordingly. Similarly, when you increase its dimensions, the resolution decreases. The exception to this rule is when you want to downsample higher-resolution images for display on the Web. If so, feel free to select the Resample Image option and enter **72 ppi** for the resolution and whatever measurements you need for the image's dimension.

Crop Your Photo

1. Select the Crop tool from the Tools panel (or press C).
 Elements can be in either Full Edit mode or Quick Fix
 mode.

2. Specify an aspect ratio on the Options bar:

 - **No Restriction:** You can freely crop the image.

 - **Use Photo Ratio:** When you crop, the original aspect
 ratio of the image is retained.

 - **Preset sizes:** Choose a common photo size.

 - **Width and Height:** Enter an image width and height
 to crop your image.

 - **Resolution:** Enter an image resolution.

3. In your image, drag around the portion you want to
 retain. The crop marquee bounding box appears, and
 the area outside the marquee box darkens to help you
 to visually frame your image. Release the mouse button.

4. To adjust the cropping marquee, drag any handle on the
 bounding box, as shown in Figure 7-9. Move the mar-
 quee box by positioning the mouse cursor inside the
 box and dragging.

5. Double-click inside the marquee to complete the crop
 (see Figure 7-10). Press Esc to cancel.

 If you move the cursor arrow just outside the corner of the marquee
 box, the cursor changes to a curved arrow. Drag clockwise or coun-
 terclockwise to rotate the image. Being able to rotate and crop your
 image simultaneously can be handy when straightening an image.

 Be careful when cropping you image. To keep your image at the same
dimensions and resolution while cropping out a significant portion,
Elements has to resample the file. You should always capture the image
you want when you take the photo. But if you want the luxury of crop-
ping later, take your photos at a high resolution. See Chapter 1 for more
information on camera-resolution settings.

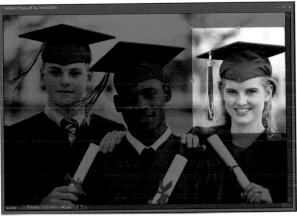

Figure 7-9: Adjusting the crop marquee box to retain portions of the image
Creatas

Figure 7-10: A cropped image
Creatas

Resize Your Canvas

1. Open an image in Full Edit mode.

2. Choose Image⇨Resize⇨Canvas Size.

3. In the Canvas Size dialog box, specify how you want to anchor the image, as shown in Figure 7-11. Elements adds canvas around the image accordingly.

4. Enter Width and Height values. Select the Relative check box to be able to add an amount to those Width and Height values.

5. Choose a canvas color from the drop-down list. Click the swatch to access the Color Picker to choose a new color.

6. Click OK. Figure 7-12 shows added canvas to create a border.

 Resize your canvas to easily and quickly add a border around your image.

Figure 7-11: Increasing the canvas size around an image

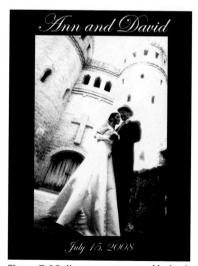

Figure 7-12: Use canvas sizing to add a border
Purestock

Change Image Bit Depth

1. Open a 16-bit image in Full Edit mode.

2. Choose Image⬄Mode⬄8 Bits/Channel.

Many digital cameras can capture 16-bit images (often in RAW format), which contain more image data and, often, better highlight and shadow areas. The bad news is that many Elements commands and features, such as layers, aren't available to 16-bit images. Therefore, conversion may be necessary.

Divide Scanned Photos

1. Open a file with multiple scanned images in either Full Edit or Quick Fix mode, as shown in Figure 7-13.

2. Choose Image⬄Divide Scanned Photos. Elements divides the images and places each one in a separate file, as shown in Figure 7-14.

To get the best results, make sure you have a clear separation between your images on the scanning bed. If your images have a lot of white areas in them, you may want to cover the images on the scanning bed with a dark piece of paper.

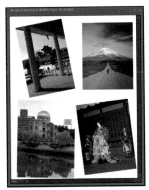

Figure 7-13: Saving time by scanning multiple photos at a time
Corbis Digital Stock

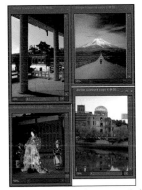

Figure 7-14: Dividing scanned photos into separate files
Corbis Digital Stock

Straighten a Photo

1. In Full Edit mode, select the Straighten tool from the Tools panel. You can also press the P key to access the tool.

2. If you have layers in your image and you want to rotate them all, select the Rotate All Layers option from the Options bar.

3. Also specify your canvas options on the Options bar:

 - **Grow or Shrink Canvas to Fit:** Rotates the image and enlarges or shrinks the size of the canvas to fit the image.

 - **Crop to Remove Background:** Trims off the background canvas around the image.

 - **Crop to Original Size:** Rotates an image without trimming off the background canvas.

4. Using the Straighten tool, drag a line in your image where you want the straight edge to be, as shown in Figure 7-15. Release the mouse button. The image is straightened, and if you chose a crop option in Step 3, the image is cropped as well, as shown in Figure 7-16.

 You can also straighten an image by using a menu command. In either Full Edit or Quick Fix mode, choose Image⇨Rotate⇨ Straighten Image. This command straightens the image without cropping. To crop *and* straighten an image, choose Image⇨Rotate⇨ Straighten and Crop Image.

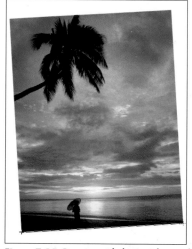

Figure 7-15: Dragging with the Straighten tool to create a straight edge
Digital Vision

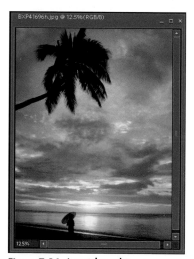

Figure 7-16: A straightened image
Digital Vision

Edit in Quick Fix Mode

1. Do one of the following:

 - Select one or more photos in the Organizer and click Fix in the upper-right corner of the application window. Then click Quick Fix in the panel below it.

 - If you're in Full Edit mode, select your photo or photos from the Photo Bin and click the Quick button in the upper-right corner of the application window. Or, you can simply choose File⇨Open to open images.

2. Choose your preview preferences from the View pop-up menu at the bottom of the application window. Choosing Before & After gives you a good idea of whether your edits are satisfactory, as shown in Figure 7-17. Also choose from Portrait or Landscape orientations.

3. Use the Zoom tool to magnify the image. You can also use the Zoom slider at the bottom of the application window.

4. Use the Hand tool to navigate around your image. Place the Hand tool in the image window and drag in any direction.

5. Use the Crop tool to crop your image. For details on cropping, see "Crop Your Photo," earlier in this chapter.

6. At the bottom of the application window, click either the Rotate Left or Rotate Right button to rotate the image in 90-degree increments.

Figure 7-17: Setting the view to Before & After in Quick Fix mode.

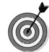 Quick Fix mode is a miniature version of Full Edit mode. You find basic editing tools, auto fixes (covered in the next few pages), and a helpful before-and-after preview window. The tools and features in Quick Fix mode may be all you need to improve your images. If not, check out Full Edit mode, the other sections in this chapter, and Chapter 8.

7. If necessary, use the Red Eye tool to remove the red color from eyes, as shown in Figure 7-18. Just click the red portion of the eye. If needed, use the sliders to adjust the Pupil Size or Darken Pupil options. You can also click the Auto button next to the Red Eye Fix option on the General Fixes panel, on the right side of the application window.

8. Apply any needed auto fixes, located on the Enhance menu or in the General Fixes, Lighting, and Color panels on the right side of the application window. All auto fixes are described in the next few sections of this chapter. Note that you can apply any fix to all or part of your image. If you want to apply it to just a portion, make a selection first. See Chapter 9 for details on making selections.

9. If you need additional color and contrast adjustments, use the Smart Fix, Levels, Contrast and Color sliders, located in the panels on the right of the application window:

 • **Lighten Shadows:** Lightens the darker areas of your image without adjusting the highlights.

 • **Darken Highlights:** Darkens the lighter areas of your image without adjusting the shadows.

 • **Midtone Contrast:** Adjusts the contrast of the midtones without adjusting highlights and shadows.

 • **Saturation:** Adjusts the intensity of the colors.

 • **Hue:** Changes all colors in an image.

 • **Temperature:** Adjusts the image's colors to be warmer (red) or cooler (blue).

 • **Tint:** Adjusts the tint after you adjust the temperature to make colors more green or magenta.

10. After you correct an image's contrast and color, sharpen the image by dragging the Sharpen slider. You can also click the Auto button for automatically applied sharpening.

Figure 7-18: Getting rid of red-eye in Quick Fix mode

Use the Auto Fixes

1. In the Organizer, or in either Full Edit or Quick Fix
 mode, choose Enhance from the menu bar and apply
 one of the following options to your open image:

 * **Auto Smart Fix:** Attempts to fix it all — lighting,
 contrast (shadows and highlight details), and color
 balance, as shown in Figure 7-19.

 * **Auto Levels:** Adjusts the overall contrast of the image.
 This command works by converting the lightest and
 darkest pixels in your particular image to white and
 black respectively. This makes the highlights lighter
 and the shadows darker, thereby increasing contrast,
 as shown in Figure 7-20. If you produce a strange
 color *cast* (a shift in color) after you apply the com-
 mand, choose Edit↩Undo and try instead the Auto
 Contrast command or the Levels command
 (described in Chapter 8).

Elements has a group of one-click automatic corrections that attempt
to fix your lighting, contrast, and color problems. Although the cor-
rections are a cinch to use, they may not give you the best results,
and you may ultimately have to use manual correction methods.
What the heck — give them a try! Note that with auto fixes, usu-
ally just one does the trick. If you not sure which one to use, just try
it. If it doesn't work to your liking, choose Edit↩Undo and try
another one. You usually want to avoid applying multiple auto fixes
because you may make things worse than they already are. If none
of the auto fixes works, move on to the manual methods described
in Chapter 8.

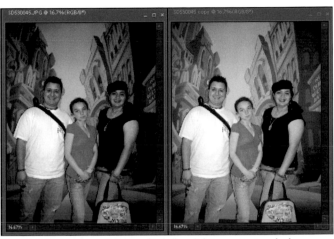

Figure 7-19: Auto Smart Fix tries to fix it all — lighting, contrast, and color

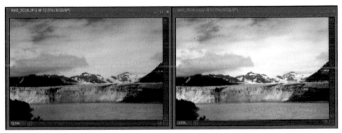

Figure 7-20: Auto Levels fixes the overall contrast

- **Auto Contrast:** Tries to fix the overall contrast without adjusting the color. Contrast adjustments usually aren't as effective as the Auto Levels command, but overall color balance is better maintained. Try this command on hazy images, as shown in Figure 7-21.

- **Auto Color Correction:** Corrects both the color and contrast of an image by analyzing the shadows, midtones, and highlights and adjusting the darkest and lightest areas. This command can come in handy in removing a color cast, as shown in Figure 7-22.

- **Auto Sharpen:** Creates the illusion of improved focus by increasing the contrast between pixels. Try not to oversharpen or else you end up with grainy, noisy images. Keep in mind that sharpening can't improve a blurry photo, just one with a slightly soft focus. Sharpening should always be your last fix after you make all other fixes. For more information on sharpening, see Chapter 8.

- **Auto Red Eye Fix:** Automatically detects and eliminates red-eye in images. If the Auto Red Eye Fix option doesn't fix your red-eye satisfactorily, use the Red Eye Removal tool, described in Chapter 8.

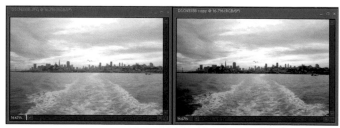

Figure 7-21: Using Auto Contrast to correct contrast without introducing a color cast

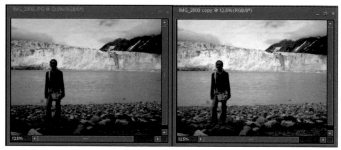

Figure 7-22: Correcting color and contrast with Auto Color Correction

Enhance with Cloning

1. In Full Edit mode, select the Clone Stamp tool from the Tools panel.

2. Specify your options on the Options bar:

 - **Brush Preset:** Choose a brush tip and size.

 - **Blend Mode:** For most cloning, the Normal default setting works well. Chapter 11 has more on blend modes.

 - **Opacity:** Specify a transparency level or leave it at the default setting of 100 percent.

 - **Aligned:** Select this option to have the clone source move as you move your cursor. To clone from the same source repeatedly, leave this option deselected.

 - **All Layers:** Select this option to sample pixels from all visible layers. Otherwise, only the active layer is used.

3. Press the Alt key (or press Option on the Mac) and click the *clone source* (the area of the image you want to clone from).

4. Release the Alt key (or Option) and then click or drag on the flawed area (the portion of the image where you want the sampled, or cloned, pixels to appear), as shown in Figure 7-23. When you click or drag, the crosshair is the clone source, and the Clone Stamp cursor is where the cloned pixels are applied. If you select the Aligned option in Step 2, when you move the mouse, the crosshair moves as well. Watch the crosshair to avoid cloning something you don't want.

 This tool is helpful for repairing small flaws — scratches, bruises, and dings — in otherwise perfect images. The Clone Stamp is also an ideal tool to duplicate images with soft shadows, as shown in Figure 7-24. Chapter 8 covers the healing tools—great for zapping blemishes and wrinkles.

 Try to be fairly light handed when cloning. If you overwork an area, it ends up looking blotchy. Remember: you don't want anyone to know that an area has been retouched.

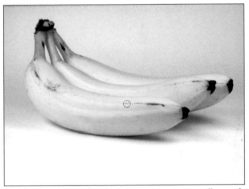

Figure 7-23: Using the Clone Stamp to remove small imperfections
www.istockphoto.com

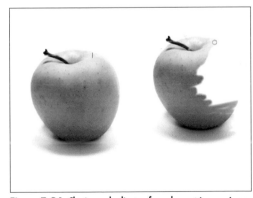

Figure 7-24: Cloning a duplicate of an element in your image
www.istockphoto.com

Tone with the Dodge and Burn Tools

1. In Full Edit mode, choose either the Dodge or Burn tool from the Tools panel.

 Reserve dodging and burning for small areas only. To adjust the overall tonal range in an image, use Auto Levels or a manual adjustment, like Levels or Curves.

2. Specify your options on the Options bar:

 • **Brush Preset:** Choose a brush tip and size.

 • **Range:** Select Shadows to darken or lighten the darker areas of your image. Select Midtones to adjust the middle tones. Select Highlights to make the light areas lighter or darker.

 • **Exposure:** Specify the amount of adjustment you want to apply with each brush stroke by adjusting the slider or entering a percentage. You should start with a lower percentage, such as 10 percent.

 • **Airbrush:** Select this option to convert your brush into an airbrush. The longer you press down the mouse button, the more "flow" of adjustment you create.

3. Brush over the areas you want to lighten or darken, as shown in Figure 7-25. Take your time between each stroke because sometimes you may experience a slight lag when using the Dodge and Burn tools. If you don't like the effect, choose Edit⇨Undo.

4. The corrected image appears in Figure 7-26.

Figure 7-25: Dodge and burn overly light or dark areas

Figure 7-26: Small areas can be lightened or darkened with the Dodge and Burn tools

Saturate and Desaturate with the Sponge

1. In Full Edit mode, choose the Sponge tool from the Tools panel. You can also press O to access the tool. If it isn't visible, press Shift+O to cycle through the tools.

2. Specify your options on the Options bar:

 - **Brush Preset:** Choose a brush tip from the drop-down list and adjust the brush diameter size as needed.

 - **Mode:** Choose a blend mode or leave it at the Normal default setting. For most editing chores, you can probably leave the default setting. For more information on blend modes, see Chapter 11.

 - **Flow:** Specify the flow rate by adjusting the slider or entering a percentage. The *flow rate* is the speed at which the saturation or desaturation effect builds while you brush over your image.

 - **Airbrush:** Select this option to convert your brush into an airbrush. As with a traditional airbrush, the longer you press the mouse button, the more "flow" of adjustment you create.

3. Brush over the areas you want to saturate or desaturate, as shown in Figure 7-27. Figure 7-28 shows how a strong focal point was created by saturating one person while desaturating the rest.

Figure 7-27: Brush carefully over areas to saturate or desaturate the color in an image
Digital Vsion

Figure 7-28: Create a focal point in your image by saturating
Digital Vsion

Blur and Sharpen Small Areas

1. In Full Edit mode, choose the Blur or Sharpen tool from the Tools panel. You can also press R to access the tool. If it isn't visible, press Shift+R to cycle through the tools.

 Reserve both these tools for small portions of your image only. Use the Blur tool to create a stronger focal point or soften a flaw. Use the Sharpen tool to also create a crisper focal point while keeping other image elements soft.

2. Specify your options on the Options bar:

 - **Brush Preset:** Choose a brush tip from the drop-down list. Adjust the brush diameter size as needed.

 - **Blend Mode:** Choose a blend mode, or leave it at the Normal default setting. For most blurring and sharpening tasks, you probably want to leave it the default setting. For more information about blend modes, see Chapter 11.

 - **Strength:** Specify the amount of blurring or sharpening that's applied with each stroke. The lower the value, the lighter the effect. You should start with a lower value — you can always increase it later if the effect is too light.

 - **All Layers:** Select this option to blur or sharpen pixels from all visible layers, if your image has layers.

3. Brush over the areas you want to blur or sharpen, as shown in Figures 7-29 and Figure 7-30.

Figure 7-29: Softening small parts of your image with the Blur tool
Purestock

Figure 7-30: Sharpening selected portions of your image with the Sharpen tool
Corbis Digital Stock

Smooth with the Smudge Tool

1. In Full Edit mode, choose the Smudge tool from the Tools panel. You can also press R to access the tool. If it isn't visible, press Shift+R to cycle through the tools.

2. Specify your options on the Options bar:

 - **Brush Preset:** Choose a brush tip and size. Consider the size of the area you want to smudge: Is it just an edge or the whole element?

 - **Blend Mode:** Choose a blend mode. For most smudging tasks, you probably want to leave the Normal default setting. For more information about blend modes, see Chapter 11.

 - **Strength:** Specify the amount of smudging effect that's applied with each stroke. The lower the value, the lighter the effect. You should start out with a lower value — you can always increase it later if the effect is too light.

 - **All Layers:** Select this option to smudge pixels from all visible layers, if your image has layers. The smudge still appears only on the active layer, but the look is a bit different, depending on the underlying layers' colors.

 - **Finger Painting:** Select this option to begin the smudge by using the foreground color. Rather than use the color directly under the cursor, the tool applies your chosen foreground color at the beginning of each stroke.

3. Brush over the areas you want to smudge. Think of using this tool as dragging a paint brush through wet paint. You can soften edges, as shown in Figure 7-31, or you can create a painterly effect by smudging large areas, as shown in Figure 7-32. Choose Edit⇨Undo if you don't like the effect.

Figure 7-31: Smudge edges to soften them
istockphoto.com

Figure 7-32: Or, smudge large areas to create a painterly effect
istockphoto.com

Correcting Content, Contrast, Color, and Clarity

Chapter

8

One strength of Elements is its ability to assist you in almost any editing endeavor. From incorrect color balance to flat contrast to nitpicky flaws here and there, Elements is equipped with tools to tackle most photographic problems. And, you don't have to spend a lot of your highly coveted time to do so, either. Chapter 7 gives you the low-down on ultraquick auto fixes. But just in case they don't quite do the job, this chapter covers multi-step, *manual* techniques — a couple of additional mouse clicks and a few swipes of an adjustment slider here and there.

If, after all corrections are applied, you're still not happy with your images, get out there and shoot again, if possible. That's part of the beauty of digital photography: No film processing means that you can shoot to your heart's content without worrying about anything other than filling up your memory card. Find out what worked and what didn't work the first time around, and make adjustments. Shooting the best image at the time of capture means less correction later.

Get ready to . . .

Correct Camera Distortion

1. In either Full Edit or Quick Fix mode, with an image open (see Figure 8-1), choose Filter⇨Correct Camera Distortion.

2. In the Correct Camera Distortion dialog box, select the Preview option.

3. Specify your correction options:

 - **Remove Distortion:** Corrects the lens barrel distortion, which makes images appear spherised. This effect, sometimes caused by using wide-angle lenses, also corrects *pincushion* distortion, where images look "pinched-in" at the center. This distortion is sometimes caused by using telephoto lenses. Move the slider and use the grid as your guide for proper alignment for this option (and all the others, too).

 - **Amount:** Adjusts the amount of vignetting (lightening or darkening) around the edges of an image, which is caused by incorrect lens shading, stacking filters, using the wrong lens, and other errors. Change the width of the adjustment by specifying a midpoint value. A lower midpoint value affects more of the image. Then move the Amount slider.

 - **Vertical Perspective:** Corrects the distorted perspective caused by tilting the camera up or down.

Figure 8-1: A distorted image
PhotoDisc

- **Horizontal Perspective:** Corrects halos and blurs caused by moving the camera. For the best results, specify the angle of movement by using the Angle option.

- **Angle:** Rotates the image to compensate for tilting the camera.

- **Scale:** Scales an image up or down to crop into the image. Using this option eliminates the "holes" that are created when blank areas remain on your canvas after you correct the perspective in an image. Be sure that if you scale up, the resolution is high enough to compensate for the increase in dimension, or else you degrade the image.

- **Show Grid:** Shows and hides the grid; can also specify the grid line color.

- **Zoom:** Zooms your view in and out.

4. Click OK if you're happy with the correction, as shown in Figure 8-2.

5. If you're not satisfied with the results, press the Alt key (the Option key on the Mac) and click Reset to try again.

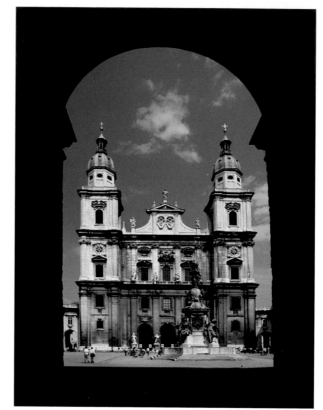

Figure 8-2: Corrected camera distortion
PhotoDisc

Use Adjustment Layers

1. In Full Edit mode, open an image. You can apply adjustment layers to a background or a layer.

 An *adjustment layer* is a special kind of layer used for correcting color and contrast. The advantage of using it rather than applying an adjustment directly on the image is that you can apply corrections without permanently altering the pixels. Because the correction resides on a layer, you can edit, add, or delete an adjustment at any time. Adjustment layers apply an adjustment only to all the layers below them — and have no effect on the layers above them. For more on layers, see Chapter 10.

2. Click the Create Adjustment Layer icon at the top of the Layers panel.

3. Choose an adjustment from the drop-down list: Levels, Brightness/Contrast, Hue/Saturation, Gradient Map (shown in Figure 8-3), Photo Filter, Invert, Threshold, or Posterize.

4. In your chosen adjustment layer's dialog box, choose your specific settings. Note that each adjustment is described in this chapter, in Chapter 7, or in Chapter 12.

5. Click OK to create the adjustment layer. It appears in the Layers panel and is annotated by the adjustment layer icon and a thumbnail image, as shown in Figure 8-3. The thumbnail represents a layer mask described in the following tip. You can see the effect in Figure 8-4.

6. To edit the adjustment layer, simply double-click the adjustment layer in the Layers panel and adjust the settings in the resulting dialog box. You can also adjust the opacity of the adjustment layer to reduce the effect.

 A layer mask is like a sheet of clear acetate that allows you to selectively apply the adjustment to layers below it by applying shades from white to black on the mask. If the mask is completely white, the adjustment is fully applied to the layers. Black areas don't show the adjustment, and gray areas partially show the adjustment. The darker the gray, the less it shows the adjustment. Use any painting tool, such as the Brush or Gradient tool, to paint on the layer mask.

Figure 8-3: An adjustment layer icon and layer mask thumbnail

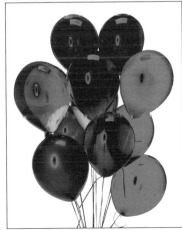

Figure 8-4: An image with a gradient map adjustment layer applied
PhotoDisc

Adjust Lighting and Color with Smart Fix

1. In either Full Edit or Quick Fix mode, with an image open, choose Enhance⇨Adjust Smart Fix. Smart Fix attempts to fix the color balance and improve the shadow and highlight detail in an image.

2. Select the Preview option in the dialog box.

3. Drag the Fix Amount slider to apply an amount of correction, as shown in Figure 8-5.

4. After the preview image looks good, click OK to apply the adjustment.

5. If you're not satisfied with the results, press the Alt key (the Option key on the Mac) and click Reset to try again.

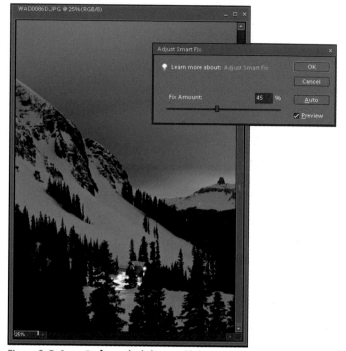

Figure 8-5: Smart Fix fixes color balance and lighting in an image
Corbis Digital Stock

Adjust Lighting with Shadows/Highlights

1. In Full Edit or Quick Fix mode, with an image open (see Figure 8-6), choose Enhance➪Adjust Lighting➪ Shadows/Highlights.

2. In the dialog box, select the Preview option to see the lighting adjustment automatically applied to your image.

3. To fine-tune the adjustment, move the sliders to lighten shadows, darken highlights, or adjust the midtone contrast. Try to get as much detail as possible to show in the dark and light areas of your image.

4. If you're satisfied, click OK to apply the adjustments, as shown in Figure 8-7 .

5. If you're not satisfied with the results, press the Alt key (the Option key on the Mac) and click Reset to try again.

 The Shadows/Highlights adjustment works well with *backlit* images — images shot in light coming from the back. This adjustment also does a good job of correcting ugly shadows in images that have been shot in bright, midday light coming from above.

 The Shadows/Highlights adjustment is also available in Guided mode in the Lighting and Exposure area.

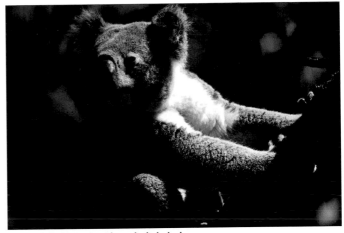

Figure 8-6: An image with overly dark shadows

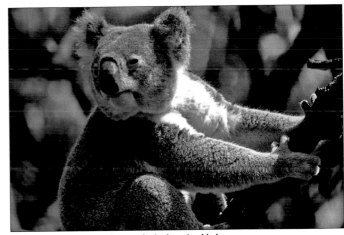

Figure 8-7: Adjusting lighting with Shadows/Highlights

Correct Contrast with Levels

1. In Full Edit or Quick Fix mode, with an image open, choose Enhance⇨Adjust Lighting⇨Levels.

 If you can, avoid using the simple, but less effective, Brightness and Contrast command. Levels enables you to adjust 256 levels of brightness, whereas Brightness and Contrast adjusts all tones in your image equally, without any regard to which areas need adjusting and which don't. Fixing shadows might make highlights overly bright.

2. In the dialog box that appears, a histogram displays how the pixels are distributed at each of the 256 levels of brightness (or *tones*) in your image, as shown in Figure 8-8. Shadows are on the left, midtones are in the center, and highlights are on the right.

3. In the Input Levels area, used to improve contrast, move the black triangle to the right to darken shadows, or to the left to lighten them. You can also enter values from 0 through 255 in the Input Levels boxes.

4. Move the white triangle to the left to lighten the highlights or to the right to darken them.

5. Move the gray triangle to the left to lighten the midtones, or to the right to darken them.

6. After you correct the contrast in your image, as shown in Figure 8-9, click OK to apply the adjustment. If you're not happy, click Reset.

 You can also adjust contrast by setting your black and white points using the eyedroppers in the Levels dialog box. Click the black eyedropper on the darkest black in your image, and click the white eyedropper on the whitest white. All remaining pixels are redistributed between these two points. If you have a grayscale image, click with the gray eyedropper to remove any color casts. Then click a neutral gray in your image.

 If your image suffers from too much contrast, adjust the sliders in the Output Levels section. Move the black triangle to the right to reduce contrast and lighten the shadow areas. Move the white triangle left to reduce the contrast and darken the highlight areas.

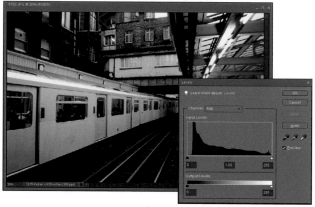

Figure 8-8: The histogram shows the distribution of brightness levels in an image
PhotoDisc

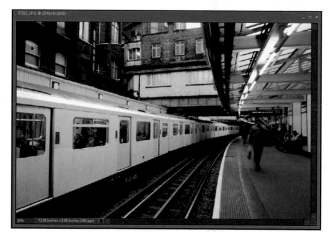

Figure 8-9: Fixing contrast with Levels
PhotoDisc

Remove Color Casts

1. In Full Edit or Quick Fix mode, with an image open (see Figure 8-10), choose Enhance⇨Adjust Color⇨ Remove Color Cast.

2. Click a portion of your image that should be white, black, or a neutral gray, such as the ceiling shown in Figure 8-10.

3. The image should show a color adjustment, as shown in Figure 8-11. What adjustment is made depends on which color you chose in Step 2.

4. If you're not satisfied with the results, click Reset and try another color.

5. Happy? Click OK to apply the adjustment.

 Use the Remove Color Cast command to eliminate green tints caused by shooting in rooms with fluorescent lighting. This command is also available in Guided mode.

 If you just can't eliminate color cast with the Remove Color Cast command, or other commands under the Adjust Color menu, try applying a photo filter. See more on photo filters in later in this chapter.

Figure 8-10: Click on areas that should be white, black, or gray
Corbis Digital Stock

Figure 8-11: A color cast removed with Remove Color Cast
Corbis Digital Stock

Use Hue and Saturation

1. In Full Edit or Quick Fix mode, with an image open, choose Enhance➪Adjust Color➪Adjust Hue/Saturation.

2. In the dialog box, select the Preview option.

3. Select all colors, the Master option, from the Edit pop-up menu or choose just one color to adjust.

4. Drag the slider for one or more of the following attributes:

 - **Hue:** Drag to the right to move the colors clockwise around the color wheel. Drag to the left to move colors counterclockwise, as shown in Figure 8-12.

 - **Saturation:** Drag to the right to increase the intensity of the colors. Drag to the left to decrease the intensity. If you drag all the way to the left, you desaturate the colors to a grayscale appearance.

 - **Lightness:** Drag to the right to increase the brightness by adding white. Drag to the left to decrease the brightness by adding black.

5. If you're satisfied, click OK to apply the adjustments.

6. If you're not satisfied with the results, press the Alt key (the Option key on the Mac) and click Reset to try again.

 Select the Colorize check box in the Hue/Saturation dialog box to create a *monotone* (one-color) effect, as shown in Figure 8-13. Drag the Hue slider to select a new color. Hue/Saturation is also available in Guided mode.

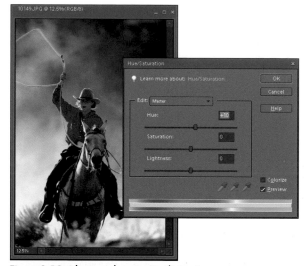

Figure 8-12: Adjusting color using Hue/Saturation
PhotoDisc

Figure 8-13: Creating a monotone effect with Hue/Saturation
PhotoDisc

Remove Color

1. In Full Edit or Quick Fix mode, with an image open, choose Enhance⇨Adjust Color⇨Remove Color.

2. All color is removed from your image, as shown on the left in Figure 8-14.

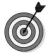 You don't have to remove color from your entire image. You can also remove color on just a layer, as shown on the right in Figure 8-14, or just a selection. For better ways to remove color, such as the Convert to Black and White command, see Chapter 12. For more on layers, see Chapter 10. For more on selections, see Chapter 9.

Replace One Color with Another

1. In Full Edit or Quick Fix mode, with an image open, choose Enhance⇨Adjust Color⇨Replace Color.

2. In the dialog box, select the Preview option.

3. Choose a preview type:

 - **Selection:** Unselected areas are displayed in black, whereas selected areas are displayed in white. Partially selected (semi-opaque) areas are displayed in shades of gray.

 - **Image:** Displays the image.

4. On your image, click the colors you want to select, as shown in Figure 8-15. You can also click the Preview thumbnail.

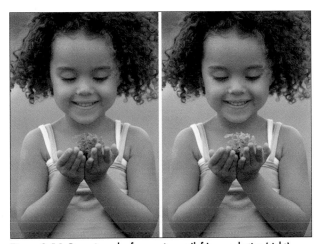

Figure 8-14: Removing color from an image (left) or a selection (right)
PhotoDisc

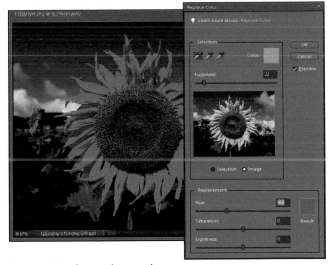

Figure 8-15: Selecting colors to replace
Corbis Digital Stock

5. To add more colors, Shift+click them. You can also use the Eyedropper tool with a plus sign.

6. To delete colors, Alt+click (Option+click on the Mac) them. You can also use the Eyedropper tool with a minus sign.

7. To add colors similar to the ones you select, drag the Fuzziness slider to the right. To delete colors from your selection, drag the slider to the left.

8. After you select an area, drag the Hue slider to choose a new color. Click the swatch to choose a color from the Color Picker.

9. Drag the Saturation slider to the right to increase the intensity of the color. Drag to the left to decrease the intensity of the color. Drag all the way to the left to make the color go to grayscale.

10. Drag the Lightness slider to the right to lighten the tonal range. Drag to the left to darken the tonal range.

11. If you're satisfied, click OK to apply the adjustments. A color replaced image appears in Figure 8-16.

12. If you're not satisfied with the results, press the Alt key (the Option key on the Mac) and click Reset to try again.

Figure 8-16: An image with replaced color
Corbis Digital Stock

Correct with Color Curves

1. In Full Edit or Quick Fix mode, with an image open (see Figure 8-17), choose Enhance⇨Adjust Color⇨Adjust Color Curves.

2. In the dialog box, select the Preview option. You see both a Before and After image to better judge the correction.

3. Select a style in the Select a Style area. Keep an eye on the After preview image.

4. Move the highlight, brightness, contrast, and shadow sliders to further fine-tune the curves adjustment. Note that the graph displays the distribution of brightness levels, or *tones*, in your image. When you first open the Color Curves dialog box, the tonal range is represented by a straight line. As you move the sliders, that straight line is adjusted and the contrast is corrected.

5. Click OK to apply the Color Curves adjustment. To start again, press Reset. A corrected image is shown in Figure 8-18.

 Color Curves is one of the best commands to use to correct both contrast and color. Use it on images that are either overexposed (too light or washed out) or underexposed (too dark). You can even use it to improve color balance or eliminate a color cast.

Figure 8-17: An image in need of contrast adjustment
Flat Earth

Figure 8-18: An image corrected with Color Curves
Flat Earth

Fix Skin Tones

1. In either Full Edit or Quick Fix mode, with an image open, do one of the following:

 - **Select a layer:** If a specific layer needs adjustment, select it in the Layers panel first. If you don't have layers (just a background), the entire image is adjusted, unless you make a selection first.

 - **Make a selection:** Choose this method if you want to apply the adjustment to just a portion of your image, such as a face. A selection is important if the colors of the other elements are satisfactory and just the skin needs adjusting. See Chapter 9 for details on selections.

2. Choose Enhance⇨Adjust Color⇨Adjust Color for Skin Tone.

3. In the dialog box, select Preview. Then move the cursor over your image and click the area of skin that needs adjustment. In Figure 8-19, I clicked the face of the woman in front.

4. If the skin tone in your image isn't improving, click another area of the skin.

5. If you're still not satisfied, try adjusting these options:

 - **Tan:** Adds or eliminates brown tones in the skin.

 - **Blush:** Adds or eliminates red tones in the skin.

 - **Temperature:** Adjusts the overall color in the skin. Move the slider to make skin tones warmer (or more red) or cooler (or more blue).

6. If you're pleased with the skin tones, click OK to apply the adjustment. If you're not happy, click the Reset button to try again. See the adjusted image in Figure 8-20.

 You can also find the Adjust Color for Skin Tone command in Guided mode.

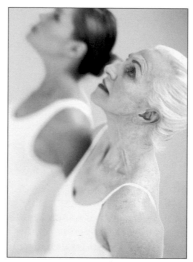

Figure 8-19: Improving skin tones
PhotoDisc

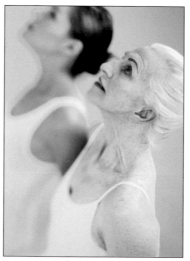

Figure 8-20: Skin tones appear closer to their natural color
PhotoDisc

Defringe to Clean Up Edges

1. In Full Edit mode only, open an image that contains layers with selected images whose edges are in need of refinement — specifically, if your selections have *halos*, or remnants of the background from which they were selected, as shown in Figure 8-21.

2. In the Layers panel, select the layer that contains your selection in need of repair.

3. Choose Enhance⇨Adjust Color⇨Defringe Layer.

4. In the dialog box, enter a value for the number of pixels that need to be "defringed." Initially, use a low value, like 1 or 2. If the halo remains, you can increase the value. The defringing process basically changes the color of the pixels in the halo to match the color of neighboring pixels.

5. Click OK to apply the adjustment. A defringed selection is shown in Figure 8-22.

Figure 8-21: Halos around selection edges
istockphoto.com

Figure 8-22: Defringed selection edges
istockphoto.com

Adjust Color with Color Variations

1. In Full Edit or Quick Fix mode, with an image open, choose Enhance➪Adjust Color➪Color Variations.

2. In the dialog box, select your options:

 - **Shadows, Midtones, Highlights:** Adjusts the dark, middle, and light tonal areas. Try midtones first.

 - **Saturation:** Adjusts the intensity of the colors. Add saturation to scanned images that have faded over time.

3. Drag the Adjust Color slider to the right to increase the adjustment that's applied in Steps 4 and 5. Drag to the left to decrease it.

4. Adjust the color in your selected tonal area (refer to Step 2) by clicking the Increase or Decrease thumbnails. Increase colors that are lacking in your image, and decrease any color that's overabundant or causing a cast, as shown in Figure 8-23. Examine the results in the After preview thumbnail. Repeat for Shadows and Highlights, if necessary.

5. Click the Darken or Lighten buttons to adjust the colors.

6. If you selected Saturation in Step 2, click the Less Saturation or More Saturation thumbnails to adjust the saturation.

7. If you go too far with your adjustments in Steps 4 or 5, click the Undo button. The Color Variations command supports multiple undos.

8. If you just messed up your corrections beyond any possibility of using Undo, click Reset Image and try again.

9. If you're satisfied, click OK to apply the adjustments. Figure 8-24 shows a freshly color-corrected image.

 You can also try the Remove Color Cast command, described in this chapter, to remove offensive color casts in your images.

Figure 8-23: Decrease any color that's causing a cast
Purestock

Figure 8-24: Color adjusted with Color Variations
Purestock

Adjust Color Temperature with Photo Filters

1. In Full Edit mode, with an open image, choose Filter➪ Adjustments➪Photo Filter.

2. In the dialog box, select Filter to choose a preset filter from the drop-down list. You can also select Color to select your own filter color from the Color Picker. The preset filters are described in this list:

 - **Warming Filter (85), (81) and (LBA):** Adjusts the white balance to make colors warmer (more yellow), as shown in Figures 8-25 and 8-26. Filter (81) is more subtle than the other two.

 - **Cooling Filter (80), (82) and (LBB):** Adjusts the white balance to make colors cooler (more blue). Filter (82) is more subtle than the other two.

 - **Red, Orange, Yellow and others:** Adjust the hue of the image. Choose a color to eliminate a color cast or to create a special effect.

3. In the dialog box, move the Density slider to specify the amount of color that's applied. If you want, select Preserve Luminosity to prevent the filter from darkening the image.

4. After you select a filter and set the options to your liking, click OK. If you're not happy, press Alt (Option on the Mac) and click Reset.

 Keep in mind that light has its own color temperature. The higher the color temperature, the more blue. The lower the color temperature, the more yellow. Photos at twilight or in snowy conditions lean toward blue. Images shot at sunset or sunrise lean toward yellow and orange.

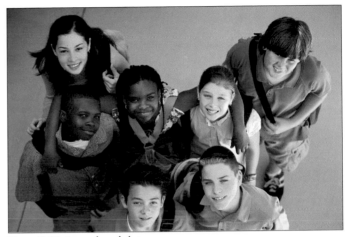

Figure 8-25: An overly cool photo
Creatas

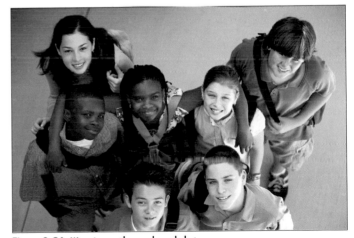

Figure 8-26: Warming up the overly cool photo
Creatas

Eliminate Artifacts and Noise

1. In Full Edit mode, with an open image, choose a filter:

- **Filter⇨Pixelate⇨Facet:** This one-step filter (no dialog box appears) breaks up your image using a subtle posterizing effect by selecting pixels of similar brightness and converting them to a single value. You can apply the filter more than once, if needed. Be careful, however: Too many applications cause your image to look painted rather than photographed. Figure 8-27 shows an image with the facet filter applied.

- **Filter⇨Noise⇨Median:** This filter reduces contrast between adjacent pixels by assigning the median value of a pixel group to the center pixel in the group. In the dialog box, choose the radius of the pixel group that Elements uses to calculate that median value. In laymen's terms, lighter spots darken, whereas darker spots lighten (see Figure 8-28). The Median option can smooth artifacts but may blur too much. If so, choose Edit⇨Undo and try Despeckle or Facet.

- **Filter⇨Noise⇨Despeckle:** This one-step filter reduces the contrast between adjacent pixels without affecting edges. This filter may cause a slight blur. It can be useful for scanned newspaper images.

- **Filter⇨Noise⇨Reduce Noise:** This filter can reduce luminance noise (creating a grainy look) and artifacts. The Strength option sets the amount of reduction. For Preserve Details, a higher value removes less noise, but retains detail. Reduce Color Noise eliminates random colored pixels. Remove JPEG Artifacts removes the blocks and halos of low-quality JPEG compression.

 If the Median and Facet filters cause your images to lose crispness, try sharpening the photos with a low radius setting. See details on sharpening later in this chapter.

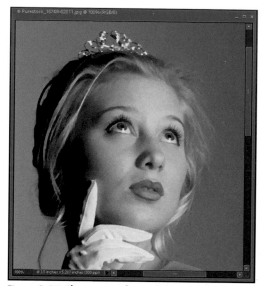

Figure 8-27: Eliminating artifacts with the Facet filter
Purestock

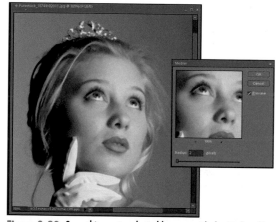

Figure 8-28: Smoothing out undesirable areas with the Median filter
Purestock

Heal Wrinkles and Blemishes with the Healing Brush

1. In Full Edit mode, select the Healing Brush tool from the Tools panel. You can heal within a single image or between two images in the same image mode.

2. Specify your healing options:

 - **Brush Preset:** Choose a brush type, diameter, and hardness as needed. You can also adjust the spacing, angle, and roundness. Using the appropriate brush to fix a flaw is important for smooth, no-telltale retouching.

 - **Blend Mode:** Choose a blend mode. For most healing tasks, the Normal default setting works well. Replace mode preserves textures, like noise or film grain, around the edges of your strokes. (Chapter 11 covers blend modes.)

 - **Source:** Sampled uses the pixels from your image. Pattern uses pixels chosen from the drop-down panel.

 - **Aligned:** When selected, the healing source moves as you move your cursor. To heal from the same source repeatedly, leave this option deselected.

 - **All Layers:** Select this option to sample pixels from all visible layers, if your image has them. If the option is deselected, the tool samples only pixels from the active layer.

3. Press the Alt key (Option on the Mac) and click the *healing source* (the area of your image that you want to heal from).

4. Release the Alt key (Option on the Mac) and then click or drag over the flawed area (where you want the healed pixels to appear). See Figure 8-29.

Figure 8-29: Eliminating wrinkles, blemishes, and other imperfections with the Healing Brush
PhotoSpin

5. When you click or drag, the crosshair that appears is the source you're healing from. The Healing Brush cursor is where the healed pixels are applied. If you chose Aligned in Step 2, when you move the mouse the crosshair moves as well. Keep an eye on the crosshair because that's the area you're healing from. Figure 8-30 shows the image after its digital makeover.

 Add a new, blank layer above your image before you start to heal. Make the blank layer the active layer and select the All Layers option. Then, as you heal the image, the pixels appear on the new layer and not on the image itself. You can then adjust opacity, apply blend modes, or make other image adjustments to fine-tune the healed layer without affecting the underlying original image.

 Be careful not to overheal an image — unless, of course, you want that maximum-Botox, "plastic" look. When people laugh and smile, they naturally have some wrinkles, even when they're young.

Figure 8-30: A digital makeover is a cheap alternative to going under the knife
PhotoSpin

Eliminate Red Eye

1. Select the Red Eye Removal tool from the Tools panel.

2. In the open image, click the red portion of the eye. The red pupil should darken while retaining the tones and textures of the eye, as shown in Figure 8-31.

3. If the red-eye wasn't fixed satisfactorily, adjust one or both of these options, found on the Options bar:

 - **Pupil Size:** Adjust the slider to increase or decrease the size of the pupil. Feel free to zoom in with the Zoom tool for more precision.

 - **Darken Pupil:** Adjust the slider to darken or lighten the color of the pupil, as shown in Figure 8-32.

 Red-eye occurs when a person or an animal (animals usually end up with yellow-, green-, or even blue-eye) looks directly into the flash. Most cameras have a red-eye prevention mode, which is a preflash that causes the subjects' irises to contract, making their pupils smaller when the real flash goes off. Other cameras mount the flash high or to the side of the lens, which also reduces the chance of red-eye. If you have either or both of these options, use them to prevent red-eye when shooting.

 If the Red Eye Removal tool didn't work for your pet's yellow-, green-, or blue-eye, try the Color Replacement tool instead. Select the pupil with either the Elliptical Marquee or Lasso tool. Then set the foreground color to black, and brush with the Color Replacement tool. For more on replacing color, see Chapter 7.

Figure 8-31: Use the Red Eye Removal tool to revert pupils back to black.

Figure 8-32: Darken the pupil if necessary.

Repair Quickly with the Spot Healing Brush

1. In Full Edit mode, select the Spot Healing Brush tool from the Tools panel. You can also press the J key to access the tool. If it isn't visible, press Shift+J.

2. Specify your spot-healing options on the Options bar:

 - **Brush Preset:** Choose a brush from the drop-down list and adjust the brush diameter size and hardness as needed. You can also adjust the spacing, angle, and roundness. Select a brush that's slightly larger than the flawed area you're healing.

 - **Blend Mode:** Choose a blend mode or leave it at the Normal default setting — the common setting for spot healing. Replace mode preserves textures, like noise or film grain, around the edges of your strokes.

 - **Type:** The Proximity Match option samples the pixels around the edge of the selection to heal the flaw. Create Texture uses all pixels in the selection to create a texture to heal the flaw.

 - **All Layers:** Select this option to sample pixels from all visible layers, if your image has them. If deselected, the tool samples pixels from only the active layer.

3. Click and release, or drag, directly on the area you want to fix, as shown in Figure 8-33. A spot-healed image appears in Figure 8-34.

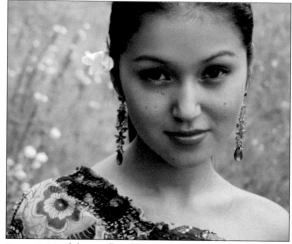

Figure 8-33: Clicking on flawed areas
Purestock

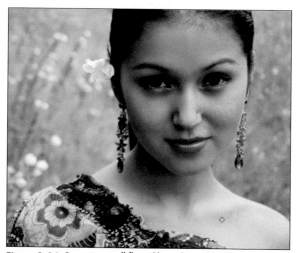

Figure 8-34: Removing small flaws, like moles and freckles, with the Spot Healing Brush
Purestock

117

Blur for Effect or Elimination

1. In Full Edit or Quick Fix mode, with an image open, choose Filter➪Blur and choose one of the following blur commands:

 - **Average:** Calculates the average value of the pixels in the image and fills the area with that value. Can smooth out noisy areas and also obliterate detail.

 - **Blur:** Averages the value of the pixels next to the edges of defined areas; applies a fixed, uniform blur to the image.

 - **Blur More:** The same as Blur — only more so.

 - **Motion Blur:** Gives the appearance of a blur caused by movement. Specify the angle of motion and the distance of the blur, as shown in Figure 8-35. Select the preview option to see the effect.

 Why would you want to blur an image? If it suffers from a moiré pattern (caused by scanning a halftone), applying a slight Gaussian blur can help to soften the annoying pattern. You may also want to blur an image to soften film grain or noise. Finally, blurring portions of an image can help to remedy distracting background elements and create a better focal point.

Figure 8-35: Motion blurs give the illusion of movement
Image 100 Ltd.

- **Radial Blur:** Creates a circular blur effect. Specify the amount of blur. Choose the Spin method. Blur along concentric circular lines or along radial lines (Zoom). Select a Quality level. Specify where you want the center of the blur by moving the blur thumbnail. Note that radial blur, in particular, is memory intensive and can be slow in rendering.

- **Smart Blur:** Has the honor of being the most precise blur command. Specify values for the radius of the area and the threshold. (See the definitions in the section "Sharpen to Improve Focus," later in this chapter.) Start with a low value and increase if necessary. Choose a Quality level and a mode setting. Normal blurs the entire image, whereas Edge Only blurs only the edges of the elements and applies black and white in the blurred pixels. Overlay Edge blurs only the edges and applies white to the blurred pixels.

- **Gaussian Blur:** One of the oldest and most commonly used blur filters, as shown in Figure 8-36. Specify a radius for the blur.

2. Average, Blur, and Blur More are one-step filters: Just apply and you're done. Click OK in the dialog box to apply the other blur commands.

 You're better off skipping the one-step filters. You get better control with Gaussian Blur and Smart Blur for your basic blurring tasks.

Figure 8-36: A Gaussian blur creates a sharper focal point
Purestock

Sharpen to Improve Focus

1. In Full Edit or Quick Fix mode, with an image open, choose Filter⇨Sharpen and then choose a command:

 - **Unsharp Mask:** For the *amount* of edge sharpening, the higher the value, the more contrast between pixels around the edge. Start with 50 percent and adjust as necessary. If you oversharpen, the image appears grainy. Specify the *radius* (the width of the edges that will be sharpened). For low-resolution images (72 ppi), use a smaller radius, like .4 pixels. For high-resolution images (300 ppi), use a higher radius, around 1.5 pixels). For the threshold, specify the difference (between 0 and 255) in brightness that must be detected between pixels before the edge is sharpened. A lower value sharpens edges that have little difference in contrast. Set the threshold to 0 unless the image is noisy or grainy. That way, sharpening is applied uniformly, as shown on the right in Figure 8-37.

 - **Adjust Sharpness:** Specify the Amount and Radius options. Choose a sharpening algorithm with the Remove option. Gaussian Blur is used for Unsharp Mask. Lens Blur preserves detail while eliminating halos caused by sharpening. You can also choose Motion Blur or More Refined, which apply the filter slowly but more accurately, as shown in Figure 8-38.

2. Click OK in the dialog box to apply the commands.

 Always make sharpening the last correction you make. The last thing you want to do is sharpen bad color, artifacts, noise, or nasty flaws. But because sharpening can increase contrast, you may have to redo your lighting adjustments.

 Keep in mind that you can't add focus that wasn't there in the first place. By sharpening in Elements, you merely create the illusion of focus by increasing the contrast between adjacent pixels. Even Elements can't resurrect very blurry shots.

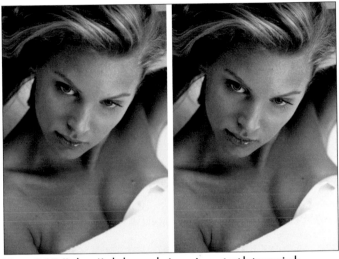

Figure 8-37: Unsharp Mask sharpens by increasing contrast between pixels
Purestock

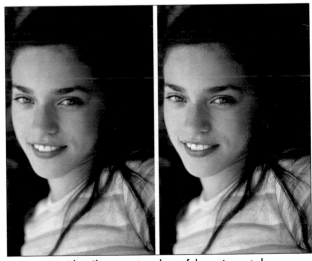

Figure 8-38: Adjust Sharpness gives plenty of sharpening control
Digital Vision

Creating Selections

Sometimes, you want to use a photo just as it is. That is, you want to keep intact all contents within the frame. Anything you do to the photo, such as color or contrast adjustments, is done to the entire photo. But at other times, you may want to correct only a portion of the photo or use just a part of the image and combine it with another image. That's where the skill of making selections is valuable.

Making good selections is a skill that serves you well if you plan to make the most of digital imaging tools and techniques. The more accurate your selections, the higher the quality of your images. To make selections in a digital image-editing program, like Elements, you specify which part of an image you want. Elements provides you many options to isolate pixels and create accurate selections.

In this chapter, you find out how to use many different selection tools and methods that help you make accurate selections. Note that with the exception of Selection Brush, your image must be in Full Edit mode.

Chapter

9

Get ready to . . .

Select with the Rectangular Marquee

1. Select the Rectangular Marquee tool from the Tools palette. The tool looks like a dotted square and shares a fly-out menu with the Elliptical Marquee tool. You can also press the M key to access the tool. If the Rectangular Marquee isn't visible, press Shift+M.

2. In your image, drag from one corner of an area to the opposite. As you drag, you see a selection outline, also called a *selection marquee*. You can move a selection outline while you're making it with either of the Marquee tools by pressing the spacebar as you drag.

 To make a perfectly square or circular selection, press the Shift key after you begin dragging. After you make a selection, release the mouse button first and then the Shift key.

3. Release the mouse button to complete the selection, as shown in Figure 9-1.

 Remember that when you have a selection in Elements, everything within the selection outline is considered selected and everything outside the selection outline is unselected. For example, if you apply color adjustments, effects, or paint on your image, it affects only the area within the selection outline. When you choose Edit➪Copy, it copies only what is within the selection outline.

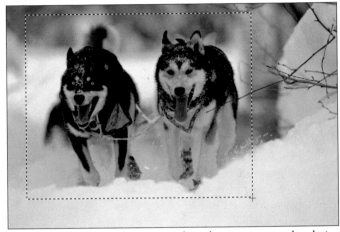

Figure 9-1: Use the Rectangular Marquee tool to make square or rectangular selections
Corbis Digital Stock

 To copy your selection to another file, select the Move tool from the Tools panel. Place the Move tool within the selection outline and drag and drop onto your destination file. For more on dragging and dropping, see Chapter 10.

 To move a selection outline and its underlying pixels, select the Move tool from the Tools panel and drag the selection. Note that you leave a "hole" that reflects the background color. To copy the selection instead, press the Alt key (or the Option key on a Mac) and drag with the Move tool. If you want to make copies of the selection, you should work with layers. See Chapter 10 for details on layers.

Select with the Elliptical Marquee

1. Select the Elliptical Marquee tool from the Tools palette. The tool looks like a dotted circle and shares a fly-out menu with the Rectangular Marquee tool. You can also press the M key to access the tool. If the Elliptical Marquee isn't visible, press Shift+M.

2. In your image, drag from one corner of an area to the opposite. As you drag, you see a selection outline, also called a *selection marquee.*

3. Release the mouse button to complete the selection, as shown in Figure 9-2.

 Sometimes you can more easily make a selection when you drag from the center outward, especially with elliptical selections. To make a selection from the center outward, simply press the Alt key (or the Option key on a Mac) and drag. After you make your selection, release the mouse button first and then the Alt key (or Option key).

 If you want a combo platter — select from the center outward and make a square or circular selection — press both the Shift and Alt keys (or the Shift and Option keys on a Mac). After you make your selection, release the mouse button first and then the Shift and Alt keys (or Shift and Option keys).

Figure 9-2: Use the Elliptical Marquee tool to make circular or elliptical selections
Corbis Digital Stock

Apply Marquee Options

1. Select either the Rectangular or Elliptical Marquee tool from the Tools palette.

2. Before you make a selection, select one or more of the following options on the Options bar, shown in Figure 9-3:

 - **Feather:** Specify a value from 0 to 250 pixels. Feathering creates a soft edge around your selection. The higher the amount, the softer the edge. Very small amounts can create a natural transition between elements in a multi-image composite. Large amounts can create creative dissolves between multiple images. This option is also available for the three Lasso tools.

 - **Anti-Alias:** Select this option to soften an edge by only 1 pixel. Anti-aliased edges are useful on jagged edges and on selections combined in a multi-image composite. This option is also available for the three Lasso tools.

 - **Mode:** Choose from three settings. In the *Normal* (default) setting, you can freely drag your selection. *Fixed Aspect Ratio* enables you to specify a fixed ratio of width to height. Select *Fixed Size* to set an exact width and height.

 - **Width and Height:** Enter Width and Height values when you select either Fixed Aspect Ratio or Fixed Size mode.

3. Make your selection. See "Select with the Rectangular Marquee" or "Select with the Elliptical Marquee," earlier in this chapter.

4. Release the mouse button to complete the selection, as shown in Figure 9-4.

The default unit of measurement for width and height is pixels. For another unit, enter its abbreviation, such as **in** for inches.

Figure 9-3: Specify options for your marquee selections
Corbis Digital Stock

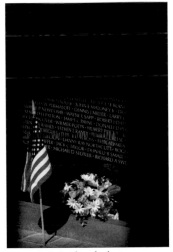

Figure 9-4: Feathered selections create soft edges
Corbis Digital Stock

Select Straight-Sided Polygons

1. Select the Polygonal Lasso tool from the Tools palette. The tool looks like a straight-sided rope. It shares a flyout menu with the Lasso and Magnetic Lasso tools. You can also press the L key to access the tool. If the Polygonal Lasso tool isn't visible, press Shift+L.

2. In your image, position the Polygonal Lasso cursor anywhere along the edge of the object you want to select. A corner is usually a good place to start. The *hotspot* of the cursor is the end, or tail, of the rope.

3. Click and release at the starting point. Move (don't drag) the mouse cursor and click at the next corner of the object. The polygonal lasso line that appears stretches out with a rubber-band effect.

4. Continue clicking and moving to each corner of the object, as shown in Figure 9-5.

5. Return to the starting point. Look for a small circle icon that appears next to the Polygonal Lasso cursor. This icon indicates that you're about to close the selection correctly. Release the mouse button to complete the selection, and the polygonal lasso line converts into a selection outline, as shown in Figure 9-6.

 If you need to add or delete areas from the selection made with any of the Lasso tools, see the section "Modify Selections," later in this chapter.

Figure 9-5: Trace with the Polygonal Lasso tool
Corbis Digital Stock

Figure 9-6: Return to your starting point
Corbis Digital Stock

Create Selections with the Magnetic Lasso

1. Select the Magnetic Lasso tool from the Tools palette. The tool looks like a straight-sided rope with a magnet. It shares a fly-out menu with the Lasso and Polygonal Lasso tools. You can also press the L key to access the tool. If the Magnetic Lasso tool isn't visible, press Shift+L.

2. In the image, position the Magnetic Lasso cursor anywhere along the edge of the object you want to select. The *hotspot* of the cursor is the end, or tail, of the rope.

3. Click at the starting point to place the first fastening point. Fastening points anchor the magnetic lasso line.

4. Move (don't drag) the mouse cursor around the edge of your object. As you move it, you see the magnetic lasso line and fastening points appear, as shown in Figure 9-7. The line and points attempt to hug, or *snap* to, the edge of the object, provided there's enough contrast to distinguish the edge.

5. If the Magnetic Lasso tool starts going awry and moving away from the edge, back up the mouse cursor along the magnetic lasso line and click to force down a fastening point.

6. If the Magnetic Lasso tool adds a fastening point where you don't want one, press the Backspace key (or the Delete key on a Mac) to delete it.

Figure 9-7: The Magnetic Lasso tool attempts to snap to the edge of your chosen object
PhotoDisc

7. If you reach a point of frustration because your selection isn't working as planned, consider modifying the default settings of the unique Magnetic Lasso options:

 - **Width:** Choose a value between 1 and 256 pixels to specify how close to the object's edge you must move the mouse cursor before the tool snaps to that edge. If your image doesn't have a lot of contrast, try using a lower value.

 - **Edge Contrast:** Enter a percentage between 1 and 100 percent to specify how much contrast is required before the tool snaps to the edge of the object. Again, if your image doesn't have a lot of contrast, use a lower percentage.

 - **Frequency:** Choose a value from 1 through 100 to specify how frequently to place a fastening point. The higher the value you enter, the more points you create. If the edge of your object has a lot of detail, try a higher value. For smoother edges, a lower value should be sufficient.

 - **Tablet Pressure:** Select this option (the pen icon) if you have a pressure sensitive drawing tablet and want an increase in stylus pressure to cause the Width value to decrease.

8. Return to the starting point. Look for a small circle icon that appears next to the Magnetic Lasso cursor. This icon indicates that you're about to close the selection correctly. Release the mouse button to complete the selection. Note that you can also double-click the mouse button to complete the selection. After releasing the mouse button, you see the magnetic lasso line convert into a selection outline, as shown in Figure 9-8.

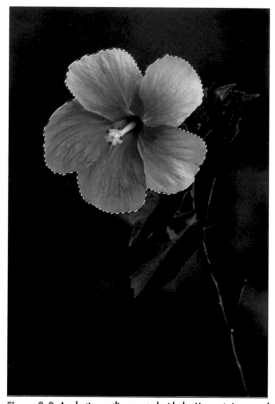

Figure 9-8: A selection outline created with the Magnetic Lasso tool
PhotoDisc

Wrangle Pixels with the Magic Wand

1. Select the Magic Wand tool from the Tools palette. It looks like a wand with a starburst. You can also press the W key to access the tool.

2. In your image, click anywhere within the area you want. The selection that's made is based on the color of the pixel you click (specifically, the pixel directly under the hotspot of your cursor). The amount of area that's selected is also determined by the Tolerance setting.

The Tolerance setting is based on brightness levels that range from 0 to 255. The default setting of 32 means that Elements selects all pixels whose brightness levels are between 16 levels lighter and 16 levels darker than that of your base color (the color you clicked to select). Ideally, the Magic Wand tool works best when you have high-contrast images or images with a limited number of colors. If your image is a bazaar of multiple colors, the Magic Wand probably isn't an effective tool for making your selection.

3. If you select everything you want on the first click, you're done. If your selection needs further modification, as shown in Figure 9-9, go to Step 4.

4. Specify a new Tolerance setting on the Options bar. If the Magic Wand selects more than you want, lower the Tolerance setting. If the wand doesn't select everything you want, increase the setting.

5. Click the area again. Note that the Magic Wand doesn't modify your first click — it deselects the current selection and makes a new one based on the new Tolerance value.

Figure 9-9: The Magic Wand selects pixels based on similar colors
Corbis Digital Stock

6. If your selection still isn't satisfactory, you can select these other options on the Options bar:

 - **Anti-alias:** Select this option to slightly soften the edge of the selection by one pixel.

 - **Contiguous:** This option instructs the Magic Wand to select *only* pixels that are adjacent to each other. Unselected, the tool selects pixels, whether or not they're adjacent.

 - **All Layers:** If you have multiple layers, the Magic Wand selects pixels from *all* visible layers. Unselected, the tool selects pixels from only the active layer. For details on layers, see Chapter 10.

 - **Refine Edge:** Click the Refine Edge button, and in the dialog box, move the Smooth slider to reduce the amount of jaggedness in your edges. For details on feathering, see "Apply Marquee Options," earlier in this chapter. Move the Contract/Expand slider to the left or right to decrease or increase the selected area. Click the custom overlay color button to preview your selection with its edges hidden and an overlay of screen-only color in the unselected area.

7. Try again to modify your selection (see "Modify Selections," later in this chapter) or move on to another tool. The finished selection is shown in Figure 9-10.

Figure 9-10: The Magic Wand tool works best with images with a limited number of colors.
Corbis Digital Stock

Brush with the Selection Brush

1. Select the Selection Brush tool from the Tools palette. It looks like a brush with a dotted oval and shares a fly-out menu with the Quick Selection tool. You can also press the A key to access the tool. If the Selection Brush tool isn't visible, press Shift+A.

2. Specify your Selection Brush options on the Options bar:

 - **Brush Presets:** Select a brush from the drop-down panel. To load additional brushes, click the downward-pointing arrow and choose a preset library.

 - **Brush Size:** Specify a brush size, from 1 to 2500 pixels, by entering the value or dragging the slider.

 - **Mode:** Select either Selection or Mask. Selection enables you to "build" a cumulative selection by brushing over the area. Each brush stroke adds to your selected area. In Mask mode, you create a selection by eliminating the areas you don't want. Again, each brush stroke adds to the mask. The methodology is also a little more complicated. First, you must select an *overlay* (an on-screen layer of color) that covers your image, indicating unselected areas. Next, choose an overlay opacity between 1 and 100 percent. Then choose an overlay color or leave it at the red default setting.

 - **Hardness:** Enter a brush tip hardness, from 1 to 100 percent. If you want a brush with softer edges, enter a lower value.

3. In your image, if the mode is set to Selection, brush over the areas you want to select. Remember that each brush stroke adds to your selection. You see a selection border appear, as shown in Figure 9-11. If you mistakenly select something you don't want, press the Alt key (or the Option key on a Mac) and brush over the area.

Figure 9-11: The Selection Brush enables you to brush in a selection . . .
PhotoSpin

4. If the mode is set to Mask, brush over the areas you don't want to select. As you brush, you see the overlay color. Remember that each stroke adds to the mask, as shown in Figure 9-12. If you mistakenly brush over an area you don't want, press the Alt key (or Option key on a Mac) and brush over the area again. When you're done creating the mask, choose Selection from the Mode drop-down list, to convert the mask into a selection outline. Remember that the selection outline is drawn around the areas you *don't* want. If you want to choose what you do want, choose Select⟶Inverse.

Figure 9-12: . . . or create a mask to select what you *don't* want
PhotoSpin

 The Selection Brush works in either Full Edit mode or Quick Edit mode.

 Masking in Elements is a way to protect the areas you *don't* want from the effect of an action, whether it's selecting, painting, or adjusting color. Although using Mask mode is a little more complex than Selection mode, the advantage is that you can make partial selections. If you paint with a soft-edged brush, those soft edges are partially selected, resulting in a feathered edge. If you set the opacity of an overlay to a lower percentage, the selection is also partially selected, or *semitransparent*. For example, set the opacity to 50 percent, and your selection is then only 50 percent selected.

Freeform Select with the Lasso

1. Select the Lasso tool from the Tools palette. The tool looks like a rope and shares a fly-out menu with the Polygonal and Magnetic Lasso tools. You can also press the L key to access the tool. If the Lasso tool isn't visible, press Shift+L.

2. In the image, position the Lasso cursor anywhere along the edge of the object you want to select. The *hotspot* of the cursor is the end, or tail, of the rope.

 It may help to zoom in and out while using the Lasso tool so that you can be more precise when selecting your element. To zoom in while you're using the Lasso tool, press Ctrl++ (or ⌘++ on the Mac) with your other hand. That's Ctrl or ⌘ and the plus sign key. To zoom out, press Ctrl+– (or ⌘+– on a Mac).

3. Hold down the mouse button and trace around the object. Keep a steady hand and trace only the area you want to select, as shown in Figure 9-13.

4. Return to the starting point. Release the mouse button to complete the selection, and then you see the traced outline convert into a selection outline, as shown in Figure 9-14.

 Caution: If you accidentally release the mouse button prematurely, Elements closes the selection from the spot where you released the mouse button to the starting point. It isn't a disaster — just an annoyance. You have to either start over or add to your existing selection. See "Modifying Your Selection," later in this chapter.

 Note that for all three of the Lasso tools, you find the same Feather and Anti-alias options on the Options bar. For details on these two settings, see "Apply Marquee Options," earlier in this chapter.

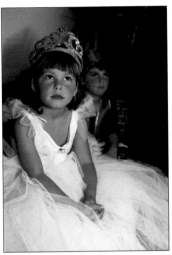

Figure 9-13: To select an object, trace around it with the Lasso tool
Corbis Digital Stock

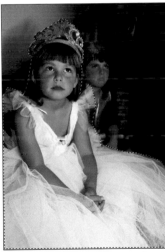

Figure 9-14: Releasing the mouse button results in a selection outline
Corbis Digital Stock

Select with the Quick Selection Tool

1. Select the Quick Selection tool from the Tools panel. It looks like a pencil with a dotted oval and shares a fly-out menu with the Selection Brush tool. Or, press the A key; if the Quick Selection tool isn't visible, press Shift+A.

2. Specify your Quick Selection tool options on the Options bar:

 • **New Selection mode:** Click the first icon to create a new selection.

 • **Brush Picker:** Specify your brush settings. Specify a diameter (from 1 to 2500 pixels), hardness, spacing, angle, and roundness. Hardness ranges from 1 to 100 percent; for a brush with softer edges, enter a lower value. Spacing sets the distance between the individual brush marks in a stroke.

 • **All Layers:** Select this option to make a selection from all the layers. If this option is unselected, you select from only the active layer.

 • **Auto-Enhance:** Select this option to automatically refine your selection by using an enhancement algorithm. Elements tries to reduce jaggedness in your selection edges.

3. Drag over some areas of the image to grow your selection. If you stop dragging and click in another portion of the image, your selection includes the area you clicked, as shown in Figure 9-15. To add or delete from the selection, see "Modify Selections," later in this chapter.

4. To refine your selection, click the Refine Edge option on the Options bar and change any settings you want. Settings are described earlier in this chapter, in the section "Wrangle Pixels with the Magic Wand." Figure 9-16 shows the completed selection.

 Note that the Selection Brush works in either Full Edit or Quick Edit mode.

Figure 9-15: Brush or click with the Quick Selection tool
Digital Vision

Figure 9-16: Select your object with speed with the Quick Selection tool
Digital Vision

Use the Cookie Cutter

1. Choose the Cookie Cutter tool from the Tools panel. The tool looks like a star-shaped cookie cutter. You can also press the Q key to access it.

2. Specify your options on the Options bar:

 - **Shape:** Choose a shape from the preset library. To access other preset libraries, click the panel pop-up menu and choose from the submenu.

 - **Shape Options:** Draw a shape with some geometric definitions. Draw freely with *Unconstrained,* or use *Defined Proportions* to keep the height and width proportional. *Defined Size* crops the image to the original size of the shape you choose. *Fixed Size* lets you enter width and height values. Select *From Center* to draw from the center outward.

 - **Feather:** This option creates a soft-edged selection. For details, see "Apply Marquee Options," earlier in this chapter.

 - **Crop:** Click to crop the image into the shape. See an image cropped to a snowflake shape in Figure 9-17.

3. Drag the mouse cursor on the image to create the shape you want.

4. Size the shape by dragging a handle on the bounding box, as shown in Figure 9-18. To move the shape, place the mouse cursor inside the bounding box and drag.

5. After the shape is to your liking, press Enter or click the Commit button right outside your bounding box, as shown in Figure 9-18. If you change your mind about creating a shape, press the Cancel button outside of your bounding box, or press the Esc key.

Figure 9-17: Crop your selections into interesting shapes with the Cookie Cutter tool
Corbis Digital Stock

Figure 9-18: Size your Cookie Cutter shapes by dragging a handle
Corbis Digital Stock

Eliminate with the Eraser

1. Choose the Eraser tool from the Tools panel. The tool looks like an analog eraser and shares a fly-out menu with the Background Eraser and Magic Eraser tools. You can also press the E key to access the tool. If the Eraser tool isn't visible, press Shift+E.

2. Specify your options on the Options bar:

 - **Brush Presets:** Choose a brush from the drop-down panel. You can access additional preset libraries from the Brushes pop-up menu.

 - **Size:** Click the downward-pointing arrow to access the Size slider. Drag the slider and specify a size from 1 to 2500 pixels.

 - **Mode:** Select from Brush, Pencil, and Block modes. The Brush and Pencil modes enable you to select any brush preset. Block mode is restricted to a 16-x-6-pixel tip and also doesn't have an Opacity option.

 - **Opacity:** Choose an opacity percentage of 1 to 100 percent for erased areas. The higher the opacity percentage, the more it erases.

3. In the image, drag over the areas you want to delete, as shown in Figure 9-19. Because the Eraser tool isn't the most accurate tool for selecting, use the Zoom tool (the magnifying glass) to move in close for a better view. Click on or drag around the areas you want to view more closely. To zoom out, press the Alt key (or Option key on a Mac) and click.

Figure 9-19: Erase unwanted areas in an image
Corbis Digital Stock

Keep in mind when you erase that if your image contains just a background, you erase to the background color. If your image is on a layer, when you erase, you're erasing to transparency. This statement is true for the Eraser, Background Eraser, and Magic Eraser tools. For more on backgrounds and layers, see Chapter 10.

Pluck Out an Element with Magic Extractor

1. From the menu bar, choose Image➪Magic Extractor.

2. In the Magic Extractor dialog box, select the Foreground Brush tool (the highlighter with a plus-sign on it) and click or drag to designate the foreground area, or the area you want to select. You can change the size of the brush tip, from 1 to 100 pixels, in the Tool Options area on the right side of the dialog box. To change the color of the foreground (red) and background (blue), click the swatch and choose a new color from the Color Picker.

3. If needed, select the Zoom tool to help magnify your image. Click on the image to zoom in. Press the Alt key (or the Option key on a Mac) and click to zoom out.

4. To move around the image after you zoom in, select the Hand tool and drag on the image.

5. Select the Background Brush tool (the highlighter with a minus sign on it) and click or drag to designate the background area or the area you don't want to select, as shown in Figure 9-20.

6. Click Preview to view the extraction. You can change the preview by choosing either Selection Area or Original Photo from the Display drop-down list.

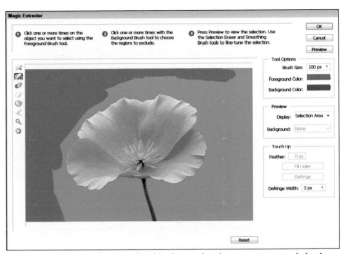

Figure 9-20: Select a foreground and background in the Magic Extractor dialog box
Corbis Digital Stock

You can see your selection against a different background, such as black matte, by choosing one from the Background drop-down list.

7. If you aren't happy with the extraction, you can refine it by taking one or more of these actions:

 - **To erase the designated foreground or background areas:** Select the Point Eraser tool and click or drag over the area.

 - **To add to the selected area:** Click or drag with the Add to Selection tool (the brush-with-marquee icon).

 - **To delete areas from the selected area:** Click or drag with the Remove from Selection tool (the eraser-with-marquee icon).

 - **To smooth the edges of your foreground selection:** Drag over the edges with the Smoothing Brush tool (the brush with the squiggly line).

 - **To soften the edges of your selection:** Enter a value in the Feather box. The higher the value, the softer the edge.

 - **To fill a hole:** Click the Fill Holes button.

 - **To remove the fringe of pixels between the foreground and background areas:** Click Defringe and enter a value in the Defringe Width box.

8. When you're satisfied with the extraction, as shown in Figure 9-21, click OK. If you want to start over, click the Reset button.

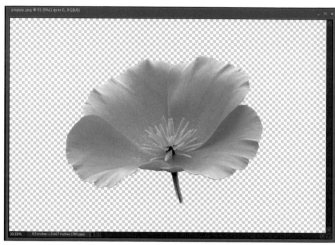

Figure 9-21: A selection created with the Magic Extractor
Corbis Digital Stock

Delete with the Background Eraser

1. Choose the Background Eraser tool from the Tools panel. The tool looks like an eraser with scissors and shares a fly-out menu with the Eraser and Magic Eraser tools. You can also press the E key to access the tool. If the Eraser tool isn't visible, press Shift+E.

2. Specify your options on the Options bar:

 - **Brush Preset picker:** Specify settings to customize the size and appearance of your brush. The size and tolerance settings are for pressure-sensitive drawing tablets.

 - **Limits:** If this option is set to Contiguous, the Eraser erases all similarly colored pixels that are adjacent to each other. If the option is set to Discontiguous, the Eraser erases all similarly colored pixels throughout the image, regardless of adjacency.

 - **Tolerance:** The tolerance value specifies how similar the colors have to be to the base color (the color of the pixel directly below the hotspot) before the Background Eraser erases them. A higher tolerance erases more colors. For more on tolerance, see the earlier section "Wrangle Pixels with the Magic Wand."

3. In your image, drag over the background area you want to delete, as shown in Figure 9-22. Try to avoid touching the foreground elements with the crosshair in the Background Eraser cursor.

Figure 9-22: Delete an image's background with the Background Eraser tool
Corbis Digital Stock

The Background Eraser attempts to erase the background while leaving the foreground untouched. To produce the best results from this tool, be careful to keep the hotspot (the cursor crosshair) on the background pixels and away from any foreground elements. This tool is also best used with images that have a definitive foreground and background with good contrast between the two. A smooth edge without a lot of detail also helps.

The Magic Eraser tool, which shares the flyout menu with the other Eraser tools, is a hybrid of the Eraser tool and the Magic Wand. It attempts to select *and* erase similarly colored pixels at the same time. Select the tool and click the unwanted areas of your image. Options for the Magic Eraser are similar to the two other Eraser tools, with the exception of two unique settings: Anti-alias creates a softened edge by one pixel, and the All Layers option enables you to sample colors using all visible layers but erases pixels on only the active layer.

Modify Selections

1. In an image, add to an existing selection by using the following tools:

 - **Marquee or Lasso:** Press the Shift key while dragging around the image areas you want. Return to the starting point and click to complete the selection.

 - **Polygonal Lasso:** Press the Shift key while clicking around image areas. Return to the starting point and click to complete the selection.

 - **Magnetic Lasso:** Press the Shift key while clicking once and then moving the mouse around the image areas. Return to the starting point and click to complete the selection.

 - **Magic Wand:** Press the Shift key and click some image areas. Continue to do so until you're satisfied with your selection.

 - **Selection Brush:** With the mode set to Selection, press the Shift key while brushing over your selection. Continue until you're satisfied with your selection.

 - **Quick Selection:** Make sure that the Add to Selection Mode icon is selected on the Options bar. Drag over the additional image area, as shown in Figure 9-23. Continue until you're satisfied with your selection.

2. To delete from an existing selection, follow the steps above, but press the Alt key (or the Option key on a Mac) rather than the Shift key. For the Quick Selection Brush, select the Subtract from Selection Mode icon on the Options bar.

3. To intersect with an existing selection, repeat Step 1 while pressing Alt+Shift (or Option+Shift on a Mac). You cannot create an intersected selection with the Selection Brush and the Quick Selection tool.

Figure 9-23: Clean up selections by adding or deleting from your existing selection
Corbis Digital Stock

 You can also use the four selection option buttons on the left side of the Options bar to create a new selection (the default), add to a selection, subtract from a selection, or intersect one selection with another. Just choose a selection tool, click the selection option button you want, and drag (or click if you're using the Magic Wand or Polygonal Lasso tool). The Add to Selection and Subtract from Selection buttons are also available when you're using the Selection Brush. Add to Selection and Subtract from Selection modes are available with the Quick Selection tool.

 You don't have to use the same tool to add to or delete from your selection as you used to create the original selection. Any selection tool is up for grabs. Use the one that makes the most sense for what you're trying to select.

 You can find more selection commands, such as All or Inverse, under the Select menu.

Transform Selections

1. With a selection created in an open image, choose Image➪Transform.

2. Choose a transformation option from the submenu:

 • **Free Transform:** Scales and rotates your selection

 • **Skew:** Skews a selection across a horizontal or vertical axis

 • **Distort:** Distorts the selection in any direction

 • **Perspective:** Adjusts the 1-point perspective of a selection

3. After you select an option, a transform box appears with handles at its sides and corners, as shown in Figure 9-24. Drag the handles to transform the selection. If you selected Free Transform and want to scale your selection proportionally, press the Shift key while dragging. If you selected Free Transform and want to rotate your selection, move the mouse cursor to a corner until you see a curved-arrow icon. Drag clockwise or counterclockwise to rotate.

 If you right-click when the transform box surrounds your selection, you open a context menu that includes the Scale, Free Rotate, Skew, Distort, and Perspective commands. Feel free to choose any of these commands during the transformation process.

4. After you satisfactorily transform your selection, double-click inside the transform box or press the Enter key. If you want to cancel the transformation, press the Esc key.

Figure 9-24: Transform the selection by dragging the transform box handles
Corbis Digital Stock

 You can also choose Image➪Rotate and Image➪Resize to either rotate or size your image smaller or larger.

 You can also transform a layer or even multiple layers. See Chapter 10 for details.

Paste into a Selection

1. Make a selection in your source image.

2. Choose Edit⇨Copy.

3. In your destination image, make the selection that will "contain" your source selection, as shown in Figure 9-25.

4. Choose Edit⇨Paste into Selection Elements to convert the selection outline into a layer mask. The pasted selection is visible only inside the selection outline, or in the white areas of the mask, as shown in Figure 9-26.

 A layer mask essentially hovers over an image layer and lets you selectively show, hide, or partially hide portions of the layer. On a mask, the color white allows the image to show through, black hides the image, and gray partially hides or shows the image.

Figure 9-25: Make a selection in both a source and destination image.
www.sxc.hu

Figure 9-26: Use the Paste into Selection to make it appear as though an element is coming out of another.
www.sxc.hu

Save and Load Selections

1. After spending your precious time making the perfect selection, you may want to save it for later use. If so, choose Select➪Save Selection.

2. In the Save Selection dialog box, shown in Figure 9-27, leave the Selection option set to New and enter a name. Click OK.

3. To load your selection later, choose Select➪Load Selection and choose an item from the Selection drop-down list. When you save your file, the selection is saved as well.

 To invert your selection, click the Invert box. You also have options to add to, subtract from, or intersect with your selection. Use these options if you want to modify a previously saved selection with a new one.

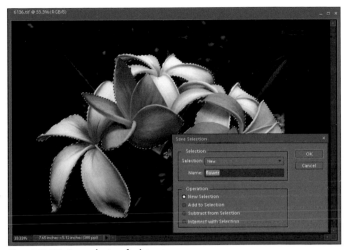

Figure 9-27: Save selections for later use.
PhotoDisc

Using Layers

Using layers is like cooking a meal in a fully equipped kitchen: Sure, you could do it over a hotplate if you had to, but having modern conveniences, like a stove and an oven, make the process a whole lot easier, quite a bit faster, and much more enjoyable. The benefits of using layers are huge because they give you a ton of added editing flexibility. Layers enable you to do things such as adjust the transparency of an image or apply a special effect, like a layer style or blend mode. (Both topics are covered in Chapter 11). They also let you easily combine multiple images and move and edit them independently of one another. Finally, layers help you experiment more comfortably with various tools and techniques. Duplicate a layer in your image and try out a tool or technique. If you don't like it, just delete that layer and you're back to square one. No harm, no foul.

This chapter gives you the bare basics of working with layers. You'll find more involved techniques using layers within some of the other chapters in this book. To work with layers, be sure that you're in Elements' Editor workspace in Full Edit mode. Note that the steps in this chapter assume that you have an image open and ready to go.

Chapter 10

Get ready to . . .

Get Familiar with the Layers Panel

1. Choose Window⇨Layers to display the Layers panel, shown in Figure 10-1. The Layers panel controls the use of layers. If your image doesn't yet have layers, you may see only a background in the Layers panel.

2. Note the anatomy of the Layers panel:

 - **Layers:** The order of layers in the panel reflects the order of the layers in the image, with the topmost layer at the top of the list, and the background at the bottom of the stack, as shown in Figure 10-1. This is the *stacking order*. You can work on a single layer or multiple layers at a time. Select a layer by clicking the layer name or its thumbnail. Select multiple layers by Ctrl+clicking (or Control+clicking on the Mac).

 - **Blend Modes:** These modes affect the interaction of the colors in the layers. Normal is selected in Figure 10-1. For more information about blend modes, see Chapter 11.

 - **Opacity:** Opacity affects how opaque or transparent a layer is, in percentages from 0 to 100 percent. In Figure 10-1, 100% is selected. For more information about opacity, see Chapter 11.

 - **Icons:** Click the small icons at the top of the panel to create a new layer, create an adjustment layer, delete a layer, link a layer, lock transparency, or lock all layers. Locking all prevents you from editing or moving the layer. All these commands are covered in this chapter, except adjustment layers, discussed in Chapter 8.

 - **Pop-up Menu:** Click the right-pointing triangle labeled *more* to open a submenu of layer commands. These commands are also on the Layer menu in the Menu bar.

 - **Show/Hide Column:** Click the eye icon to show and hide layers.

Figure 10-1: The Layers panel controls the use of layers

Convert a Background into a Layer

1. Choose Window⟐Layers to display the Layers panel.

2. Double-click Background in the Layers panel, as shown in Figure 10-2; or, in the Menu bar, choose Layer⟐New⟐ Layer from Background.

3. Name the layer or leave it with the default name Layer 0. You can also specify additional layer options, such as Blend mode and opacity, if you want. Blend modes and opacity are described in detail in Chapter 11.

4. Click OK, and the background is converted into a layer, as shown in Figure 10-3.

When you open a photo taken with a digital camera, open a file from a CD, acquire a scan, download a stock image, or create a new file with the Background Contents option set to White or Background Color, you have a file with just a background. An image contains only one background. You don't have all the editing tools and commands available for backgrounds, so you should convert the background to a layer.

Layers created from images, including backgrounds, are *image* layers. A *shape* layer contains a vector-based object (mathematically defined by points and paths), such as a polygon created by the Shape tools. *Fill* layers enable you to add a layer of color, gradient, or pattern. *Type* layers contain type. Find out more about type layers in Chapter 11. *Adjustment* layers are special layers used for color and contrast correction. For more information about them, see Chapter 8.

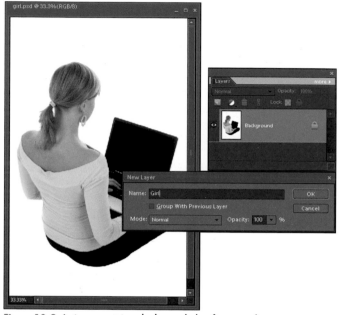

Figure 10-2: An image contains a background when first opened
www.istockphoto.com

Figure 10-3: Convert a background into a layer for editing flexibility

Create a New Layer

1. Choose Window⇨Layers to display the Layers panel.

2. Do one of the following:

 - Select the Create a New Layer icon, the leftmost icon at the top of the Layers panel, as shown in Figure 10-4.

 - Choose New Layer from the Layers panel pop-up menu.

 - Choose Layer⇨New⇨Layer from the menu bar.

3. If you create a layer by using either menu command, name the layer and set options in the dialog box. You can name a layer and specify blending and opacity options. See Chapter 11 for more on blend modes and opacity.

4. Click OK. Your newly created blank layer appears.

 Think of blank layers as digital sheets of acetate. You can put photos, graphics, or type on blank layers. Any area without a photo, graphic, or type is transparent, just like acetate is. Transparency in Elements is indicated on-screen by a gray and-white checkerboard pattern. You can stack layers on top of each other to create a combined image, rearrange their order, and add or delete layers.

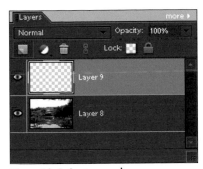

Figure 10-4: Create a new layer

 After you create layers, you may want to select them. To do so, simply click the layer name or thumbnail in the Layers panel. Elements then highlights the active layer in the Layers panel. To select multiple contiguous layers, click the first layer and then Shift+click the last layer. To select multiple noncontiguous layers, Ctrl+click (or ⌘+click on the Mac) the layers you want.

Duplicate a Layer

1. In an open image, do one of the following:

 - Drag your chosen layer to the Create a New Layer icon at the top of the Layers panel. A new layer is created with the word *copy* appended to the layer name.

 - Choose Duplicate Layer from the panel's pop-up menu, as shown in Figure 10-5.

 - Choose Layer⇨Duplicate Layer.

2. If you choose one of the menu commands, name the layer and specify its destination (either a new document or any open image) in the Duplicate Layer dialog box. Click OK.

Copy or Cut to Create a Layer

1. Do one of the following:

 - To copy an entire layer, simply select that layer in the Layers panel.

 - To copy or cut part of a layer, make a selection on your layer or background. To create a new layer by cutting, you need a selection outline. (Chapter 9 explains selections.)

2. Choose Layer⇨New⇨Layer via Copy or Layer via Cut, as shown in Figure 10-6. Keep in mind that cutting removes the selection and leaves a "hole" in your image.

3. Elements creates a new layer and places the copied or cut pixels on that layer.

 Although some commands are exclusive, much of what you can do with the Layers panel icons you can also do by using the Layers panel pop-up menu and the Layers menu on the Menu bar. It doesn't matter which you choose; if you can't find what you're looking for in one area, go to another.

Figure 10-5: Duplicate an existing layer.

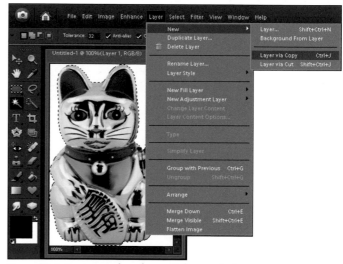

Figure 10-6: Create a new layer from copied or cut selections.
www.istockphoto.com

147

Drag and Drop a Layer between Two Files

1. In your first image, choose a layer in the Layers panel. Note that if you want to drag only a portion of the image, you must first make a selection. See Chapter 9 for more on selections.

2. Select the Move tool from the Tools panel.

3. Place the Move tool on your image and drag and drop the layer onto the second image, as shown in Figure 10-7, and release the mouse button. If you're dragging and dropping a selected portion of the layer, place the Move tool within the selection outline before dragging and dropping. You now have a composite image with two layers.

4. Repeat Step 3 as needed. A finished composite made from several images is shown in Figure 10-8.

 Dragging and dropping layers between files is more efficient than copying and pasting, because it bypasses the *Clipboard,* a temporary storage area on your computer for copied or cut data. This temporarily stored data uses computer memory, which can bog down your system performance.

Figure 10-7: Drag and drop layers between files
istockphoto.com

Figure 10-8: A multi-image composite

Select a Layer

1. Choose Window⇨Layers to display the Layers panel.

2. To select a layer, just click it in the Layers panel, as shown in Figure 10-9.

3. Or, choose Select from the Menu bar and select one of the following commands:

 - **Select All Layers:** Selects all layers in your file.

 - **Select Layers of Similar Type:** Selects all layers of a similar flavor, such as image layers, type layers, shape layers, or adjustment layers. First select a layer type and then choose the command.

Figure 10-9: Select the contents of a layer

Delete a Layer

1. In the Layers panel, select the layer you want to delete.

2. Drag the layer to the Trash icon at the top of the Layers panel, as shown in Figure 10-10. You can also just click the Trash icon. If you do so, click OK in the dialog box to delete the layer.

Figure 10-10: Delete unwanted layers

View and Hide Layers

1. To hide a layer, click the eye icon just to the left of the layer thumbnail in the Layers panel, as shown in Figure 10-11. When the layer is hidden, you see a blank box, not the eye.

2. To view the layer, click the blank box just to the left of the layer thumbnail in the Layers panel.

3. To hide all layers except one, select a layer and Alt+click (or Option+click on the Mac) the eye icon for that layer. Redisplay all layers by Alt+clicking (or Option+clicking on the Mac) the eye icon again.

 Note that only visible layers are printed, which can be helpful if you want to print separately the different versions of an image within the same file.

Figure 10-11: View and hide layers by clicking the eye icon in the Layers panel

Rearrange the Stacking Order of Layers

1. To move a layer to another position in the stacking order, drag it up or down in the Layers panel. As you drag, you see a fist icon, as shown in Figure 10-12.

2. Release the mouse button when a highlighted line appears where you want to insert the layer in the stack of layers. Remember that the topmost layer in the stack is the topmost layer in your image.

Figure 10-12: Rearrange the order of your layers

 If your image contains a background, that background must remain the bottommost layer. If you need to move the background, first convert it to a layer by double-clicking the name in the Layers panel. Enter a name for the layer and click OK.

Rename a Layer

1. Double-click the layer name in the Layers panel. The existing name is highlighted.

2. Type a name directly in the Layers panel, as shown in Figure 10-13. You can also double-click the layer thumbnail in the Layers panel. The Layers Properties dialog box appears, enabling you to type a new name. Click OK.

 Note that, in Elements, when you create a new layer from scratch, it provides that layer with default names, such as Layer 1 and Layer 2. Get into the habit of giving your layers more descriptive names, especially if you plan on having several layers, so that you can more easily locate the layer you want later.

Figure 10-13: Rename your layers

Link Layers

1. In the Layers panel, click the first layer and then Ctrl+click (or ⌘+click on the Mac) all the other layers you want to link.

2. Click the Link Layers icon at the top of the Layers panel. A link icon (it looks like a chain) appears to the right of the layer name, as shown in Figure 10-14.

3. To unlink any layers, select some layers and then click the Link Layers icon again.

 You don't need to link layers to perform commands such as moving or sizing several layers simultaneously. Merely selecting them and then applying your transformation works just fine. But if you want your layers to group together more securely, feel free to link and unlink as needed.

Figure 10-14: Link your layers to temporarily group them

Lock Layers

1. Select a layer in the Layers panel.

2. Lock the layer in one of these two ways:

 - **Lock transparency:** To lock the transparent areas of a layer, click the checkerboard icon at the top of the Layers panel, as shown in Figure 10-15. When the transparent areas are locked, you can't edit or paint on any of them on the layer.

 - **Lock all:** To lock everything on a layer, click the Lock icon at the top of the Layers panel. When all elements are locked, you can't alter the layer in any way, including moving or transforming it.

3. To unlock the layer, click the respective icon again.

 If you have a background in your image, it's locked by default. To unlock the background, you must convert it into a layer.

Select the Contents of a Layer

1. Choose Window➪Layers to display the Layers panel.

2. To merely select a layer, just click it in the Layers panel. However, if you want to place a selection outline around the contents of a layer, press the Ctrl key (or the ⌘ key on the Mac) and click the Layer thumbnail in the Layers panel. You then see a selection outline around all pixels on that layer, as shown in Figure 10-16.

 Use the Auto Select Layer option on the Options bar to interactively select the contents of a layer when you hover the mouse over any of the pixels. To have a highlighted outline appear around the layer contents, select the Show Highlight on Rollover option, also on the Options bar.

Figure 10-15: Lock the transparency of a layer

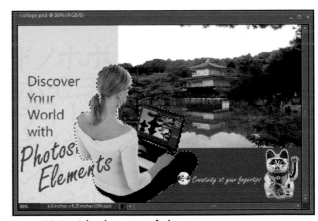

Figure 10-16: Select the contents of a layer
istockphoto.com

Transform a Layer

1. Select a layer, or layers, in the Layers panel. Choose Image➪Transform➪Free Transform. A bounding box appears around the layer contents.

2. Drag a corner handle to size the contents. Press Shift while dragging to constrain the proportions.

3. Move the cursor just outside a corner handle until it converts into a curved-arrow icon. Drag clockwise or counterclockwise to rotate, as shown in Figure 10-17.

4. To distort, skew, or apply perspective to the layer, right-click (or Control+click on the Mac) and choose a command from the context menu. Alternatively, you can click the rotate, scale, and skew icons or enter transformation values on the Options bar.

5. After you transform your layer, double-click inside the bounding box.

 Try to execute all transformations in one command! Each time you apply a transformation, you resample the image. (See Chapter 7 for more on resampling.) Repeated interpolation can degrade the image quality.

Adjust the Opacity of a Layer

1. Select a layer in the Layers panel.

2. At the top of the Layers panel, drag the Opacity slider to the left to reduce the percentage of opacity and increase the amount of transparency. Note that if you have a layer underneath the active layer, you see more of the underlying layer, as shown in Figure 10-18. If you don't have a layer underneath the active layer, you see the transparency checkerboard start to appear. The opacity percentage ranges from 0 to 100 percent.

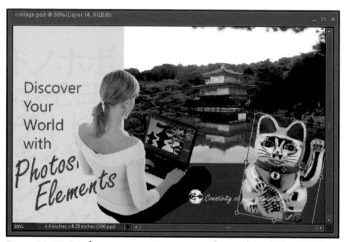

Figure 10-17: Transform your image in one command to avoid repeated interpolation
istockphoto.com

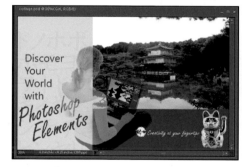

Figure 10-18: Reduce the amount of opacity on a layer to show more of the underlying layer
istockphoto.com

Simplify a Layer

1. Select a type, shape, or fill layer in the Layers panel.

2. Choose Simplify Layer from the Layers panel pop-up menu, as shown in Figure 10-19, or choose Layer⇨ Simplify Layer. The type, shape, or fill layer is converted into an image layer.

 To apply a filter or certain edits, such as painting, to type, shape, or fill layers, you must simplify them first. A shape layer contains a vector object (an object drawn with mathematical formulas indicated by points and paths). A fill layer contains solid color, a gradient, or a pattern. Type layers contain text.

Merge Layers

1. Click the eye icon to the left of the layer thumbnail to hide any layers that you don't want to merge.

2. Choose Merge Visible from the Layers panel pop-up menu, as shown in Figure 10-20. Note that you can also choose Layer⇨Merge Visible. All visible layers are combined into a single layer.

3. To merge two adjacent layers, select the topmost layer and choose Merge Down from the Layers panel pop-up menu or Layer menu. The topmost layer is merged with the layer directly below it.

4. If you make a mistake, immediately choose Edit⇨Undo. You can also use the Undo History panel.

 Merging combines layers on the basis of which ones are visible, which ones are linked, or which ones are adjacent. Although merging layers reduces the size of your file, be sure that you don't need the editing flexibility of separate layers. After you merge files, you can't "unmerge" them.

Figure 10-19: Simplify a type, shape, or fill layer into an image layer
istockphoto.com

Figure 10-20: Merge layers to combine multiple layers into one layer

Flatten Layers

1. Make sure that all layers you want to keep and flatten are visible. If you have any hidden layers, Elements asks whether you want to discard them.

2. Choose Flatten Image from the Layers panel pop-up menu, as shown in Figure 10-21. All layers are combined into a single background.

3. If you make a mistake, immediately choose Edit⇨Undo. You can also use the Undo History panel.

 Remember that flattening is permanent, so you should always keep your original file with the layers intact. That way, if you ever need to go back and make edits, you have the added editing flexibility of separate layers. Create a copy of your file and then choose File⇨Save As and select the As a Copy option. Flatten the copy while retaining your original.

Figure 10-21: Flatten multiple layers into a single layer

Adding Type, Blend Modes, Filters, and Effects

So you cleaned up your images: Your image has the perfect crop, inviting color, excellent contrast, sharp focus, and no flaws. Now what? Well, you can always share them with friends and loved ones and even with perfect strangers, if you want to. Often the simplest image is the best one and the one with the greatest impact. But if you feel inclined to add an embellishment or two first, this chapter is the place to do just that.

The tools and techniques described in this chapter enable you to add an enhancement, a special effect, or even just the written word. You may find — after experimenting with various blend modes, filters, effects, and types — that you like your image the way it was. That's fine. Just be sure to make a copy of the image, or at least the layer, before you wander away on other artistic endeavors.

Get ready to . . .

Add Type

1. In Full Edit mode, with an image open, select the Horizontal Type tool in the Tools panel. You can also press the T key to access the tool. If the tool isn't visible, press Shift+T.

2. Choose some type options on the Options bar, as shown in Figure 11-1:

 - From the Font Family menu, select a font from the submenu.

 - From the Font Style menu, choose a style, such as Bold or Italic.

 - From the Font Size menu, choose a point size from the submenu. If you don't see the size you want, simply type a value. You can choose a value from .01 to 1296 points. Or, you can visually size the type by dragging the handles of the bounding box. Be sure to press the Shift key when dragging so that you don't size the type disproportionately.

 - Choose whether to anti-alias the text. Remember that anti-aliasing adds one row of pixels for a softer edge. If you're creating small text for Web or screen display, you may not want to apply anti aliasing.

 - Choose a style, if you want. Styles include Faux Bold, Faux Italic, Underline, and Strikethrough. Keep in mind that you should always first choose real styles from the Font style drop-down list.

 - Choose a text-alignment method — left, centered, or right.

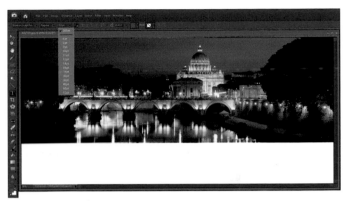

Figure 11-1: Specify your type options
Digital Vision

By default, all text is created as vector type, which provides scalable outlines that you can resize without creating jagged edges. Vector type is fully editable and always prints with excellent quality. You can also rasterize text. See "Simplify Text," later in this chapter.

To create vertical type, select the Vertical Type tool from the Tools panel. Follow Steps 2 through 5 in this step list.

- From the Leading menu, choose a leading value. *Leading* is the amount of space between the lines of text. If you don't see the size you want, type a value. Note that Auto Leading is 120 percent of the type point size.

- From the Text Color menu, choose a color for your text.

- Click the Create Warped Text button to distort the text. Choose a warp style from the Style drop-down list (either a horizontal or vertical warp). Adjust the settings for the bend and the horizontal and vertical distortions.

- Click the Text Orientation button to change the orientation from horizontal to vertical or vice versa.

3. Position the cursor in the image window. Click and then type some text, as shown in Figure 11-2.

4. Click the Commit arrow on the Options bar or press Enter on the keypad. Note that Elements automatically creates the text on its own type layer (see the Layers panel).

5. To reposition the text, select the Move tool from the Tools palette. Drag the text to a location within the image window.

Figure 11-2: Click with the Type tool and enter some text
Digital Vision

The text created by clicking and typing is referred to as *point* type. It's anchored by a single anchor point. To make type wrap, you must press the Enter key (or Return on the Mac). To create *paragraph* type, or type that stays contained within a bounding box, see "Create Paragraph Type," later in this chapter.

Edit Type

1. In Full Edit mode, with an image open, select the Horizontal Type tool in the Tools panel.

2. Highlight some text, as shown in Figure 11-3. Double-click with the tool within a word to select the entire word. Triple-click within any sentence to select all the type in the sentence. Finally, click anywhere within the text and press Ctrl+A (or ⌘+A on the Mac) to select all the type.

3. With the text highlighted, select a new setting in any of the options described earlier in this chapter, in the section "Add Type," as shown in Figure 11-4.

4. To delete text, highlight it and press the Backspace (or Delete on the Mac) key.

5. To add text, make an insertion point by clicking the tool within the line of text and then typing.

6. When you're done with your edits, click the Commit arrow on the Options bar or press Enter on the keypad.

Figure 11-3: Highlight the text for editing
istockphoto.com

Figure 11-4: Edit any of the text options
istockphoto.com

Create Paragraph Type

1. In Full Edit mode, with an image open, select the Horizontal Type tool in the Tools panel.

2. Choose your type options, as described in the earlier section "Add Type."

3. Position the cursor in the image window and click and drag a rectangle, referred to as a *bounding box*, as shown in Figure 11-5. You can also hold down the Alt key (the Option key on the Mac) and click on the image. In the Paragraph Text Size dialog box, enter the bounding box dimensions and click OK.

4. Type some text, as shown in Figure 11-6. Note that the text automatically wraps when it reaches the right boundary of the bounding box. If you type more text than can fit within the bounding box, an overflow icon appears. Resize the bounding box by positioning the tool over a handle and dragging accordingly.

5. Click the Commit arrow on the Options bar or press the Enter key.

6. To reposition the text, select the Move tool from the Tools palette. Drag the text to a location within the image window.

Figure 11-5: Create a bounding box for paragraph text
istockphoto.com

Figure 11-6: Type text within the bounding box
istockphoto.com

Simplify Type

1. In Full Edit mode, either open an image that contains type or create some type by following the steps in the earlier section "Add Type."

2. In the Layers panel, select a type layer. Make sure that the type is fully edited to your liking before simplifying.

3. Choose Layer➪Simplify Layer, as shown in Figure 11-7. The type is now rasterized and turned into uneditable pixels, as shown in Figure 11-8.

 When Elements converts vector type into pixels, the text is simplified, or rasterized. It is no longer editable but is converted into a raster image. Why would you want to simplify your text? Usually in order to apply filters to produce a special effect. Note that you can't resize simplified type without losing some quality.

Figure 11-7: Simplify the type layer
Purestock

Figure 11-8: Convert type into pixels
Purestock

Create a Type Mask

1. In Full Edit mode, with an image open, select the Horizontal Type Mask tool in the Tools panel.

2. Choose your type options, as described in the earlier section "Add Type."

3. Position the cursor in the image window. Click and type some text, as shown in Figure 11-9.

4. Click the Commit arrow on the Options bar or press Enter on the keypad. Note that the text is indicated by a selection outline.

5. Select any selection tool and move the selection to the position you want.

6. To fill the selection outline with the underlying image, choose Layer➪New➪Layer via Copy.

7. In the Layers panel, click the eye icon on the background to hide that layer. You should see your type filled with your chosen image, as shown in Figure 11-10.

 The Type Mask tools, both Horizontal and Vertical, don't create actual type. They create selection outlines in the shape of your letters. After they're created, you can treat them like any other selection outline. See more on selections in Chapter 9.

 Be forewarned that the Type Mask tools put the selection outlines on the active layer. Elements doesn't automatically create a new layer, as it does with actual type.

Figure 11-9: Create a type mask
Corbis Digital Stock

Figure 11-10: Fill the type mask with an image
Corbis Digital Stock

Adjust Type Opacity

1. In Full Edit mode, with an image open, select the Horizontal Type tool in the Tools panel.

2. Select a type layer in the Layers panel. If you want only some of your text adjusted, highlight some text with the Horizontal Type tool.

3. In the Layers panel, drag the Opacity slider to the percentage you want, as shown in Figure 11-11. Figure 11-12 shows text with various percentages of opacity.

Figure 11-11: Adjust the text opacity setting
Digital Vision

Figure 11-12: Text at various percentages of opacity
Digital Vision

Apply Text Effects

1. With an image open, in Full Edit mode, select a type layer in the Layers panel.

2. Choose Window⇨Content.

3. Select Text from the drop-down list in the upper-right corner of the panel.

4. In the Text panel, double-click a text effect such as a bevel, as shown in Figure 11-13, or drag the effect onto the type.

Figure 11-13: Apply an effect to text
Corbis Digital Stock

Mix with Blend Modes

1. Open an image with two or more layers in Full Edit mode.

2. Select a layer and select a blend mode from the drop-down list in the Layers panel. A brief description of some modes follows, but the best way to get a feel for the blend modes is to experiment. Figures 11-14 and 11-15 show examples of several blend modes.

 - **Normal:** Shows the pixels unadjusted in any way.

 - **Dissolve:** Enables some pixels from underlying layers to show through the selected or top (also referred to as *target*) layer. You must set the opacity of the target layer to less than 100 percent.

 - **Darken:** Makes lighter pixels become transparent if pixels on the target layer are lighter than those below.

 - **Multiply:** "Burns" the target layer onto underlying layers, darkening colors where they mix.

 - **Color Burn:** Darkens the layers below the target layer, again burning them with color. Using this mode is similar to applying a dark dye on your image.

 - **Color Dodge:** Lightens the pixels in underlying layers and applies colors from the target layer. Using this mode is similar to applying a bleach on your image.

 - **Soft Light:** Darkens pixels that are greater than 50 percent gray and lightens pixels that are less than 50 percent gray. Using this mode is similar to shining a soft spotlight on the image.

 - **Difference:** Produces a negative effect.

 - **Color:** Blends the luminance of underlying layers with the saturation and hue of the target layers. Use this mode for colorizing grayscale images.

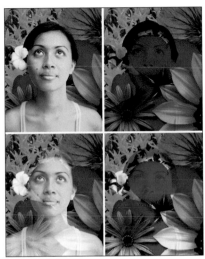

Figure 11-14: Normal, Multiply, Screen, and Overlay blend modes
Corbis Digital Stock

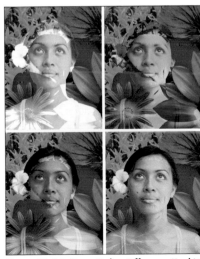

Figure 11-15: Linear Dodge, Difference, Hard Light, and Luminosity blend modes
Corbis Digital Stock

Apply Photo Effects

1. With an image open, in Full Edit mode, select a layer in the Layers panel. If your image has no layers, you can apply the effect to the background as well. Or, to apply an effect to just a portion of your image, make a selection first. (See Chapter 9 for more on selections.)

2. Choose Window⊅Effects.

3. Select the Photo Effects button at the top of the Effects panel.

4. Select a category of effects from the drop-down list in the upper-right corner of the Effects panel:

 • **Frame:** Enhances the edges of the layer or selection, as shown in Figure 11-16.

 • **Faded Photo, Old Photo, Monotone Color, and Vintage Photo:** These effects makes your image look faded, old, sketched with a pencil, colored with a single color, or printed on vintage paper (as shown in Figure 11-17).

 • **Miscellaneous Effects:** Includes a variety of effects, such as lizard skin, neon tubes, and oil pastel.

 • **Show All:** Shows all effects in the list.

5. In the Effects panel, double-click an effect or drag the effect onto the image. You can also apply a photo effect to a type layer. An alert box alerts you that the type layer must be simplified before the filter can be applied. See "Simplify Type," earlier in this chapter.

 Effects alter pixels to create special effects. You have no options to specify and, unfortunately, you cannot preview the effect before you apply it. Some effects automatically create a duplicate of the selected layer. Other effects can work only on flattened images. (See Chapter 10 for more on layers.)

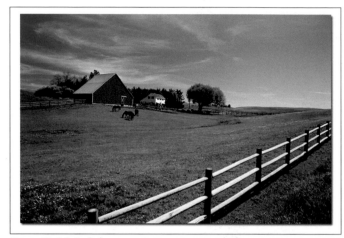
Figure 11-16: Apply frames to images
Corbis Digital Stock

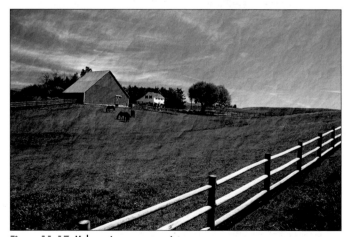
Figure 11-17: Make an image appear vintage
Corbis Digital Stock

Add Filters

1. With an image open, use any of the three methods that follow to apply a filter, and make a duplicate layer beforehand to preserve your original image:

 - In Full Edit or Quick Fix mode, choose Filter, a filter category, and then a specific filter.

 - In Full Edit mode, choose Window➪Effects to open the palette. Click the Filters button at the top of the panel. Select a category from the drop-down list in the upper-right corner. Double-click a filter's thumbnail.

 - In Full Edit or Quick Fix mode, choose Filter➪Filter Gallery to apply filters in an editing window.

2. One-step filters are automatically applied without options or dialog boxes. Multistep filters display a dialog box with options, as shown in Figure 11-18, which vary with each filter. If you're transported to the Filter Gallery, follow Steps 3 through 6.

3. In the center of the Filter Gallery, click a filter category and then select a filter. Specify options and check the preview.

4. To apply another filter, click the New Effect Layer button in the lower-right corner. Then choose a new filter.

5. To delete a filter, select it from the applied-filters list in the lower-right corner and click the Delete Effect Layer button. To edit filter settings, select it and make changes. To change the filter order, and thus the image's appearance, drag a filter up or down the list.

6. Click OK to apply the filter(s), as shown in Figure 11-19.

 Filters can improve image appearance or create special effects. You can apply filters to text, but remember to simplify the text first or else you can't apply a filter. You can't apply filters to Bitmap or Index Color mode, or sometimes to Grayscale mode.

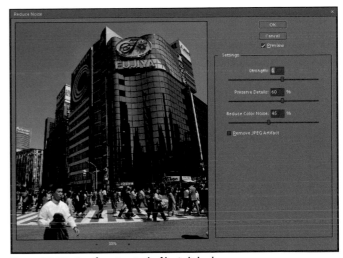

Figure 11-18: Specify options in the filter's dialog box
Corbis Digital Stock

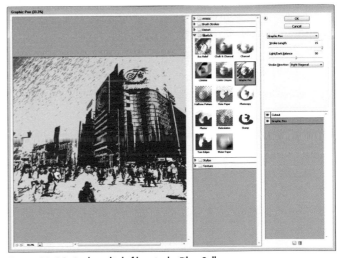

Figure 11-19: Apply multiple filters in the Filter Gallery
Corbis Digital Stock

Modify a Filter's Effects

1. To lessen the intensity of a filter, select your desired layer and choose Layer⇨Duplicate Layer. Click OK.

2. Apply the filter to the duplicated layer. If your image has multiple layers, you can apply the filter to only single layers.

3. Use the various blend modes and opacity settings in the Layers panel to combine the filtered and unfiltered image to your liking, as shown in Figure 11-20.

4. To apply a filter to just a portion of the image, make a selection on the image before applying the filter, as shown in Figure 11-21. See more on selections in Chapter 9.

Figure 11-20: Combine filtered and unfiltered layers
Corbis Digital Stock

Figure 11-21: Apply filters to selections only
Corbis Digital Stock

Use Liquify

1. In either Full Edit or Quick Fix mode, choose Filter⇨ Distort⇨Liquify. It's advisable to choose your selected layer and make a duplicate to preserve your original layer.

2. Choose a distortion or navigation tool, as described in the following list:

 • **Warp:** Pushes pixels forward as you drag, creating a stretched appearance, as shown in Figure 11-22.

 • **Turbulence:** Randomly jumbles pixels; can be used to create flames and waves. Use the Turbulent Jitter slider in the Tool Options area to adjust smoothness.

 • **Twirl Clockwise, Twirl Counterclockwise:** Place the cursor in one spot and hold down the mouse to rotate pixels clockwise or counterclockwise. You can also drag the cursor to create a moving twirl effect.

 • **Pucker:** Press and hold or drag to pinch the pixels toward the center of the area covered by the brush.

 • **Bloat:** Press and hold or drag to push pixels toward the edge of the brush area.

 • **Shift Pixels:** Move pixels to the left when you drag the tool straight up. Move pixels to the right when you drag down. Drag clockwise to increase the size of the object being distorted. Drag counterclockwise to decrease the size.

 • **Reflection:** Drag a reversed image of the pixels at a 90-degree angle to the motion of the brush. Hold down the Alt key (Option key on the Mac) to create a reflection in the direction opposite the motion of the brush.

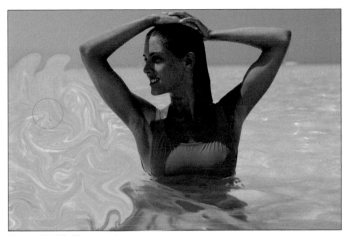

Figure 11-22: Warp your image
PhotoDisc

- **Zoom:** Click to zoom in. Press the Alt key (the Option key on the Mac) to zoom out. You can also zoom by selecting a magnification percentage from the pop-up list in the lower-left corner of the dialog box.

- **Hand:** Drag with the Hand tool to move the image around the window.

3. Specify your options in the Tool Options area:

- **Brush Size:** Drag the pop-up slider or enter a value from 1 to 600 pixels to specify the width of your brush.

- **Brush Pressure:** Drag the pop-up slider or enter a value from 1 to 100 to change the pressure. The higher the pressure, the faster the distortion effect is applied.

- **Turbulent Jitter:** Drag the pop-up slider or enter a value from 1 to 100 to adjust the smoothness when you're using the Turbulence tool.

- **Stylus Pressure:** Click this option to select the pressure of your stylus, if you're using one.

4. Select the Reconstruct tool and hold down or drag the mouse on the distorted areas of your image that you want to reverse or reconstruct, as shown in Figure 11-23. The reconstruction occurs faster at the center of the brush's diameter. To partially, or slowly, reconstruct your image, specify a lower brush pressure.

5. Click OK to apply the distortions. Or, click Revert to put the original image back again.

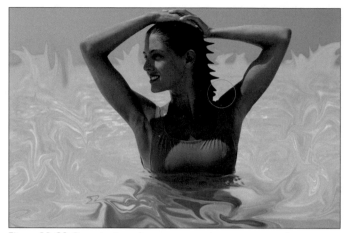

Figure 11-23: Reconstruct your image
PhotoDisc

Apply Layer Styles

1. In Full Edit mode, open an image with layers. If the image contains just a background, convert it to a layer by double-clicking Background in the Layers panel and clicking OK.

2. Select a layer in the Layers panel. You can also apply layer styles to a type layer.

3. Choose Window⇨Effects.

4. Select the Layer Styles button at the top of the Effects panel.

5. Select a library of styles from the drop-down list in the upper-right corner of the Effects panel:

 - **Bevels:** Adds a three-dimensional edge to the outside or inside edges of your layer, as shown in Figure 11-24. Emboss styles give either a raised or punched in appearance. Adjust lighting angle, distance, size, bevel direction, and opacity for your bevel.

 - **Drop and Inner Shadows:** Adds a soft drop or inner shadow around the edges of your layer, as shown in Figure 11-24. Keep shadows at their default setting or add noise, neon, or outlines. Adjust the lighting angle, distance, size, and opacity of shadows in your image.

 - **Outer and Inner Glows:** Adds a soft drop or inner halo around the edges of your layer. Adjust the lighting angle, size, and opacity of your shadows.

Figure 11-24: Applying a bevel and drop shadow layer style
Corbis Digital Stock

 Layer styles enhance an image and its text by adding elements such as shadows, bevels, glows, chrome, and plastic appearances. Unlike filters and effects, pixels are not permanently altered. You can edit layer styles or delete them if they're no longer needed.

- **Visibility:** Click Show, Hide, or Ghosted to either display, hide, or partially show (respectively) the layer contents. The layer style itself stays fully displayed.

- **Complex and others:** Adds a variety of special effects, such as buttons, neon, plastic, or chrome. The Batik layer style is shown in Figure 11-25. Adjust various settings to customize the style to your liking.

6. In the Layer Styles panel, double-click a style or drag the style onto the image. An *fx* symbol appears next to the layer name in the Layers panel.

7. To edit a layer style, double-click the *fx* symbol on the Layers panel or choose Layers⇨Layer Style⇨Style Settings. To delete the layer style, drag the *fx* symbol to the trash icon in the Layers panel or choose Layer⇨Layer Style⇨ Clear Layer Style.

Figure 11-25: A batik layer style applied at 50 percent opacity
Corbis Digital Stock

 You can apply multiple styles — one from each library — to a single layer.

 You can also copy and paste layer styles onto other layers, hide or show layer styles, and scale layer styles. All commands for these actions are on the Layer⇨Layer Style submenu.

Getting Creative with Compositions

Chapter 12

After you crop, correct, contrast, and clarify, you're ready for the last *c* word — creative. I mean, all work and no play makes digital image editing a dull boy. Although Elements gives you a multitude of tools for correcting, repairing, and enhancing, it also provides lots of opportunity for you to create interesting compositions — quickly and easily.

The techniques in this chapter are performed in Photoshop Elements. You can use the same techniques in Photoshop and most likely modify them for use in other digital image editing programs. And, remember: There's no substitute for opening some images and experimenting. Sometimes the most interesting creations are the ones you stumble upon through play.

Get ready to . . .

Make a New Color Photo Look Old

1. In Full Edit mode, with an image open (see Figure 12-1), choose Layer⇨Duplicate Layer to create a copy of the image. You can also choose Duplicate Layers from the Layers panel pop-up menu. Click OK.

2. On the duplicated layer, choose Filter⇨Noise⇨ Dust & Scratches.

3. Set the Radius value to 16 and the Threshold value to 8. Depending on the resolution of your image, you may need to adjust these values up or down. (Values of 16 and 8 were used in Figure 12-2.)

4. In the Layers panel, set the opacity of the duplicated layer to 50 percent.

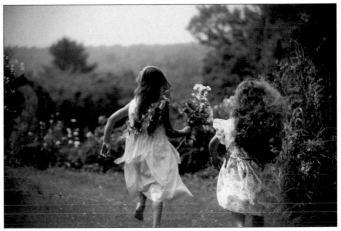

Figure 12-1: A color image, circa 2008
Corbis Digital Stock

 Another way to age photos is make them appear sepia toned. To see how, check out "Use Hue and Saturation" in Chapter 8.

5. On the duplicated layer, choose Enhance➪Adjust Color➪ Color Variations. Adjust the color for each tonal range as noted in the following list. Again, you may need to adjust higher or lower for your particular image. Your goal is to add red and greenish or yellowish tones for an antiqued appearance, as shown in Figure 12-2.

- **Shadows:** Move the Color Intensity slider to the right one notch to increase the increment of intensity. Click More Red two or three times. Click More Green one time. Move the Color Intensity slider back to the center. Click Darken once.

- **Midtones:** Make the same adjustments for midtones as you made for the shadows.

- **Highlights:** Click More Red one time. Click More Green one time. Click OK.

6. On the duplicated layer, choose Enhance➪Adjust Color➪ Color Curves. Drag the slider for the midtone contrast to the left until it's about halfway to the maximum. Drag the Adjust Shadows slider the same amount. Again, depending on the image, you may need to adjust the amount. Your goal is to increase the contrast in the middle and darker tonal ranges, as shown in Figure 12-2. Click OK.

7. Finally, on the duplicated layer, choose Enhance➪ Unsharp Mask. Set the Amount to 100, the Radius to 1, and the Threshold to 8. Click OK.

Figure 12-2: An image from yesteryear

 You can take the aging process one step further by adding a paper texture. Scan a wrinkled paper bag or find a stock image of aged paper or parchment. Drop and drag the image onto your antiqued photo. Choose Image➪Resize➪Scale and size the paper layer. In the Layers panel, set the blending mode to Overlay or Soft Light. Adjust the opacity on that layer however you want.

Combine Color and Grayscale Layers

1. In Full Edit mode, with a color image open, shown in Figure 12-3, convert the background into a layer by double-clicking it in the Layers panel. Name it **color** and click OK.

2. Choose Layer⇨Duplicate Layer to create a copy of the image. Name the duplicate **grayscale** and click OK.

3. On the grayscale layer, choose Enhance⇨Adjust Color⇨ Adjust Hue/Saturation. Drag the Saturation slider to the far left to desaturate the layer. Click OK.

4. Choose one of these techniques:

 - **Drag the color layer above the grayscale layer**. Select the Soft Light blend mode for a hand-tinted effect. For more color, try the Overlay blend mode with 50 percent opacity.

 - **Choose Layer⇨New⇨Layer or click the New Layer icon in the Layers panel.** Choose the Color blend mode. Select the Brush from the Tools panel, and choose a soft-tip brush from the Brush Preset drop-down panel. Click the Foreground color swatch in the Tools panel and choose a new color from the Color Picker. Paint on the first part of the image. Adjust the layer opacity. Repeat the process for other portions of the image, using separate layers for each color. For better accuracy, make selections before brushing on color. Figure 12-4 shows the tinted image.

 You can also convert a color image to grayscale by choosing Enhance⇨Convert to Black and White. Choose a preset style in the lower-left corner of the dialog box. Fine-tune the conversion by dragging the RGB sliders. Click OK when you like the results. Choosing Hue/Saturation and Convert to Black and White are better ways to convert to grayscale than choosing Image⇨Mode⇨ Grayscale, which can leave an image looking flat.

Figure 12-3: Create a soft, hand-tinted image automatically
Purestock

Figure 12-4: Manually tint an image
Purestock

Produce an Angelic Glow

1. In Full Edit mode, with an image open (see Figure 12-5), choose Layer⇨Duplicate Layer to create a copy of the image. You can also choose Duplicate Layers from the Layers panel pop-up menu. Click OK.

2. On that duplicated layer, choose Filter⇨Blur⇨Gaussian Blur.

3. Move the Radius slider to create a softened effect on the duplicated layer. Specify a moderate amount of blurring. In Figure 12-6, a radius of 3 was used.

4. On that duplicated layer, choose the Lighten blend mode from the Modes drop-down list in the Layers panel. The Lighten blend mode works by comparing the two layers and replacing the darker pixels with lighter ones. Light pixels are left unchanged.

5. Adjust the Opacity slider in the Layers panel to reduce the amount of glow, if you want.

 This effect works nicely with portraits.

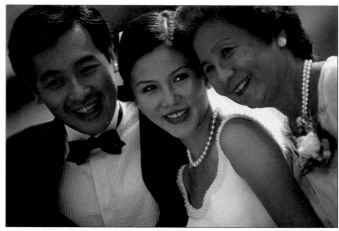

Figure 12-5: Open an image in need of softening
Purestock

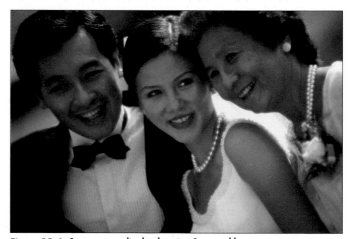

Figure 12-6: Create an angelic glow by using Gaussian blur
Purestock

Construct a Panorama

1. In Full Edit mode, choose File⇨New⇨Photomerge Panorama. In the dialog box, select your original source files. Choose From Files or From a Folder from the Use drop-down list.

2. Click Add Open Files to use all open files or click Browse and navigate to your files or folder.

3. Choose a merge mode in the Layout area:

 - **Auto:** Elements automatically merges the source files.

 - **Perspective:** For images with perspective (or angle).

 - **Cylindrical:** For images shot with a wide-angle lens or 360-degree panoramic images.

 - **Reposition Only:** Elements repositions images without compensating for any distortion.

 If you choose any of the preceding modes, Elements opens and automatically stitches together the source files to create a composite panorama in the work area of the dialog box. If Elements alerts you that it can't make the panorama, you then have to stitch the images manually. If you choose any of these modes, skip to Step 6.

 - **Interactive Layout:** Elements tries to stitch the images, but you may have to complete the panorama manually.

4. If needed, adjust images manually, as shown in Figure 12-7. Use the Select Image tool to drag the image thumbnails from the light box area to the work area. Use the Rotate Image tool to rotate the thumbnails. Check the Snap to Image option so that overlapping images snap into place automatically. The Zoom, Move View, and the Navigator view box help you view and navigate.

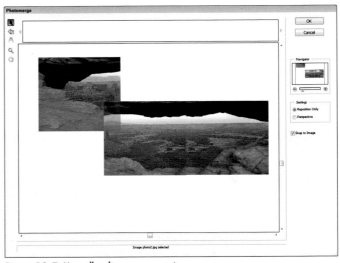

Figure 12-7: Manually adjust your source images
PhotoDisc

5. To adjust the vanishing point, select the Perspective option in the Settings area. Click the image with the Set Vanishing Point tool. Elements adjusts the perspective of the panorama. By default, the center image is chosen as the vanishing point. Adjust the other images as needed.

6. Click OK to apply the photomerge and close the dialog box. Elements opens a new image in the native Photoshop Elements file format, shown in Figure 12-8.

Figure 12-8: A panorama image created by the Photomerge command
PhotoDisc

 To construct the best combined panoramic image, start with the best original photos. Make sure that when you shoot, you overlap your shots by 15 to 40 percent. Next, try to avoid using distortion lenses and your camera's zoom setting. Then try to keep the same exposure settings for all shots. Finally, try to stay, at minimum, in the same position and keep your camera at the same level for all photos. The best method is to use a tripod with a rotating head.

Create High-Contrast or Posterized Art

1. In Full Edit mode, with an image open, choose Filter⇨ Adjustments⇨Posterize. The Posterize command reduces the number of colors in an image.

2. In the dialog box, select the Preview option to view the results. Specify the number of levels you want. Choose between 2 and 255 colors. Lower values, such as 2 through 8, create an illustrative look, as shown in Figure 12-9 (which uses a value of 3). Higher values create a more realistic appearance. If you posterize a grayscale image and use two levels, you achieve a high-contrast, line art feel, as shown in Figure 12-10.

3. Click OK.

 Posterize is one of the Elements color mappers, which change the colors of your image by mapping them to other values. All mappers, including Posterize, are on the Filter⇨Adjustments submenu, including Equalize (darkest and lightest pixels are black or white, and the rest are redistributed to gray), Gradient Map (maps colors to a gradient), Invert (reverses colors), and Threshold (all pixels are either black or white). Open an image and give these options a try.

Figure 12-9: A low Posterize value creates an illustrative look
Purestock

Figure 12-10: A two-level posterized grayscale image
Purestock

Photomerge a Group Shot

1. In Full Edit or Quick Fix mode, choose two or more photos from the Photo Bin.

2. Choose File➪New➪Photomerge Group Shot.

3. Take your best group shot and drag it to the Final window.

4. Click one other photo to use as the source image.

5. With the Pencil tool, draw a line around the parts of the source image you want to merge into your final photo, as shown in Figure 12-11. You can choose to show the pencil strokes or regions, which are highlighted with a blue overlay.

6. Repeat Steps 4 and 5 on any remaining photos.

7. To further align the photos, use the Alignment tool, click the source image, and position the three target markers on the three key locations. Then position the three target markers on the three key locations on the final image.

8. Click the Align Photos button. If the image doesn't look satisfactory, click Reset. If you're happy with the result, click Done. A photomerged group shot appears in Figure 12-12.

 The Photomerge Group Shot command enables you to composite the best group shot from several photos where one or more of the subjects' has their eyes closed or has some other flaw.

 As with merged panorama images, the better the source images for the perfect group shot, the better the merged image looks. Try to take shots that are similar in framing, size, and exposure.

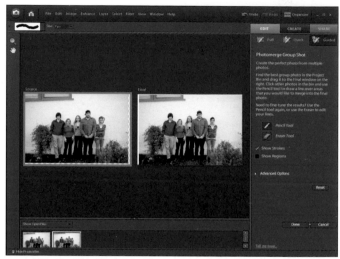

Figure 12-11: Select the elements that you want to merge into the group shot

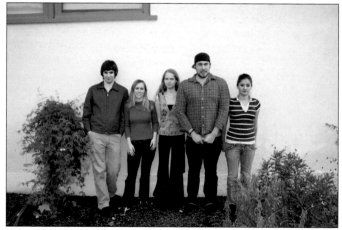

Figure 12-12: Merge two or more shots into one perfect group shot

Create a Photomerge Faces Image

1. In Full Edit or Quick Fix mode, select two or more photos from the Photo Bin.

2. Choose File➪New➪Photomerge Faces. You then move into Guided mode.

3. Choose the face you want to be the starting image, and drag it from the Photo Bin into the Final window.

4. Click one other photo in the Photo Bin to use as the source image.

5. With the Alignment tool, click the source image and position the three target markers on the eyes and mouth of the face. Then do the same on the final image.

6. Click the Align Photos button to better size the images to match and align features.

7. Use the Pencil tool to draw a line around the features of the source photo you want to merge into the final photo, as shown in Figure 12-13. You can choose to show the pencil strokes or regions, which are highlighted with a blue overlay.

8. If you're happy with the results, click Done. If you want to start over, click Reset. A shot of two photomerged faces appears in Figure 12-14.

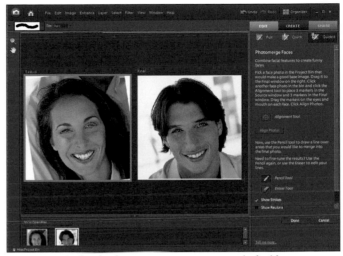

Figure 12-13: Select the elements you want to merge into the final face
Digital Vision

As with merged panorama and merged group-shot images, the better the source images are, the better the merged image looks. Try to take shots that are similar in framing, orientation, size, and exposure.

Just for fun, merge your face with your spouse's face to see what your offspring may look like.

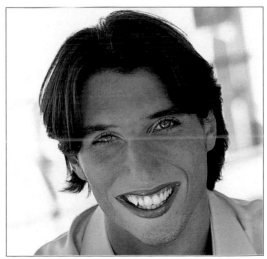

Figure 12-14: Merge two or more images into one new face
Digital Vision

Part III
Managing and Sharing Your Photos

The 5th Wave By Rich Tennant

"If I'm not gaining weight, then why does this digital image take up 3 MB more memory than a comparable one taken six months ago?"

Organizing and Managing Your Images

1 don't know about you, but I have boxes of photos begging to be put into photo albums or at least labeled and organized into some semblance of a grouping. But somehow this task never seems to even come close to the top of my to-do list. Fortunately, the task of organizing digital photos has been made less labor intensive with the creation of digital asset-management software programs.

Digital assets can include anything from digital photos to video or audio files to PDF files. Several programs are out there, from the simple and inexpensive to the more complex and costly. Many cameras come with their own basic proprietary programs. Some of the more popular third-party programs are Canto Cumulus, Extensis Portfolio, Microsoft Expression Media, Adobe Lightroom, and Apple's Aperture. If you're an Elements user, however, you don't need a stand-alone program. In addition to being a great image editor, Elements provides the Organizer, a workspace that takes care of your photo-management needs. The Organizer is found only in the Windows version of Elements, however. If you're a Mac user, you can use Adobe Bridge or iPhoto to manage your assets. Because I can't cover all existing software flavors in this chapter, I give you the basics of using Elements for your photo organization and management. I recommend jumping on the organization bandwagon from the get-go. That way, you're sure to avoid the digital version of the anonymous bulging shoebox.

Get ready to . . .

Open the Elements Organizer

1. Launch Elements. At the Welcome screen, click Organize, as shown in Figure 13-1. If you're already in Elements, in the Editor, click the Organize tab in the upper-right corner.

2. The Organizer workspace opens, as shown in Figure 13-2. *The Organizer* is the workspace within Elements where you can locate, import, organize, sort, search for, and manage your photos. If you have already added images to the Organizer, they appear in the window, referred to as the *Photo Browser.*

3. If you want to go to, or return to, the Editor workspace, click the Editor tab in the upper-right corner and choose a mode — Full Edit, Quick Edit, or Guided Edit.

 Adobe Elements uses two main workspaces: the Editor and the Organizer. For retouching and manipulation, you use the Editor. For importing, viewing, finding, sorting, and managing photos, you use the Organizer. You find the Organizer only in the Windows version of Elements. The Mac version of Elements uses Adobe Bridge to organize and manage digital assets.

Figure 13-1: Click Organize at the Welcome screen

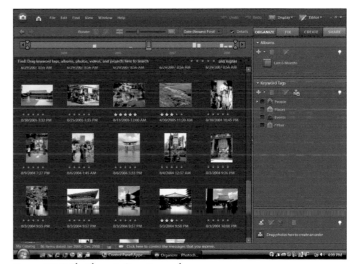

Figure 13-2: The Elements Organizer workspace

Add Files to the Organizer

1. In the Elements Organizer, choose File⇨Get Photos and Video⇨From Files and Folders.

2. Navigate to your hard drive and select the folder containing your chosen images. Or, if you're pulling images from a CD or DVD, navigate to that media and select the photos you want to import.

3. If you're importing from your hard drive, from the dialog box, select a file type or choose All Files to import your files, as shown in Figure 13-3. If you're pulling images from a CD or DVD, select the Copy Files on Import option to import a high-resolution copy of the image. Or, select Generate Preview to import a low-resolution copy of the image. If you want to keep the original master photo offline, type the name of the volume for the CD or DVD that contains the photo.

4. Select the Automatically Fix Red Eyes option to eliminate any red-eye effect in your photos upon import.

5. Click the Get Photos button to import your images into the Organizer (see Figure 13-4).

You can also easily acquire images in the Organizer from files on a digital camera, memory card, or mobile phone or from a scan or video. See Chapter 6 for more details.

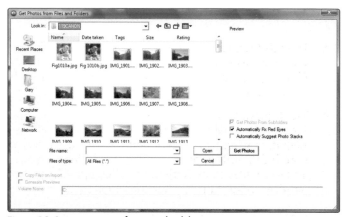

Figure 13-3: Import images from your hard drive

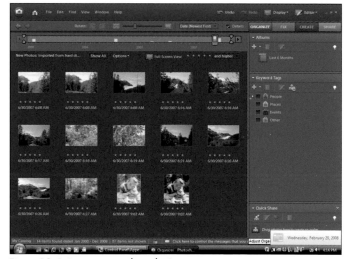

Figure 13-4: Images imported into the Organizer

View Files in the Organizer

1. After opening the Elements Organizer and adding images to the workspace, you can view your images.

2. The Photo Browser, shown in Figure 13-5, shows, by default, thumbnail images of your photos. If you have added video clips, the first frame of the video is displayed. Audio files are also displayed and are indicated by a sound icon. Use the arrows in the upper-left area (above the Browser) to scroll through the thumbnails. You can also use the scroll bars.

3. To change the view of your images, click Display in the upper-right corner of the Elements window and choose Thumbnail View, View Photos in Full Screen, or Compare Photos Side by Side.

4. To change the size of the image thumbnail (shown in Figure 13-6), move the Size slider to the left or right. It's directly above the Photo Browser. You can also rotate selected photos by clicking the Rotate buttons just to the left of the Size slider.

5. To view the details attached to an image, such as date or ratings, select the Details check box.

6. Use the View menu (on the Menu bar) to display images by media type, filename, details, or other criteria.

7. To select a photo, click it in the Photo Browser. After photos are selected you can add them to projects and e-mails, edit them, or add various tags for easier sorting and locating later, as described later in this chapter.

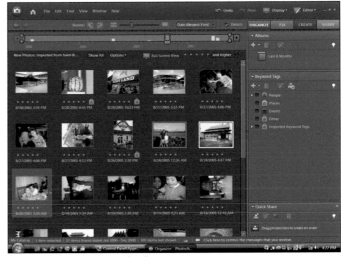

Figure 13-5: View images in the Photo Browser

Figure 13-6: Change the thumbnail size

Create Catalogs

1. In the Elements Organizer, choose File➪Catalog.

2. In the Catalog Manager dialog box, shown in Figure 13-7, click New to create a catalog.

3. In the New Catalog dialog box, enter a name for your catalog. You can also choose to import free music when creating a new catalog.

4. Click OK. Elements saves all catalogs in a default folder (Catalog folder) at a fixed location on your hard drive. Be sure to be consistent with this saving methodology so that you can always locate your catalogs.

5. From your catalog, you can now create subsets of images (albums), tag images with keywords, and rank them with stars. Note that the catalog is simply a reference of, or a link to, the files. It displays thumbnails and the corresponding metadata (information about the image, such as date and exposure) of each image, but the actual files are stored in their original location (on the hard drive or a CD, for example).

 When you first launch Elements, by default it automatically equips you with an initial catalog file, where all files you acquire in the Organizer are cataloged. Most people choose to have a single catalog, but as your catalog starts to become overly large and unwieldy, you may want to create additional catalogs (for example, for each employee or family member). That way, you can manage your images more productively, as shown in Figure 13-8.

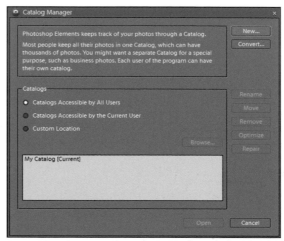

Figure 13-7: Create a catalog

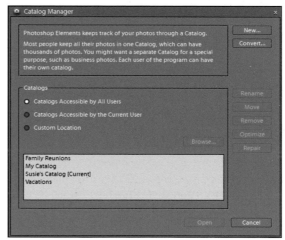

Figure 13-8: Create additional catalogs

Create Albums

1. In the Elements Organizer, click the Create New Album icon (a plus sign) in the Albums palette in the Organize Bin on the right side of the window.

2. Choose New Album from the submenu, as shown in Figure 13-9. You can also choose a new smart album (an album based on a criteria such as a keyword tag) or new album group (a group of albums).

3. In the Create Album dialog box, enter a name for the album and add any notes you have about the album, such as Alaskan Vacation. The icon appears as a question mark until you add your first photo.

4. Click OK. Your new album appears in the Albums palette.

5. To add a photo to the album, select the photo (or photos) in the Photo Browser and drag it from the browser into the album in the Albums palette, as shown in Figure 13-10. You can also drag the album from the Albums palette into the Photo Browser onto the photo. The first photo then becomes the icon for the Album.

 Albums in Elements resemble analog hard-copy albums. Create an album and then store and organize your photos in it. You can then just display the albums or use them in various projects. Each photo in an album is numbered, and the same photo can appear in more than one album.

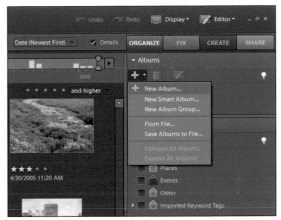

Figure 13-9: Create an album

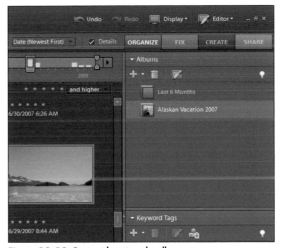

Figure 13-10: Drag a photo into the album

Find Files in the Organizer

1. In the Elements Organizer, you can search for images in different ways and also by various criteria:

 - **Timeline:** Set a date range to find images chronologically. (See the details in the section "Sort Images with the Timeline," later in this chapter).

 - **Find Bar:** Drag a photo, a tag, a project, or an album here to find similar files.

 - **Find⇨By Caption or Note, shown in Figure 13-11:** Choose this command to search for images by captions or notes that you added. (See "Add a Caption," at the end of this chapter). You can also choose other criteria from the submenu, such as File Name, History, Media Type, Details (metadata), Unknown dates, Untagged images, and even Visual Similarity. Choose Faces for Tagging to find all photos where a face appears. And then, you may want to tag those images with a keyword for quicker locating later. (See "Create and Tag Images with Keywords," later in this chapter.)

 - **Albums palette:** Use this palette in the Organize Bin on the right side of the window to find and view contents of albums.

 - **Keywords palette:** Use this palette in the Organize Bin to find and view the images with a selected keyword tag only. See details in the later section "Create and Tag Images with Keywords."

 - Use the **Star Rating filter** above the Photo Browser to find and view the images with a particular rating, as shown in Figure 13-12. To add a rating, select the photo (or photos) in the Photo Browser, choose Edit⇨Ratings and choose from No Rating to 5 Stars.

 Tag your favorite photos with five stars to find them quickly and easily.

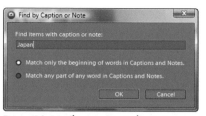

Figure 13-11: Choose your search criteria

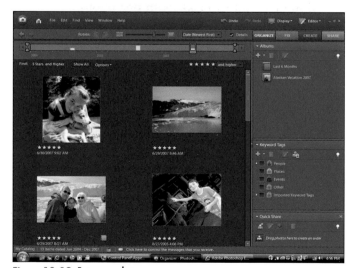

Figure 13-12: Rate your photos

Sort Images with the Timeline

1. In the Elements Organizer, choose Window➪Timeline, if it's not already visible.

2. Select Display and choose Thumbnail View, Import Batch, or Folder Locations to specify whether the timeline represents a month, batch, or folder.

3. Use the left and right arrows to move across the timeline. You can also drag the date marker to view photos for that period. Or, finally, drag the endpoint markers (the stacked arrows, shown in Figure 13-13) to specify a date range.

4. If Step 3 proves to be too confusing, you can choose Find➪Set Date Range and enter start and end dates, as shown in Figure 13-14. Click OK.

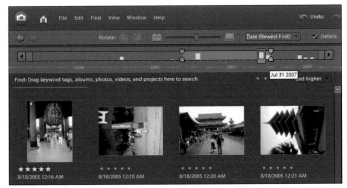

Figure 13-13: Sort images by date

Figure 13-14: Narrow the date range

Create and Tag Images with Keywords

1. In the Elements Organizer, click the new button (the plus-sign icon) in the Keyword Tags palette in the Organizer Bin. Choose New Tag.

2. In the Create Keyword Tag dialog box, type a name for the tag. Choose a keyword category. You can also associate the tag with a place on the map. (Enter a location, such as **Japan**, and a map appears on the left side of the window.) Specify any descriptive words. Note that the first time you attach the tag to a photo, that photo becomes the tag's icon. You can later change the icon, if you want.

3. Click OK.

4. To attach a keyword tag to an image, first select it (or multiple images) in the Photo Browser, as shown in Figure 13-15.

5. Drag the photos onto the tag in the Keyword Tags palette. Conversely, you can also drag the tag onto the photos. Note that you can apply multiple keyword tags to an image. To remove a tag, right-click the photo and choose Remove Keyword Tag from the context menu.

 A keyword tag is a word or phrase, such as *Susie* or *European vacation*, that you can attach to images (and other digital media assets, as well as PDFs) to more easily locate them.

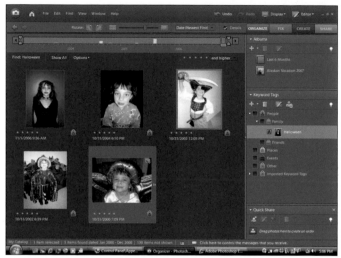

Figure 13-15: Tag images with keywords

Add a Caption

1. In the Elements Organizer, choose a photo in the Photo Browser.

2. Choose Edit➪Add a Caption. You can also double-click a photo and add the caption under the image, as shown in Figure 13-16.

Figure 13-16: Add a caption

Sharing Your Photos

*A*fter you crop, color-correct, contrast, clarify, and creatively polish your photos, you may feel that it's high time you share them with the world. You can send photos as e-mail attachments or as photo mail, post them to an online sharing site, burn them to CD or DVD, export them as a slide show PDF or movie, or add them to a blog. If you want to print them and pass them out, see Chapter 15. If you want to make projects — such as greeting cards, photo books, and calendars — check out the Elements Creations feature or Web sites such as Shutterfly.com and Kodak.com. Whatever format your images take and however you share them, they're sure to be appreciated by your family and friends.

Chapter 14

Get ready to . . .

E-Mail Photos or a Slide Show from Elements

1. In Windows, in the Organizer, select the photos or slide show you want to e-mail. If you're in the Editor in Full Edit mode, you can also open a selected photo.

2. Open the Share panel and click the E-mail Attachments button. If this is your first time e-mailing from Elements, you're prompted to select your e-mail client. Click Continue.

3. In the E-mail panel, select a maximum photo size and fine-tune the photo quality with the slider. Click Next.

4. In the Message panel, type an e-mail message, as shown in Figure 14-1. Then select some recipients. To add recipients, click the Edit Recipients button in the upper-right area and add names and e-mail addresses. Finally, decide whether you want to select the Save As Quick Share Flow option. If you choose No, your photo or slide show is simply attached to the e-mail. If you specify Yes, the file appears in the Quick Share panel at the bottom of the Share panel. Click Next.

5. Elements prepares your file and launches your e-mail client. Click the Send button to transmit the e-mail.

Figure 14-1: E-mail an image in Windows

To change your default e-mail client, press Ctrl+K (or ⌘+K on a Mac) to open the Preferences dialog box. Click Sharing in the left pane and select a new e-mail client from the drop-down list.

6. On a Mac, there's no Organizer; therefore, select some photos in the Photo Browser in the Editor in Full Edit mode. You can also attach a file to an e-mail in Adobe Bridge.

7. Open the Share panel and click the E-mail Attachments button. If this is your first time e-mailing from Elements, you're prompted to select your e-mail client. Click Continue.

8. Elements may prompt you if your file isn't in JPEG format and ask whether you want to convert it, as shown in Figure 14-2.

9. Elements opens your e-mail client and attaches your file automatically.

10. Compose your e-mail and send it as you normally would.

 You don't have to use Elements to e-mail your images. You can simply attach your photos to an e-mail message within your specific e-mail client, whether it's Microsoft Outlook, Entourage, or a Web mail client, like Google Mail, Yahoo! Mail, or Windows Live Mail (also known as Hotmail). Try to keep your photo attachments small unless you're sure that your recipient can receive large file sizes. The JPEG file format is the recommended file format to use for photo e-mail attachments. PDFs are a good format also.

Figure 14-2: E-mail an image on a Mac
PhotoDisc

Send a Photo Using Photo Mail in Elements

1. In Windows only, in the Organizer, select the photos you want to e-mail via Photo Mail. If you're in the Editor, you can also open a photo that you want to e-mail in either Full Edit or Quick Fix mode.

2. Click Share on the Shortcuts bar and then click the Photo Mail button. If this is your first time e-mailing from Elements, you're prompted to select your e-mail client. Click Continue.

3. The Items panel appears. Your selected photos are displayed. Click Next.

4. Add your e-mail message and choose recipients. To add recipients, click the Edit Contact button on the upper-right side and add names and e-mail addresses. Click Next.

5. In the Stationery and Layout Wizard, choose a stationery style (such as various frame designs) and background from the pane on the left. Click Next.

6. Specify a layout and font style, as shown in Figure 14-3. Click Next.

7. Elements launches your e-mail client and embeds the photo mail in the body of your e-mail.

Figure 14-3: Send your photo as jazzy photo mail

 You can send Photo Mail by using the e-mail client Windows Mail, Outlook Express, or Adobe E-mail Service.

Upload to an Online Sharing Site

1. Launch your Web browser and go to www.kodak gallery.com.

2. Create an account by following the easy instructions.

3. Click Upload Photos.

4. Name your album. Specify a date. Provide a description, if you want. Specify whether to use filenames as captions. Click Continue.

5. Click Choose File. Navigate to and select a photo. Repeat until all your chosen photos are selected.

6. Click Start Uploading. It takes a few minutes for a browser to upload the photos, as shown in Figure 14-4.

7. You can choose to add embellishments, such as borders, or perform simple edits, such as cropping and fixing red-eye.

8. Click Share Photos to share them with others.

9. Select an album and click Next.

10. Type your recipients' e-mail addresses in the To box. Add a Subject line and an e-mail message.

11. Click Send Invitation, and your album is now shared, as shown in Figure 14-5. Your recipients receive an e-mail with a link to the sharing site. Check your guestbook to see who has viewed the album and view the comments they have left.

 Some of the most popular online sharing Web sites are Shutterfly, Snapfish, Flickr, Picasa, SmugMug, Kodak Gallery, and Photobucket. Each site has its own features and procedures for uploading and sharing images, but all are easy to use. Try a couple to see what suits you.

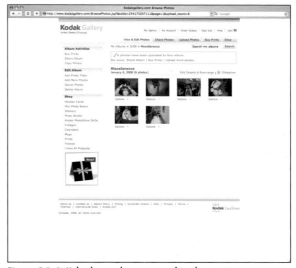

Figure 14-4: Upload your photos to an online sharing site

Figure 14-5: Send an invitation for others to view your album

Burn a Slide Show to a CD or DVD by Using Elements

1. In the Organizer, select a slide show. On a Mac, use Adobe Bridge.

2. Click CD/DVD in the Share panel.

3. In the Burn dialog box, select your CD or DVD drive.

4. Choose a file format, as shown in Figure 14-6. NTSC is used in North America, Japan, and elsewhere. PAL is used in Europe, Australia, and elsewhere. Use whichever format is appropriate for your disc drive or player.

5. Select a drive speed.

6. Insert a blank CD or DVD in the drive.

7. Click OK.

8. Elements writes to your CD or DVD and alerts you that a Video CD or DVD was created successfully. Note that when Elements burns a slide show to a CD, it burns it as a Video CD (VCD).

9. Click OK.

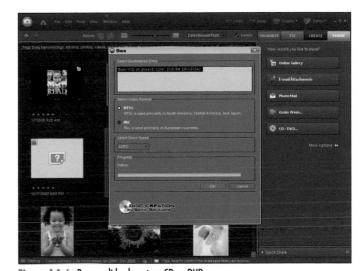

Figure 14-6: Burn a slide show to a CD or DVD
Photos courtesy Corbis Digital Stock, Purestock, Digital Vision

 Video CDs can be read by most computer CD-ROM and DVD-ROM drives and by some DVD players.

 You can also burn an online gallery creation to a CD or DVD.

Publish to a PDF Slide Show

1. In the Organizer, double-click a slide show to open a project in the Slide Show dialog box.

2. Click Output.

3. Choose the Save As a File option on the left.

4. Select the PDF File (.pdf) option on the right, as shown in Figure 14-7.

5. Choose a file size. Take your audience into consideration when choosing a size. Select Loop to automatically have the show replay. Select Manual Advance to let users advance the show manually. Select View Slide Show after Saving to view the PDF after creating it. Click OK.

6. In the Save Slide Show As PDF dialog box, name your file and make sure to choose PDF File as the file type. Click Save.

7. In the dialog box, click Yes to add your file to your catalog.

 Some animation features and transitions, such as pans and zooms, may not be preserved in the PDF file. Embedded video clips in a slide are also not saved.

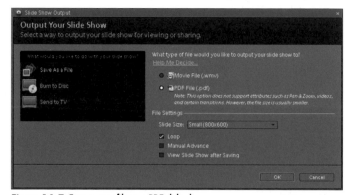

Figure 14-7: Export your file to a PDF slide show

Publish to Video

1. In the Organizer, double-click to open a project in the Slide Show dialog box.

2. Click Output.

3. Choose the Save As a File option.

4. Select the Movie File (.wmv) option, as shown in Figure 14-8, to export a Windows Media video file. You can then view your video in Elements, Windows Media Player, or any other application that supports the .wmv file format.

5. Choose a slide size. Consider your audience when choosing a size. Click OK.

6. In the Save Slide Show As Movie dialog box, name your file and make sure to choose Windows Media File as the file type. Click Save.

7. In the Windows Media File Save dialog box, click Yes to add your file to the catalog.

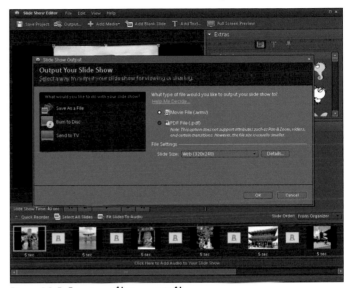

Figure 14-8: Export your file to a movie file

 If you have a Windows Media Center Edition computer, you can also export your slide to TV. Select the Send to TV option in Step 4. If you have Adobe Premiere Elements, you can export your file into that application. Select the Send to Premiere Elements option in Step 4.

Send Photos to a Mobile Phone

1. In the Organizer, choose an image.

2. In the Share panel, click More Options and choose Email to Mobile Phone.

3. Select some recipients. Note that the recipients' mobile phone e-mail addresses must be listed in their contact information.

4. Choose a maximum size for the photo.

5. Type your message, as shown in Figure 14-9.

6. Click Next.

7. Your e-mail client is launched. Finish composing the e-mail and click Send.

8. Your photo is sent to the recipients' mobile phones.

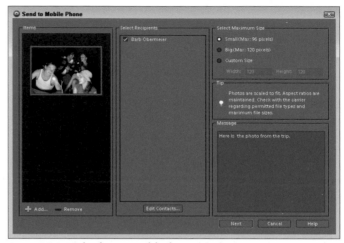

Figure 14-9: Send a photo to a mobile phone
Purestock

Add Photos to a Blog

1. In your Web browser, go to www.blogger.com/start. This blog site, called Blogger, is sponsored by Google and is free.

2. Create an account by following the easy instructions.

3. Name your blog and specify a blog URL. Click Continue.

4. Select a template for your blog. Click Continue.

5. The blog is created. Click Start Posting to create your first entry.

6. Create a title for your entry.

7. Enter some text and specify a font and font size.

8. To add a photo, click the Add Image icon (third from right) on the toolbar, as shown in Figure 14-10.

9. Choose a photo from your computer or from your Web site. Stick with the JPEG format, and keep the resolution low. For important information on image resolution, see Chapter 7.

10. Choose a layout. Click Upload Image.

11. Your blog is done, as shown in Figure 14-11.

 Blog is short for *Web log*. It's usually a simple Web site where entries are made. These entries, usually displayed in reverse chronological order, are often centered around news or commentary on a topic. Other blogs are more like journals or diaries. Blogs can consist of all text, text and images, or text with images and multimedia. Viewers can typically post responses to blog entries. Check out www.blogcatalog.com or www.MyBlogLog.com to find blog sites on a variety of topics.

Figure 14-10: Click the Add Image icon to add a photo

Figure 14-11: A completed blog entry

Printing Your Images

*I*f you're like most people, viewing images on-screen is fine and dandy, but eventually you want to print an image or two. The biggest issue to keep in mind is that it can be challenging to make what you see on-screen match what's printed on paper. First, you calibrate your equipment and find out how to create and use color profiles (briefly explained in Chapter 7). Then you color-correct your images to make sure that they look great on-screen (see Chapters 7 and 8). Next, you get to know your own printer or service provider or online print service. Understanding what kind of output to expect can help you make necessary tweaks and adjustments in your images' color and in the color settings on your computer and printer. Finally, you complete numerous test prints until you're satisfied with the quality of your prints. Yes, it all takes time, but it's time well spent.

Chapter 15

Get ready to . . .

Prepare Images for Printing

1. Make all contrast, color, and clarity adjustments that you want. See Chapters 7 and 8 for details.

2. Use the proper resolution. A resolution that's too low results in a print of inferior quality. A resolution that's too high results in an unnecessarily large and cumbersome file size. Generally, use a resolution that's two times the lines per inch (lpi), of your printed output. Ask your vendor, client, service provider, or end destination (newspaper or magazine) what it recommends. If you're printing an image yourself, check out the printer user manual and follow its recommendation. If all else fails, a resolution of 300 dots per inch (dpi) works for most print jobs.

3. Save the image in the proper file format (see Figure 15-1). For print, stick with the following formats: Photoshop EPS, Photoshop PDF, PSD, and TIFF. TIFF is compatible with most programs and platforms.

4. Use the proper color mode, and avoid using Indexed Color mode for printing. The color gamut (range) is quite limited, and images may appear dithered or blocky. RGB mode is fine for printing on your desktop color printer or for ordering prints online or at kiosks. If you're preparing an image for offset printing, it must be converted to process color, or CMYK (cyan, magenta, yellow, and black), which Elements doesn't support (but full-scale Photoshop does).

5. Apply transformations in your native application. If you're preparing the image to import into another program, always execute all image transformations in your native application, such as Elements. Scale, rotate, skew, and manipulate the image to its final appearance in Elements so that the processing of the image data is quicker when printing. Try not to do any resizing and rotating in the application you're importing the image to.

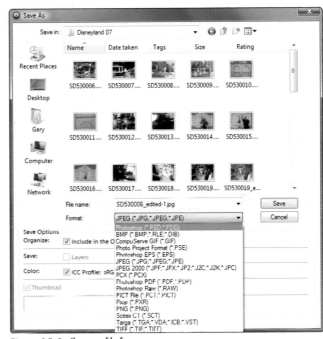

Figure 15-1: Choose a file format

6. Limit the number of typefaces. If you added type to your image, you may want to limit the number of fonts you use. Not only does the image then look more polished, but you also reduce the time it takes to download those fonts to the printer.

7. Print from your native application first. Even if you're planning to import your image into another program, always print initially from your native application, such as Elements. If the image doesn't print from Elements for some reason, it won't print from another application and you at least eliminate one step from your troubleshooting process.

8. Allow time and resources for test prints. The world of screen viewing and the world of printing on paper are rarely identical. If you're printing the images yourself, give yourself enough time, paper, and ink to tweak color adjustments — in your program and in your specific printer's settings, including color-management settings — until you're satisfied with the results. Get to know your printer's strengths, weaknesses, and inclinations. If you're sending prints to a service provider or online printer, check to see whether it has recommendations for "prepping" your files. You may have to print a few rounds before you produce something you're pleased with.

9. An image that's ready to print is shown in Figure 15-2.

Figure 15-2: An image that's ready to print
Corbis Digital Stock

 For more on resolution, color modes, and file formats, see Chapter 7.

Print a Single Photo from Windows

1. In the Organizer, select a photo (or photos) and choose File⇨Print. You can also open an image in the Editor and choose File⇨Print. See specific print options in the later section "Print a Single Photo from a Mac."

2. In the Print Photos dialog box, select a printer from the Select Printer drop-down list. Depending on your printer model, printer-specific options may appear.

3. Select Individual Prints from the Select Type of Print drop-down list. To add photos, click the Add button, and select the check box next to a photo (or photos). To remove a photo, select an image thumbnail and click the Remove button.

4. Select a print size from the drop-down list.

5. If you're printing more than one photo and want one photo per page, select the One Photo Per Page check box.

6. Select the Crop to Fit check box to have the image fit into your chosen print size.

7. Click More Options to specify additional settings:

 • **The Label section:** Select the Date, Caption, and File Name check boxes (shown in Figure 15-3) if you want that information printed next to your image.

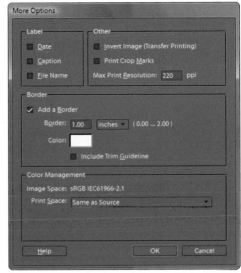

Figure 15-3: Specify additional print options

- **The Other section:** Select Invert Image if you're printing to transfer paper. Transfer paper is used for printing on T-shirts and other types of material. Indicate whether you want crop marks around your image as a guide in cutting, and enter a maximum print resolution, if you want. I recommend leaving the resolution as is for this option, unless you just want a quick, preliminary print of a high-resolution image. For more on the important topic of resolution, see Chapter 7.

- **The Add a Border check box:** Select to add as much as a 2-inch border. Click the Color swatch to choose a border color. Select the Include Trim Guidelines check box to add crop marks for cutting purposes.

8. For color-management options, see "Specify Color-Management Settings," later in this chapter.

9. Click OK.

10. Click Print, as shown in Figure 15-4.

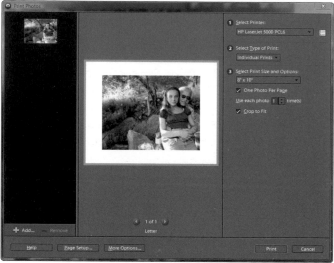

Figure 15-4: Print a single photo from Windows

Print a Single Photo from a Mac

1. In Adobe Bridge, select a photo and choose File⇨ Print. You can also open an image in the Editor and choose File⇨Print.

2. In the Print dialog box, select a printer from the Select Printer drop-down list. Depending on your printer model, printer-specific options may appear.

3. Specify a print size from the drop-down list. Enter the number of copies, as shown in Figure 15-5.

4. Click the icons below the image to specify the print orientation (portrait or landscape) and to rotate the image 90 degrees right or left.

5. To center the image, select the Center Image check box. Or, use the Top and Left boxes to specify where the image appears on the page. Choose a unit of measurement.

6. If you want to scale your image, choose the scale percentage or enter height and weight values in the Scaled Print Size area. Choose a unit of measurement.

7. Select the Scale to Fit Media check box to size the image to fit on a specific paper size. Selecting the Show Bounding Box option places handles around the image and enables you to visually size the image on your chosen paper size.

8. In the Output section, choose whether to add a filename, caption, border, background (border color), or crop marks (guides for cutting, as shown in the photo in Figure 15-5) to your print. Select the Flip Image check box if you're printing to transfer paper.

9. For color-management options, see "Specify Color-Management Options" (the following section).

10. Click Page Setup if you need to visit the Page Setup dialog box. When you're ready, click Print.

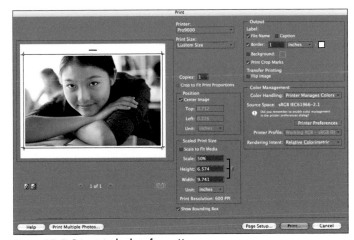

Figure 15-5: Print a single photo from a Mac
Imagesource

Specify Color-Management Settings

1. Choose File➪Print.

2. In the Print dialog box, in the Color Management section, you can choose one of these three options from the Color Handling drop-down list:

 - **Printer Manages Color:** Your printer decides which profile to use when your photo is sent to the printer. It makes this decision based on the type of paper you select as the source paper. If you choose another paper, your printer chooses a different color profile. This feature automatically chooses a color profile for you when you print your file. This option is a good one if you don't have a custom profile for your printer, ink, or paper.

 - **Photoshop Elements Manages Color:** Elements performs all color-management tasks when sending data to the printer. This option is a good one if you have a custom profile for a specific printer, ink, or paper. Disable color management in the printer driver dialog box if you use this option. Select a printer profile from the drop-down list, as shown in Figure 15-6.

 - **No Color Management:** Color isn't managed. I don't recommend selecting this setting unless you have a very good reason to do so.

3. Click Printer Preferences to open the Page Setup dialog box. Specify your settings the way you want.

4. Keep the Rendering Intent option at the default setting unless you have a very good reason to change to it. This option specifies how colors are translated from your photo's color space when certain colors aren't available in the print space.

5. Click Print.

Figure 15-6: Specify a color-management option

 The complex issue of understanding and executing color management is way beyond the scope of this brief, one-page explanation. If color-management expertise is important to you, invest in a book dedicated solely to the topic: Check out *Color Management for Digital Photographers For Dummies*, by Ted Padova and Don Mason (Wiley Publishing).

Print a Contact Sheet in Windows

1. In the Organizer, select some photos, as shown in Figure 15-7, and choose File➪Print. You can also choose File➪Print Multiple Photos in the Editor, which then launches the Organizer and opens the Print Photos dialog box.

2. In the Print Photos dialog box, select a printer from the Select Printer drop-down list. Depending on your printer model, printer-specific options may appear.

3. Select Contact Sheet from the Type of Print drop-down list. Other choices include Individual Print, Picture Package, and Labels. To add photos, click the Add button. Pick photos by selecting their corresponding boxes. To remove a photo, select an image thumbnail and click the Remove button.

4. Select a layout, as shown in Figure 15-8. Choose the number of columns (1 through 9). Choose whether to add text labels, which can include a date, caption (from the file's metadata), filename, and page number (for multiple paged contact sheets).

5. Click More Options to print using color management. Choose a color profile from the Print Space drop-down list.

6. Click Print, as shown in Figure 15-8.

Figure 15-7: Choose some photos in the Organizer
Corbis Digital Stock

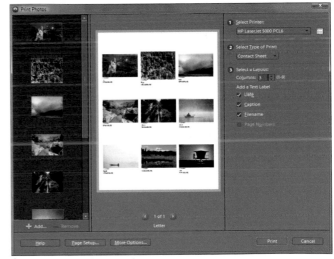

Figure 15-8: Specify contact sheet options
Corbis Digital Stock

Print a Contact Sheet from a Mac

1. In Adobe Bridge or the Editor, choose File↪ Contact Sheet II.

2. In the Contact Sheet II dialog box, choose Current Open Documents, Folder, or Selected Images from Bridge from the Use drop-down list. Click Choose to navigate to a folder, if that's your choice.

3. In the Document section, specify a document (page) size, resolution, and color mode. For details on these elements, see Chapter 7.

4. Select the Flatten All Layers check box if you want your contact sheet thumbnails to reside on a single layer.

5. In the Thumbnails section, choose whether to place thumbnail images across or down first. Specify the number of columns and rows, as shown in Figure 15-9. Finally, select the Rotate for Best Fit check box to have the thumbnails rotated before they're placed on the contact sheet.

6. Select Use Filename as Caption if you want to do that. Choose a font and font size for the caption.

7. Click OK. Elements runs a script and creates the contact sheet, as shown in Figure 15-10.

8. Choose File↪Print to print the contact sheet. For information on print settings, see "Print a Single Photo from a Mac," earlier in this chapter.

Figure 15-9: Specify contact sheet settings

Figure 15-10: Print a contact sheet
Corbis Digital Stock, Flat Earth, PhotoDisc, Digital Vision

Create a Picture Package in Windows

1. In the Organizer, select some photos and choose File⊅Print. You can also choose File⊅Print Multiple Photos in the Editor, which then launches the Organizer and opens the Print Photos dialog box.

2. In the Print Photos dialog box, select a printer from the Select Printer drop-down list. Depending on your printer model, printer-specific options may appear.

3. Select Picture Package from the Type of Print drop-down list.

4. From the drop-down list, select a layout representing how you want your images sized and arranged.

5. Select a preset frame from the Select a Frame drop-down list. Or, keep the default of None, shown in Figure 15-11.

6. To replace a photo in the layout, simply drag and drop an image thumbnail from the left panel onto an image on your layout. To add a photo not listed in the dialog box, click the Add button. Pick photos by selecting their corresponding check boxes. To remove a photo, select an image thumbnail and click the Remove button.

7. Select the Fill Page with First Photo check box to print each image on its own page.

8. Select the Crop to Fit check box option to make your photos perfectly fit the layout size.

9. Click More Options to print using color management. Choose a color profile from the Print Space drop-down list. For more on color profiles, see Chapter 7.

10. When your picture package is complete, as shown in Figure 15-12, click Print.

Figure 15-11: Specify picture package settings
Corbis Digital Stock

Figure 15-12: A completed picture package
Corbis Digital Stock

Create a Picture Package from a Mac

1. In the Editor, choose File⇨Picture Package.

2. In the Picture Package dialog box, in the Source Images section, choose File, Folder, Frontmost Document (the selected image), Selected Images from Bridge, or Open Files from the Use drop-down list. If you chose File or Folder, navigate to that file or folder.

3. Choose a page size from the drop-down list. Select a layout and specify a resolution. If you're printing the package, stick with a higher resolution, such as 300 ppi.

4. Choose a color mode from the Mode pop-up menu — RGB Color for color or Grayscale for black-and-white images.

5. To change a photo, click its thumbnail. Navigate to your new image and select it. See Figure 15-13.

6. Click the Edit Layout button to further customize your layout. In the dialog box that appears, enter a name for the layout and choose page dimensions and measurement units.

7. In the Grid area, select the Snap To check box to see a grid to help position thumbnails, and then enter a size for grid increments. Click the placeholders and drag them to a location of your choice. To reposition a placeholder, enter X and Y values. Drag a handle to resize the placeholder or enter Width and Height values. Click Add Zone to add another placeholder. Delete Zone and Delete All delete placeholders.

8. Click Save. Then Click OK to create the picture package. Elements runs the script and prepares the picture package, as shown in Figure 15-14.

9. Choose File⇨Print to print the package.

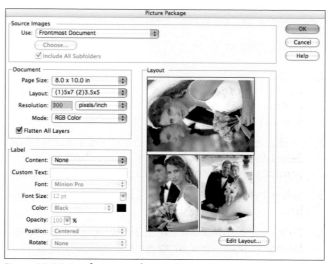

Figure 15-13: Specify picture package settings
Purestock

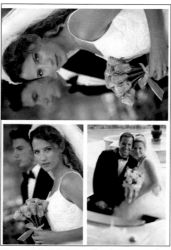

Figure 15-14: A completed picture package
Purestock

Submit Files to a Service Provider

1. Go online to check out which services your local service provider offers. You may find info on pricing and file specifications. Some offer downloadable resource files and online ordering and uploading services.

2. Before you submit a file to a service provider, know the file specifications for your project. Know which file format, resolution, and color mode the provider prefers. "Prepare Images for Printing," earlier in this chapter has more tips.

3. After you find a good service provider, stick with it for all your jobs. First, you know what to expect, and your projects will be consistently produced. Second, by building a working relationship, you get good customer service and secure a better negotiating position if another provider comes in with a lower bid.

Order Prints Online

1. In the Organizer, select the photos you want to order prints for.

2. Open the Share panel and click the Order Prints button.

3. The Kodak EasyShare Wizard appears, as shown in Figure 15-15. Create an account and enter your order information. You can order prints for yourself and send prints to friends and family. Note that you can also order prints from sites such as Snapfish and Shutterfly.

 On a Mac, in Adobe Bridge, select a photo or photos, and choose Tools➪Photoshop Services➪Online Photo Printing.

 Service providers, or bureaus, are businesses that provide a variety of services that can include photo processing, slide processing, printing, mounting and lamination, scanning, image setting (color separations to film and paper), digital printing, photo retouching and restoration, DVD archving, and more. Providers normally offer services that you don't find at more copy-oriented centers, like FedEx Kinkos.

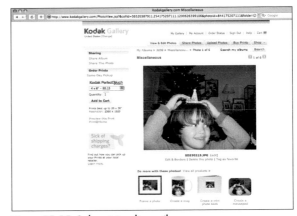

Figure 15-15: Order prints online easily

Index

Digital Photography Just the Steps™ For Dummies®, 2nd Edition

Published by
Wiley Publishing, Inc.
111 River Street
Hoboken, NJ 07030-5774

www.wiley.com

Copyright © 2008 by Wiley Publishing, Inc., Indianapolis, Indiana

Published by Wiley Publishing, Inc., Indianapolis, Indiana

Published simultaneously in Canada

For general information on our other products and services, please contact our Customer Care Department within the U.S. at 800-762-2974, out-side the U.S. at 317-572-3993, or fax 317-572-4002.

For technical support, please visit www.wiley.com/techsupport.

Wiley also publishes its books in a variety of electronic formats. Some content that appears in print may not be available in electronic books.

Library of Congress Control Number: 2008927013

ISBN: 978-0-470-27558-0

Manufactured in the United States of America

10 9 8 7 6 5 4 3 2 1

WILEY

Digital Photography Just the Steps™

FOR

DUMMIES®

2ND EDITION

by Barbara Obermeier

WILEY

Wiley Publishing, Inc.